# VANCOUVER ART
# & ECONOMIES

Edited by
Melanie O'Brian

Arsenal Pulp Press | Artspeak

What you see depicted on the front cover of this publication are the twenty-five spiral-bound photo albums that comprise Eric Metcalfe's photo documentation of the Vancouver art community from 1995 to 2005. It is a project conceived in part by Eric's fascination with the social aspects that comprise the community around him and by his desire to "document the generational shift occurring at the turn of the century." This span of time—a decade—falls between the publication of *Vancouver Anthology: The Institutional Politics of Art* in 1991 and this book, *Vancouver Art & Economies*.

By making this photographic project the subject of its own portrait, I hope to preserve, in an ethical sense, the silent contract that exists between friends when a photograph is taken. I hope, as well, that this gesture is not interpreted as a conceptual endgame but as a way to accurately depict the project which, in my opinion, should not be reproduced within the context of any publication. I believe that the collection of snapshots is best understood *en masse*, and within their habitus: the photo albums that contain them.

Since the mid-1980s, the once marginal city of Vancouver has developed within a globalized economy and become an internationally recognized centre for contemporary visual art. Vancouver's status is due not only to a thriving worldwide cultural community that has turned to examine the so-called periphery, but to the city's growth, its artists, expanding institutions, and a strong history of introspection and critical assessment. As a result, Vancouver art is visible and often understood as distinct and definable. This anthology, *Vancouver Art & Economies*, intends to complicate the notion of definability. It offers essays on diverse topics to address the organized systems that have affected contemporary art in Vancouver over the last two decades.

It has been over fifteen years since Stan Douglas edited *Vancouver Anthology: The Institutional Politics of Art* (1991), a compilation of Vancouver art histories that were linked through what Douglas called "their common preoccupation: a critique of the institutionalization of previously alternative art activities in North America...." The length of time that has passed since *Vancouver Anthology* was published was not the sole impetus for another critical assessment of Vancouver art; the need for this book was further compounded by a perceived increase in the professionalization of Vancouver artists and institutions. Signaling another level of institutionalization, Vancouver (and global) culture can be said to look toward the homogenizing effects of corporate enterprise and systems of privatization, whether in non-profit organizations, educational systems, intellectual concerns, or commercial structures. The essays in *Vancouver Art & Economies* collectively remark, both compatibly and contradictorily, on the economies at work in Vancouver art—its historical, critical, and political engagement; its sites of cultural production; and its theoretical and practical intersection with technology or policy. Considering a selection of conditions, focuses, and resources within the community, this anthology is intended to function as a marker of shifting ideologies and perspectives on art, politics, society, and capital in this city.

There have been a number of publications that consider Vancouver and its recent visual arts culture. Among these are *Vancouver: Representing the Postmodern City* (1994), which took stock of the city's culture in general; *Stan Douglas: Every Building on 100 West Hastings* (2002), which examined the city through Douglas's photograph of the same name; and a selection of local exhibitions and accompanying catalogues that contribute

to the ongoing definition of Vancouver art, such as the Vancouver Art Gallery's *Topographies: Aspects of Recent B.C. Art* (1996), and the Morris and Helen Belkin Art Gallery's *6: New Vancouver Modern* (1998). Additionally, international exhibitions have investigated recent Vancouver art within international and local contexts, including *Baja to Vancouver: the West Coast and Contemporary Art* (2003), organized by the Vancouver Art Gallery and three American institutions, and *Intertidal: Vancouver Art and Artists* (2005), organized by the Museum van Hedendaagse Kunst Antwerpen with the Morris and Helen Belkin Art Gallery.

While this book relies on the contributions of these and other publications, *Vancouver Art & Economies* takes *Vancouver Anthology* as its model. Both books originated from artist-run centres—the Or Gallery in 1991 and Artspeak in 2007—and a series of public lectures that allowed the anthology contributors to vet their ideas before an interested community, effectively building on the history of critical dialogue between artists, writers, curators, and others. The first series was held in 1991 at the Western Front, and the second in 2005 at Emily Carr Institute; lectures from both were reworked into publications. Vancouver is hungry to talk and hear about itself, and if audience attendance at the lectures is any indication, *Vancouver Art & Economies* is, I am sure, only one of many future looks at Vancouver art.

The topics I originally proposed to the writers sought to highlight the key changes Vancouver art has witnessed or undergone in the last two decades; these topics were then honed by the writers. They include: locating contemporary Vancouver art within its own international history and acknowledging recent legacies; examining Vancouver art within a contemporary political economy; assessing the particulars of writing about Vancouver art; considering art's practical and theoretical relationship to technology; approaching various subjectivities in local production; problematizing the bureaucracy of cultural diversity; taking stock of the role and definition of artist-run centres; and tracing the rise of commercial galleries as cultural producers. The result is a collection of essays that operate as a snapshot, or an album of snapshots, of Vancouver art.

Given this photo album analogy, it is crucial to note that such a compendium is subjective and incomplete by definition. There are additional anthologies that could be compiled on topics that lie both within and beyond this framework to address the increasingly diverse concerns of the Vancouver art community. This publication capitalizes on an existing multifaceted dialogue and the writers were selected accordingly. Amongst the issues that are not addressed are a reconsideration of the city's physical landscape (the well-worn city/wilderness dichotomy); a reassessment of women or First Nations artists in Vancouver art; an examination of the role of the Vancouver Art Gallery, universities, art schools, and collectors; and a close look at the art market system—all of which play into a larger picture of Vancouver's art economies. These topics we leave to future analyses.

I would like to extend my sincere thanks to the nine writers who delivered their papers to a public audience and have produced considered essays for this publication: Clint Burnham, Randy Lee Cutler, Tim Lee, Sadira Rodrigues, Marina Roy, Sharla Sava, Reid Shier, Shepherd Steiner, and Michael Turner.

In addition to the writers, I would like to thank the individuals and organizations who contributed to the project. Thanks to Stan Douglas for supporting a follow-up project to *Vancouver Anthology: The Institutional Politics of Art*. Antonia Hirsch, Sharla Sava, and William Wood were instrumental in the incipient stages of the project and provided feedback throughout the process. John O'Brian provided important critical advice and support. Geoffrey Farmer's cover representing Eric Metcalfe's document of the Vancouver art community offered critical problematics that informed the shape of the project overall. Amy O'Brian provided research assistance. Wayne Arsenault planted the seed for this project and provided invaluable on-going dialogue through its development.

Thank you to Arsenal Pulp Press for collaborating on this publication. Brian Lam was tireless, engaged, and a pleasure to work with. Robert Ballantyne and Shyla Seller were always helpful.

Deanna Ferguson has been an invaluable, meticulous editor and coordinator of images and their permissions. Thank you to Robin Mitchell at Hundreds & Thousands for her design. At Artspeak, thank you to Colleen Brown and the Board of Directors for their support. Thanks also to volunteers Aina Rognstat, Martin Thacker, and Ron Tran.

The *Vancouver Art & Economies* lecture series and book were financially supported by Arts Now: Legacies Now 2010, the Spirit of BC Arts Fund, and the Hamber Foundation. Artspeak gratefully acknowledges the ongoing support of the Canada Council for the Arts, the BC Arts Council, and the City of Vancouver. Arsenal Pulp Press received support from the Canada Council for the Arts and the BC Arts Council.

Thanks to the artists who provided images for reproduction and to the Vancouver Art Gallery library for access to its archives. And finally, thanks to the public for attending the lectures and for the ongoing dialogue.

—Melanie O'Brian

# INTRODUCTION: SPECIOUS SPECULATION

Melanie O'Brian

Vancouver's identity has been shaped by more than a century of specula-tion. At once risky and analytic, Vancouver's commercial and theoretical modes of inquiry have yielded numerous opportunities for the city to re-invent itself. Its rapid change and growth has been a result of remote ven-tures in that it has been colonized, developed, and largely supported by global migrations of financial and cultural capital.[1] As the frontier termi-nus of a westward expansion of European colonization and, more recently, as an entry point from Asia, Vancouver has sought (and made) its fortune through ventures that require a belief in risk and progress, such as timber, mining, fishing, gold, tourism, technology, and most characteristically, real estate and land development.[2] These industries have been instrumental in the short history of British Columbia and although the province's econ-omy remains based on natural resources, the city's economy has largely given way to the service sector and is thus attracting investment that relies on status and cultural assets. As Vancouver's speculative focus turns from extraction industries to abstract, symbolic economies contingent on the forces of globalization, the city's desire for world status has prompted it to seek an international stage for validation.

The recent history of Vancouver has been, and is being, shaped by two events that position the city in the spotlight. The first was the transporta-tion and communication-themed Expo '86 World's Fair that commemo-rated Vancouver's centennial; the second is the upcoming 2010 Olympic Winter Games. While the Olympics have not yet taken place, they have produced enough public consideration that it is safe to say that they will be a defining factor of the city's cultural and economic evolution. In the twenty years since Expo '86 visited upon Vancouver promises of prog-ress and global recognition, the event has been acknowledged as con-tributing greatly to Vancouver's deputization as a "world-class" city. As the impetus for significant investment and development, Expo '86 was a catalyst that prompted a new downtown trade and convention centre; the establishment of a rapid transit system; the British Columbia govern-ment's purchase of property on Vancouver's False Creek North to stage the fair; the subsequent selling of the Expo grounds to a condominium developer; the building of the Coquihalla Highway that connected Van-couver to the province's interior; expanded tourist facilities and services; and raised public expectations.[3] Expo '86 helped to define the city, and it appears that its promises have been largely realized, given the interna-

tional acknowledgment of Vancouver, including the awarding of the 2010 Olympics in 2003, and *The Economist* naming it the most livable city in the world in 2005.[4]

Preparations for the upcoming Olympics are coinciding with widespread new development in Vancouver that echoes the Expo '86 era: another convention centre; expansion of the rapid transit system; development of Southeast False Creek into an Olympic Athletes' Village that will be later sold as market housing; condominium developments in Yaletown, Gastown, and areas spreading east ("Be Bold or Move to the Suburbs" was the campaign slogan for the redevelopment of the Woodward's complex in the city's Downtown Eastside); and the expansion of the Sea to Sky Highway to Whistler, as well as event-related construction and upgrading of recreational facilities.[5]

This construction boom is helping to increase the city's population density, but may also be laying the groundwork for a privatized resort city.[6] Since the 1970s, the City of Vancouver has had numerous planning objectives to repopulate the downtown core; the residential densification plan took hold in the 1980s when commercial development slowed and rezoning allowed for condominium towers instead. The residential property market was driven at this time by a wave of Asian investment from Taiwan, Singapore, Japan, and most notably Hong Kong, which precipitated an increase in the pace and scale of development,[7] but the intense construction on the downtown peninsula has yielded largely upscale homes.[8] The lack of affordable housing downtown is pushing less affluent populations out of the city, as well as forcing workers to commute to and from the suburbs.

Land developers hold a central place in the history of Vancouver's civic leadership and the city's evolution, from its inception through to Expo '86 and the Olympics. Olympic profits are typically privatized while its losses are socialized; in many Olympic host cities, the Games' legacy includes artificially inflated real estate prices, a decrease in low-income housing stock due to gentrification, the criminalization of poverty and homelessness, and the privatization of public spaces.[9] Although the development that occurs alongside the Olympics is rationalized as an accelerator for better standards of living, in other Olympic cities this has been an empty promise. The loss of Vancouver's low-income housing stock has been an ongoing issue since the 1970s, with social housing unable to keep up with the rate of demolition of low-cost housing units.[10] This has been exacerbated by the 1993 abolishment of federal housing programs and the 2001 provincial cuts to the social housing program, as well as ongoing decreases to social welfare programs. At the same time, our governments have not been prioritizing culture; instead their programs reflect a possible "twilight" of the welfare state. In the current climate, the arts (like housing, health care, and numerous other social services) are not well supported at the federal, provincial, or municipal levels, while corporate

models for running public institutions as businesses are encouraged.[11] The results of this trend are seen not only in the development instigated by Expo '86 and the Olympics. In 1991, in the introduction to *Vancouver Anthology: The Institutional Politics of Art*, Stan Douglas remarked on a widespread and increasing privatization affecting the social and cultural fabric of Vancouver. The consequences of this most recent wave of speculation remain to be seen, but it appears that a corporate model influences the reshaping of the city and its identity.

### Unlimited Growth

… the economy of art closely reflects the economy of finance capital.

—Julian Stallabrass[12]

… anyone who wishes to understand how the economy functions and what effect it has on everyday life should turn to contemporary art.

—Olav Velthuis[13]

In light of Vancouver's speculative development ethos, an investigation into the city's art economies must surely reflect aspects of the city's political and business principles. An assessment of recent art in Vancouver calls for an examination of the financial, political, social, and intellectual economies at work, and necessitates contextualization within a city that is growing (population and construction-wise) and at the same time delimiting the nature of that growth. It may be useful to compare Vancouver's urban development to the state of contemporary art in the city, as both the urban and art economies speculate on "good appearances." The city is gambling on its future *vis-à-vis* the Olympics by presenting to the world a cleaned-up image of itself absent of social inequities. In doing so, the city reveals how marginalized groups, even the art community, may be vulnerable in the urban development scheme. However, this development has brought forward both opportunities and challenges for the city's non-profit groups. Although arts groups in Vancouver continue to rely on public sector funding to various degrees, they also seek other sources of support to promote long-term stability, specifically through the private sector.[14]

The demands of funders and supporters are helping to determine the parameters by which art, artists, and institutions function. Growth has been a shared desire by both supporters and by individual artists and institutions in the system. Although many in Vancouver have had a strong voice in the contestation of the privatization and institutionalization of

art, it is inevitable that art will at some point adopt the language of those it seeks to criticize. Stan Douglas writes: "It is the predicament of any group of people who want to contest the actions of a social institution by speaking that institution's language and who may, thereby, run the risk of becoming bound to their antagonist, as they mirror its form and more than a few of its contents."[15] Institutional critique can be seen as a trope of the last two decades, and it has become increasingly acknowledged that the artist's role is similarly institutionalized. Artist Andrea Fraser has observed that corporate expansion "is producing an institutional mono-culture of management and marketing that's destroying the diversity not only of culture but also of social and economic relations." She argues that artists are trained in a manner that is "the very model for labour in the new economy ... highly educated, highly motivated 'self-starters' ... convinced that we work for ourselves and our own satisfaction even when we work for others."[16] Even in critique and innovation, contemporary art (taken as a whole) is complicit in these homogenizing migrations.

Ostensibly existing outside the effects of an international art scene or the art market, Vancouver has been perceived as a peripheral city that manages to produce remarkable artists without the powerful promotional systems evident in cities like New York or London. It might be argued that Vancouver has now shed its previous status as marginal and arrived on the international art map, commercial endeavors playing an increasingly significant role in its growth and maturation.[17] The tactic toward internationalism is another sign of Vancouver's changing art economy, and reflects a larger move within the city and province to recognize the benefits of culture to the general economy. Given the effects of globalization on Vancouver, the art world mirrors a shifting aspiration toward the international that can be attributed to a least two significant factors. First, that the visual arts, as part of the cultural sector, have been identified as contributing to the gross domestic product,[18] and second, that the international success of a handful of Vancouver artists has set a benchmark for interested outsiders as well as for subsequent generations of Vancouver artists.

The period bracketed by Expo '86 and the Olympics marks transformations largely associated with the rise of globalization. Within the art world, the effect of the rise of international biennials, art fairs, and a "star" system not only implicates a handful of local artists but curators, collectors, and students.[19] While contemporary art's concerns are both responses to broader economic and political transformations as well as to internal dialogues, they do not stand outside the economy's rules or its establishment of hierarchies of wealth and power. Instead, art is often used to reaffirm these rules. The proliferation of professionalizing art schools reveals their programs and degrees to be part of the professionalized art economy. Art's perceived critical freedom is (literally) bought into through ownership and patronage, and the growing industries of

education (art schools and universities), cultural tourism (museums), and marketing (from real estate to technology) increasingly betrays the business aspect of culture. Vancouver has not only seen an influx of capital, investment, residents, and attention, but has responded to this interest by offering a professionalized city, which includes a polished and authoritative culture.

In this climate of expansion, the Vancouver art community and its institutions have grown, diversified, stabilized, and many, including the Vancouver Art Gallery (VAG), are eager to establish an international presence. The VAG is looking at expanding, having outgrown its neo-classical home, and is considering a new, purpose-built, architecturally significant building. In the last five years, under Director Kathleen Bartels, its aspirations have become far-reaching, promoting internationalization, and it uses the success of Vancouver artists as leverage to appeal to a global art community. Compared to the complaints the VAG received in the early 1980s that then Director Luc Rombout was ignoring local artists,[20] today Vancouver artists (both established and emerging) are buoyed by the institution, their work floated out into international waters with the help of larger commercial and international networks. The VAG is also popularizing art in the city, mixing the visual art scene with marketing, design, music, and performative events in what appears to be successful cultural branding for a mainstream audience.[21] Along with the development of Vancouver's largest visual arts institution, the city has also accommodated the growth of mid-sized art galleries. In 1995, the Morris and Helen Belkin Art Gallery opened a rededicated building to replace the University of British Columbia's Fine Arts Gallery and later initiated a downtown satellite space. The Contemporary Art Gallery has also built a presence in Vancouver; in 1996 it transitioned from an artist-run centre to a public gallery and after moving to a new location in 2001 has become increasingly visible. In this vein, it has been argued that Vancouver's many artist-run centres, the bulk of which were established in the 1980s, have also become mini-institutions with stable funding, permanent staff, career curators, and an eye toward internationalism.[22]

What are some of the factors that have prompted this expansion and increased professionalization? In late twentieth-century Britain and the United States, contemporary art gained material and symbolic currency in corporate and political systems.[23] In the 1980s, a new model for how the visual arts functioned within society became obvious; "...artworks came to be seen as investment products, art buyers as speculators and artists as superstars...."[24] This was largely driven by a corporate system, switching the artistic consciousness of the 1980s away from the public domain toward the harnessing of corporate capital.[25] Reaganomics and Thatcherism yielded buzzwords like efficiency, deregulation, privatization, and enterprise culture; and the systems of art marketing and institutional fundraising began to proliferate. This made it possible to shift

ideological perspectives and view the relationships between the artist, artwork, institution, and public in economic terms. The resulting changes in public arts funding, particularly in Britain and the US, moved toward free-market policies and pro-business ideologies. While this is less apparent in the Canadian system due to the support of the Canada Council for the Arts and other public funding agencies, the ideological shift has become increasingly normalized.

While there is extreme mobility in the art market, the art world's distribution of power has a strong resemblance to the economic and political world. Julian Stallabrass writes: "Art prices and the volume of art sales tend to match the stock markets closely, and it is no accident that the world's major financial centres are also the principal centres for the sale of art. To raise this parallel is to see art not only as a zone of purposeless free play but as a minor speculative market in which art works are used for a variety of instrumental purposes, including investment, tax avoidance, and money laundering."[26] Certainly cultural, social, and market economies are inextricably entwined—it is consistent with the cliché of the Medici's use of art for power, influence, and affiliation—but the way in which corporate culture has meshed with the visual arts to promote development by a powerful new creative class reflects the specific conditions of an era. Vancouver, like other cities, is developing its cultural capital, which in turn helps the economy by attracting investment. The creative class (this so-called class includes "knowledge workers" such as educators, scientists, lawyers, architects, designers, and artists, among others) is considered a key force in the economic development of postindustrial cities by creating outcomes in new ideas (such as technology) that assist with regional growth. The development of a creative class in a city encourages identities that serve big business and forces the commingling of corporate, cultural, and other economies.[27]

As Vancouver moves from a resource to a service-based economy (its current distinctive economic structure, emblematic of late capitalism, is based on what economists call dynamic services, meaning that it thrives without producing visible or substantial goods),[28] visual art maintains a dialogue with these developments. It can be observed that the work of Vancouver's most prominent photoconceptual artists has depicted Vancouver's shifting economy from its foundation on the exploitation of natural resources to the industries of the postmodern world. While commenting on both the history of art and the "landscape of the economy," these artists address the transformative effects of modernity on the city and its landscape, while simultaneously employing the staging and technology of film (another distinctive aspect of the local economy; Vancouver is often termed Hollywood North). The work of a younger generation of Vancouver artists can be characterized as focusing less on the city and its landscapes, looking instead to contemporary cultural patterns and the globalized secondary and tertiary markets of manufactured and

intangible goods and services. These artists engage with representations and simulacra, not only alluding to the increasing influence of the global market and the film industry on their cultural situation, but also to a self-conscious understanding of their place in history. Examples of this type of work include cultural hybrids that navigate the territory between the commodity and the artifact, apparent readymades that address the construction of art systems, or strategies that trouble the issues of cultural translation through iconic moments in North American popular culture.

In Vancouver, art's instrumentalization is a fairly young exploit, as contemporary visual art and culture have not been strongly recognized or supported, let alone used for political or corporate gain. However, the kind of showcasing of culture by events such as Expo and the Olympics are often specious, mainstream, and uncritical.[29] Vancouver's lack of private support through the local market has forced artists to export their work to Europe and the US. Vancouver has not had a substantial visual art market to speak of, but the city has several commercial galleries that are brokering the careers of local artists with an eye to the larger world. The city has also produced a handful of private foundations and corporate supporters,[30] but the type of political and corporate instrumentalization that has occurred elsewhere, such as in the Guggenheim Museum's expansion or Bloomberg in London, is still in its nascent stages in Vancouver. That said, the goals of local institutions and galleries are decidedly international and not only follow precedents set in the art world for global reach, but corporate examples as well. Chin-tao Wu notes this shift in the art institution, citing the Guggenheim's multi-venue spread—from New York to Venice, Las Vegas, Bilbao, Berlin, and now possibly Hong Kong—as indicative of a growing pattern: "If Guggenheim is the epitome of the nineties' art institutions that envisage their futures ... as being multinational museums, it inevitably sees itself in terms similar to those of a multinational [corporation]. Once business vocabulary and corporate sets of values enter an art institution, its theatre of operations will inevitably be also dominated by the ethos and practices of multinationals."[31]

Despite burgeoning corporate structures, the Vancouver art world has been largely self-determined, government funded, and there has always been a vein of resistance to the corporate ethos. If, as I am claiming, the art economy has become increasingly reliant on the promotional apparatus of big business, in Vancouver certain voices have maintained critical stances in their resistance to the valuation of profit over critical or social responsibility. For example, a text work conceived by the owner of the Del Mar Inn, George Riste, and artist Kathryn Walter comments on the survival of his rooming hotel within the redevelopment of the city block that envelops it. Located on the exterior of Riste's building—which formerly housed the Contemporary Art Gallery and now is the home of the Belkin Satellite Gallery—the text work reads "Unlimited Growth Increases the Divide" and is "directed at those who operate our free-market economy

in their own interests, while excluding those interests that would be 'responsive to the needs of the community.'"[32] Riste maintains his Edwardian building to provide affordable accommodation on the upper floors and space for a non-profit gallery on the main floor. Despite hundreds of offers to buy his property, Riste refuses to sell (in the late 1980s, BC Hydro, which has owned all the land around the Del Mar Inn since 1981, persistently tried to buy Riste's building in order to knock it down for a proposed office tower). Riste's personal support of low-income housing and culture is made clear by Walter's text, and is as pertinent today as it was at the time of its installation in 1990.

When the Contemporary Art Gallery moved from the Del Mar Inn to the ground floor of a new Yaletown condominium development in 2001,[33] Brian Jungen rethought Walter's statement for his exhibition at the new space. Jungen's work, *Unlimited Growth Increases the Divide*, was similarly conceived for the exterior of the new gallery to draw attention to the specific conditions of the site. Temporarily mimicking the plywood hoardings that signal construction in the city, Jungen cut holes in the hoarding to direct one's view back to the street, framing the progress of development in the urban environment, particularly referencing the boom of condominium building that has taken place in Yaletown since Expo '86. Few areas of Vancouver have been as emblematic of the city's development, particularly in contrast to the stagnation and decline of other neighbourhoods.[34]

### Mirroring

All art is at once surface and symbol.
Those who go beneath the surface do so at their peril.
Those who read the symbols do so at their peril.
It is the spectator, and not life, that art really mirrors.

—Oscar Wilde[35]

Extolling symbolic values over material ones, postmodern economies promote the consumption of the abstract. Art, like money, is a symbolic system, its value socially constructed, aided by marketing and branding. Art economies have taken up the language of advertising to generate audience growth and support, which has manifested in the labeling of practices from specific locales or generations (e.g., "Vancouver art" or "slacker art"), the selling of a lifestyle associated with knowledge, exclusivity, and status. The local art economy is not immune to the scenes that are created around contemporary production, threatening to tip serious work into a melting pot of aesthetic and intellectual posturing. As the city's art community grows and diversifies, a positive result is a greater number of voices and the dissolution of a perceived monolith, yet in this diversifica-

tion there is a desire to appeal to a common denominator, and as a result serious debate and discourse can get lost amid the hyperbole.

In what appear to be successful campaigns to reach a wider public as well as entice sponsorship, Vancouver institutions have adopted a more corporate model of marketing. The Vancouver Art Gallery's exhibitions are often sponsored by corporations or financial institutions whose logos appear prominently on title walls, in catalogues, and newsletters. The VAG undertakes advertising campaigns that aggressively combine media coverage and prominent print advertisements, and have mounted design programming that uses a marketing model for display as well as promotion. For example, the VAG's 2004 project *Massive Change: The Future of Global Design* was constructed and publicized as its own brand, a package that included displays on two floors of the gallery, a website, book, speaker series, film, and radio show.[36] The Contemporary Art Gallery also receives a high level of corporate sponsorship and has produced two exhibitions conceived by an advertising firm.[37] These examples only begin to demonstrate the incorporation of marketing vocabularies into the realm of the non-profit cultural institution, and are by no means singular.

Vancouver's desire for recognition is not only reflected in the events such as Expo '86 that seek to bring the world to Vancouver, but also in the cultural products we export. While Vancouver is well pictured by local artists, its image is often exported via the film industry as a stand-in for other cities (almost always American). Television has largely followed suit; however, there are two notable exceptions to this pattern that are emblematic of a changing local identity. The drama *The Beachcombers* (1972–89, the longest-running series of its sort in Canadian television) at one time presented to an international audience a specifically British Columbian identity, a representation of a rural, ocean-reliant way of life that has been replaced in more recent television programs by a focus on the city and its globalized crises. *Da Vinci's Inquest* (1998–2005) and *Da Vinci's City Hall* (2005) were based largely on real-life politics in Vancouver, mirroring the city's current events. Taking the experiences of the city's former chief coroner, later city mayor, as a starting point, the series "documented" Vancouver as politically and economically complex, often corrupt and addicted, participating in the global drug, sex, and goods trades. Both shows had strong international appeal in their representation of changes in local politics, multiculturalism, and industry. However, the specific (and perhaps exotic to international audiences) British Columbia of *The Beachcombers* yielded to representations of a city that shares global pressures with other urban centres around the world. This shift in appearances from *The Beachcombers* to *Da Vinci's Inquest*—from provincial to global, from the focus on issues of primary to tertiary industries—provides another marker of a mutating Vancouver.

Within this period of growing international reputation, art and artists in Vancouver were branded, concurrent with the rise of a culture of

designer labels and market research.[38] Since the mid-1980s, Rodney Graham, Ken Lum, Jeff Wall, and Ian Wallace (and sometimes Roy Arden and Stan Douglas) have been entangled and exported under the Vancouver School label. French art historian Jean-Francois Chevrier is cited as being responsible for the designation, which is at once useful and erroneous, a term that could only be achieved from a distanced, outside perspective and in conjunction with other such "schools" of practice or thought. It has been argued that this label arose at a moment when consumer labeling—not only for products but for cities and lifestyles—became ever more important to marketers.[39] The assignation functioned to represent Vancouver to an international art world, establishing a benchmark for the manner in which Vancouver art is to be understood. The vehicles for the presentation of Vancouver art include important international museum exhibitions, biennials, and art fairs, pointing to an ideological construct that follows a world's fair or Expo model to promote identities that serve a dominant paradigm. The artists held under the Vancouver School umbrella do not often exhibit their work in Vancouver and are represented by galleries in New York, London, and Frankfurt rather than in Vancouver (or Canada, for that matter).[40] Thus, the market economy for their work exists internationally, while their intellectual economy is constructed between home and away.

When considering the branding of Vancouver and Vancouver art by external forces, it is perhaps useful to consider mirroring as a form of speculation. There is identification, in Vancouver, with what is seen in the mirror. Cast as a picturesque site of rich resources and a producer of serious art that reflects on its physical location within a globalized milieu, Vancouver rises to meet these expectations. This has an impact on art that has been produced in the shadow of the Vancouver School, under a different brand that might be called Vancouver Art. As Marina Roy has noted in her essay for this publication, a *Canadian Art* article asserted: "When you collect one of her [Catriona Jeffries] artists—say a Ron Terada or a Damian Moppett—you are ostensibly 'collecting Vancouver.'"[41] It appears that Vancouver Art signifies the work of a younger generation of artists, a group separate from the Vancouver School but defined by a similar set of rules that speculate on its history. Vancouver Art has come to designate a group of self-reflexive artists, largely in their thirties, who reference and scrutinize not only their artistic position, but also their historical situation, location, and culture.[42] The label Vancouver Art again raises the problem of regionalism, but the work of these artists reaches beyond the local to engage in critique and satire legible to a global audience. It has been argued by many that the successful work coming out of Vancouver has international currency in its aesthetic and conceptual strategies, though artists such as Ron Terada continue to call attention to how Vancouver artists are identified in terms of a local brand for the purposes of commerce and publicity.[43]

The success and consequential mirroring of the Vancouver School—and now Vancouver Art—has led to a palpable atmosphere of careerism in this city's art economy.[44] The patterning of success relies on externally generated accolades for artists who are often promoted through the "outside" view. For example, the local marketing campaign for Brian Jungen's VAG exhibition foregrounded a quote from the *Washington Post*, positioning Jungen as "one of today's most interesting and widely acclaimed younger artists." While Vancouver takes pride in its self-determined, boom-and-bust identity, it seems that we remain impressionable, malleable to outside forces; we identify with how we are described, even as we resist it. Although Vancouver's art community has attempted to avoid typification, it must be acknowledged that a publication of this sort also plays into the branding of Vancouver, even given the current line of questioning.

In this post-Expo, pre-Olympic moment, Vancouver is again speculating on its future. And Vancouver art, despite the self-awareness and criticality written into its systems, is not unaffected by the language and forces of development or the marketing of place. A growing component of the abstract economy of "dynamic services," Vancouver art is at once a sector to be considered in terms of monetary value and growth, while it also has the potential to maintain a critical autonomy, apart from the systems of big business and the pressures of politics. It might be said that art's autonomy is contingent on the fact that it, in and of itself, has little agency. Art's strength lies in its reflection on the world; it represents social and subjective realities in images, texts, and situations that document, digest, and critique. But art has not typically intervened or taken an active role in the production of political realities, despite its instrumentalization. It is the very uselessness of art that allows it to reveal something of the world, and indeed something of the viewer. In mirroring, it reflects the values that have become dominant in Western culture: "The dollar is now the yardstick of cultural authority...."[45] Perhaps the alignment of the art economy with the market economy is inevitable, but art will always seek alternative structures and spaces for analytic, vital inquiry. If contemporary art is contradictorally complicit with and resistant to privatizing developments, new economies and publics will surface to address this paradox. And perhaps real potential lies in accepting these inherent conflicts. As the world continues to focus on Vancouver, Vancouver art will speculate on its place in the world.

1. A young port city on the Pacific coast, Vancouver has developed into Canada's third largest metropolitan centre in its short history. The city was first settled in the 1860s, largely as a result of the Fraser Canyon Gold Rush, and developed from a small lumber mill town into an urban hub following the arrival of the transcontinental railway in 1887. See Paul Delany, ed. *Vancouver: Representing the Postmodern City* (Vancouver: Arsenal Pulp Press, 1994): 1. For histories pertinent to Vancouver's recent development, see Lance Berelowitz, *Dream City: Vancouver and the Global Imagination* (Vancouver/ Toronto/Berkeley: Douglas & McIntyre, 2005); and John Punter, *The Vancouver Achievement: Urban Planning and Design* (Vancouver/Toronto: UBC Press, 2003).

2. Berelowitz notes that land speculation began at Vancouver's inception, as the earliest District Lots (1860s) were flipped, subdivided, resold, and developed by different owners at different times. "Real estate is Vancouver's true passion, its real blood sport....": 95.

3. Gary Mason, *The Globe and Mail* (April 29, 2006): S1. Mason was assessing the impact of Expo '86 on the occasion of its twentieth anniversary. Punter lists a more complete set of Expo '86 related "results": 192.

4. www.bccanadaplace.gov.bc.ca. Ironically, at the same time Vancouver was (and is) the second most expensive Canadian city to live in, after Toronto.

5. In early 2006, the Vancouver City Council, led by Mayor Sam Sullivan, opted for less social housing in Southeast False Creek from the originally proposed one-third. This decision was reportedly made for economic gain, as the City projects a $50 million return on the land when it is developed. Frances Bula, *Vancouver Sun* (January 21, 2006): B11. The current City website (city.vancouver.bc.ca/olympicvil- lage) claims that 25% of the 1,000 units will become affordable housing after the games.

6. The notion that Vancouver may become a resort city is attributed to Trevor Boddy's observations in a lecture entitled "Van- couverism, Civic Space, and Dubai's Very False Creek," June 16, 2006, Presentation House Gallery, on the occasion of the opening of the exhibition *Territory* (a co- production with Artspeak). Boddy touches on a fear that the disproportionate num- ber of high-rise residences to commercial offices will result in a city that is for living in, not working in. The idea that aspects of Vancouver's recent development are modelled after resort structures is made clearer in Berelowitz's *Dream City* where he cites that the initial concepts for the development of the Expo lands posited "a resort in the city": 107.

7. Punter: 12–13, 85, 109, 218.

8. For example, only 15% of Yaletown's housing is classified as low-income (although the city sets goals for 20% or more in such developments). thetyee.ca/ Views/2006/02/27/ErasingOlympicImage/

9. Charlie Smith, "Olympic cities punish poor," *Georgia Straight* (Aug. 31 – Sept. 7, 2006): 17. Smith's article cites sociologist Helen Jefferson Lenskyj's paper "The Olympic (Affordable) Housing Legacy and Social Responsibility." Another example that aligns with Lenskyj's argument is the implementation of the Safe Streets Act in early 2005 that targets aggressive panhandlers.

10. Over 1,000 evictions occurred in the period prior to Expo '86, primarily from fifteen rooming hotels, despite the campaigns and lobbying by the Downtown Eastside Residents Association. This campaign gained international recogni- tion and spoke out against the negative impacts of mega-projects and rezoning on low-income housing in central Vancouver. Punter: 192.

11. Here I am not only thinking of arts institutions, but other public/private de- velopments such as private medical clinics. Nina Möntmann notes in her introduction to *Art and Its Institutions: Current Conflicts, Critique and Collaborations* (London: Black Dog Publishing, 2006) that "the backdrop for institutional constitution is to be found in the basic value structure of a society. Therefore the current eruptions of the welfare state are mirrored in various insti- tutional changes, predominantly revolving around concepts of centralisation and privatisation.": 8.

12. Julian Stallabrass, *Art Incorporated: The Story of Contemporary Art* (Oxford/ New York: Oxford University Press, 2004): 4.

13. Olav Velthuis, *Imaginary Economics: Contemporary Artists and the World of Big Money* (Rotterdam: Nai Publishers, 2005): 12.

14. For example, the Vancouver Art Gallery's budget over the last two years indicates that approximately 32% of its annual budget is attributable to government grants and 68% is from other revenue that includes admissions, fundraising, the gallery store, member- ships, public programs, sponsorships, and the foundation which is set up to receive bequests, donations, and gifts (source: VAG annual reports, 2004, 2005). The Contemporary Art Gallery's revenue budget ending in 2004 indicates that 48.8% is derived from grants and 51.6% is from private donations and generated income (source: Council for Business in the Arts Annual Survey of Public Museums and Art Galleries, 2003–2004). Artspeak's 2004 year-end financial statements show

that 84.4% of its budget is derived from grants and 11.6% is from private sources (source: I.E. Artspeak Gallery Society 2004 annual report).

15. Stan Douglas, "Introduction," *Vancouver Anthology: The Institutional Politics of Art* (Vancouver: Talonbooks, 1991): 18.

16. Andrea Fraser quoted in Peter Suchin, "Art and its Institutions," *Art Monthly* (July–Aug 2006): 298. See Möntmann, ed. for complete essay. Andrea Fraser, "A museum is not a business. It is run in a businesslike fashion": 86–98.

17. It is for this reason that *Vancouver Art & Economies* includes a nascent history of Vancouver's commercial galleries. See Michael Turner's essay, "Whose Business Is It? Vancouver's Commercial Galleries and the Production of Art."

18. See Statistics Canada.

19. School programs (and their students) aspire to enter their graduates into the professional realm of art, whether as artists, curators, or arts administrators. The professional realm of art is meant to denote an art system of recognition that is confined to specific venues. Local educational programs have reflected the growth of the art economy. For example, in 1989 Vancouver's Emily Carr Institute received granting authority for Bachelor of Fine Arts degrees through the Open Learning Agency, but was not able to issue its degrees in its own name until 1994. In 2006, it admitted its first class of Masters of Applied Arts degree students. From its foundation in 1925 (as Vancouver School of Decorative and Applied Arts) to 1989, Emily Carr Institute offered diplomas. Curatorial programs are also on the rise, such as the University of British Columbia's Critical and Curatorial Studies program, which was established in 2001. It

should be noted that Emily Carr Institute, then Emily Carr College of Art & Design, had a short-lived diploma program in Curatorial Studies in the 1980s.

20. Douglas: 16.

21. This observation is not only confined to the VAG, but is indicative of a larger museum trend. "The welfare states may be shrinking, but certainly not the museum. The latter is rather fragmenting, penetrating ever more deeply and organically into the complex mesh of semiotic production. Its spin-off products—design, fashion, multimedia spectacle, but also relational technologies and outside-the-box consulting—are among the driving forces of the contemporary economy.... We are talking about museums that work, museums that form part of the dominant economy, and that change at an increasing rate of acceleration imposed by both the market and the state. Is it impossible to use this vast development of cultural activity for anything other than the promotion of tourism, consumption, the batch-processing of human attention and emotion?" Brian Holmes quoted in Nina Möntmann: 28.

22. See Reid Shier's essay, "Do Artists Need Artist-Run Centres?" in this anthology.

23. See Chin-tao Wu, *Privatising Culture: Corporate Art Intervention Since the 1980s* (London/New York: Verso, 2003): 6, for a considered study of the art economy's entanglement with business and the private sector in Britain and the United States.

24. Velthuis: 26.

25. Wu: 2–3.

26. Stallabrass: 5.

27. Pier Luigi Sacco, an Italian political economist, lectured at Simon Fraser University on June 21, 2006. His talk, entitled "Arts and the Economy: Vancouver at the Crossroads," spoke to a shifting economics

focused more on individual and cultural identity, pointing to the potentiality of arts and culture as powerful new drivers of the economy.

28. Delany: 11–12.

29. However, I must acknowledge that Arts Now: 2010 Legacies Now provided support for this publication. This fund was implemented to build the capacity for the arts in the years leading up to the Olympics, and provides a significant opportunity for project funding. Despite the fact that this fund will not be ongoing, its goal is to encourage and allow for increased production in the arts and culture community of this region.

30. For example, the Vancouver Foundation, the Hamber Foundation, the Koerner Foundation, and the Audain Foundation provide support to the arts. The Vancouver Foundation's Renaissance Fund matches non-profit funds and encourages corporate donations. Corporate supporters have become increasingly visible within larger institutions. In recent years, the Vancouver Art Gallery has had programming support from banks including RBC Financial Group and TD Bank Financial Group, developers such as Concord Pacific and Polygon, and other corporations including Mercedes-Benz and Weyerhaeuser.

31. Wu: 284. Also see Möntmann for a concise account of how the Guggenheim Museum is conceived and staged by politicians and sponsors: 10.

32. Bill Jeffries, "The Interventions of Kathryn Walter" (Vancouver: Contemporary Art Gallery, 1990) www.city.vancouver.bc.ca.

33. The public/private partnership in condominium development warrants another paper, but it is important to note that through the City of Vancouver's Private Development Program, new developments

are required to allocate $.95 per build-able foot to art in public areas. This too offers opportunities for the arts within Vancouver's development.

34. It is an easy contrast to pit the residential, shopping, and restaurant development in Yaletown against the decline of the Downtown Eastside. But it is important to note that affordable housing is localized in the latter neighbourhood. In 2003, the Downtown Eastside had only 3% of the city's population, but 79% of all single room occupancy units and 22% of non-market housing. At the same time, social services, shelters, meal centres, and health agencies are concentrated in this area. Punter writes: "In the Downtown Eastside it is clear what has *not* been achieved in the last thirty years. The multiple exclusions induced by the gentrification and aestheticization of the city at large reinforce deeper and more pernicious social, economic, and political processes that have set the DTES on a spiral of social decline. These processes include globalization, labour-shedding, senior government's withdrawal from welfare provision and housing subsidies, municipal fiscal crises, and deep civic indifference to problems of poverty collectively." Punter: 283.

35. Oscar Wilde, *The Picture of Dorian Gray and Other Writings by Oscar Wilde* (New York/Toronto/London/Sydney/Auckland: Bantam Books, 1982): 3.

36. William Wood, "Massive Change: The Future of Global Design," *Parachute* 118 (Spring 2005): 7–8. Wood discusses the branding of curator Bruce Mau's

projects under the umbrella of *Massive Change*, their marketability, and their use by the VAG. Wood writes that show's "slogans came thick and fast as in a pitch, heading breathlessly towards the sort of uncomfortable silence that closes a motivational seminar.": 8. Wood closes his review with the conclusion that the only display institution that would support this type of *exposition* (not exhibition) is the contemporary art museum. "A science museum would question the research; a local history curator the global reach; an ethnographer would ask 'whose "we" wills this?' Only art galleries like the VAG, diffident about disciplinary competencies and anxious about relations with the broader public, would fall for the inept hucksterism of Mau's design.": 8.

37. Re-Think Advertising has worked with the CAG to organize *Buttons*, as well as *Day Tripper* (a program of videos by Vancouver artist Brady Cranfield presented as a drive-through video window).

38. William Wood, "The Insufficiency of the World," *Intertidal: Vancouver Art and Artists*, eds. Dieter Roelstrate and Scott Watson (Antwerp/Vancouver: Museum van Hedendaagse Kunst Antwerpen and The Morris and Helen Belkin Art Gallery, 2005): 66. I am indebted to Wood's astute observations on Vancouver branding.

39. Wood: 76.

40. The current exception is Ian Wallace, who is locally represented by Catriona Jeffries Gallery.

41. Ralph Rugoff, "Baja to Vancouver: The West Coast and Contemporary Art"

in *Baja to Vancouver: The West Coast and Contemporary Art*: 18–19, quoting SiSi Penaloza, "She's the One," *Canadian Art* (Spring 2003): 78–83.

42. Here I am thinking of the work of Geoffrey Farmer, Brian Jungen, and Damian Moppett in particular.

43. Rugoff: 19.

44. It is clear that the artists collected under the Vancouver School umbrella have set a standard for younger artists. But these younger artists, such as Brian Jungen, have also achieved substantial local, national, and international success. Jungen, like a handful of other artists of his generation, represent a newer face of Vancouver art that has generated widespread attention, and will result in new goals for emerging artists wishing to emulate their pattern of success.

45. Jonathan Franzen, *How to be Alone: Essays* (New York: Farrar, Straus and Giroux, 2002): 62. Later, in the same essay "Why Bother?" Franzen discusses the agency of the novel. I am indebted to his observations on the role of literature, and by extension the role of visual art, in society. He writes, "What emerges as the belief that unifies us is not that a novel can change anything, but that it can *preserve* something.... novelists are preserving a tradition of precise, expressive language; a habit of looking past surfaces into interiors; maybe an understanding of private experience and public context as distinct but interpenetrating; maybe mystery, maybe manners. Above all, they are preserving a community of readers and writers...": 90.

**11**

Stuart Blackley
Hank Bull
Clint Burnham
Christine Corlett
Kate Craig
Damon Crain

Gerald Creede
Mari Dumett
Geoffrey Farmer
Deanna Ferguson
Brian Jungen
Andrew Klobucar

Brian Jungen, cover of *Boo* magazine #11, 1997 (detail)

# LATE EMPIRE

Clint Burnham

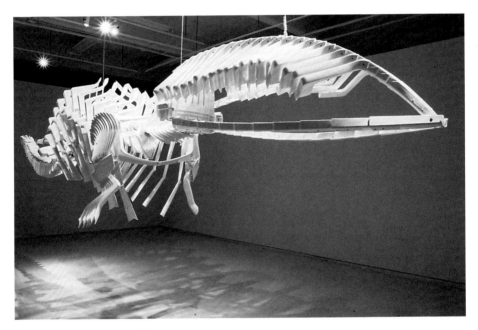

Brian Jungen, *Shapeshifter*, 2000
plastic chairs
Collection of National Gallery of Canada
Courtesy of Catriona Jeffries Gallery, Vancouver
Photo: Linda Chinfen

## I. Empire of Images

... all rulers are the heirs of those who conquered before them.
Hence, empathy with the victor invariably benefits the rulers.
Historical materialists know what that means. Whoever has emerged
victorious participates to this day in the triumphal procession in
which the present rulers step over those who are lying prostrate.
According to traditional practice, the spoils are carried along in the
procession. They are called cultural treasures, and a historical
materialist views them with cautious detachment. For without
exception the cultural treasures he surveys have an origin he cannot
contemplate without horror. They owe their existence not only to
the efforts of the great minds and talents who have created them,
but also to the anonymous toil of their contemporaries. There is no
document of civilization which is not at the same time a document
of barbarism. And just as such a document is not free of barbarism,
barbarism taints also the manner in which it was transmitted from
one owner to another. A historical materialist therefore dissociates
himself from it as far as possible. He regards it as his task to brush
history against the grain.

—Walter Benjamin[1]

This quote from Walter Benjamin's "Theses on the Philosophy of History"
is well-known—perhaps so well-known that we no longer think about
what it means. "There is no document of civilization which is not at the
same time a document of barbarism." This is one of the great twentieth-
century programmatic statements for dialectical criticism; that is, for con-
necting cultural objects—be they novels, paintings, or songs—to the
social conditions under which they were created and disseminated. For
my purposes, the greater context of this quotation indicates a specific cul-
tural history from which Benjamin has drawn his theoretical statement:
a bloody imperial history—not simply of Europe—in which brutish
conquerors signal their triumph with cultural treasures. The triumphal
procession—I will confine my discussion to the Roman version—then is
a parade of booty, of the looted artifacts of vanquished peoples.

A colourful description of such a procession is to be found in Edward
Gibbon's *The Decline and Fall of the Roman Empire*:

> As soon as Diocletian entered into the twentieth year of his reign
> [303 CE], he celebrated that memorable era, as well as the success
> of his arms, by the pomp of a Roman triumph. Maximian, the equal
> partner of his power, was his only companion in the glory of that
> day. The two Caesars had fought and conquered, but the merit
> of their exploits was ascribed, according to the rigour of ancient
> maxims, to the auspicious influence of their fathers and emperors.
> The triumph of Diocletian and Maximian was less magnificent,
> perhaps, than those of Aurelian and Probus, but it was dignified
> by several circumstances of superior fame and good fortune. Africa
> and Britain, the Rhine, the Danube, and the Nile furnished their
> respective trophies; but the most distinguished ornament was of a
> more singular nature, a Persian victory followed by an important
> conquest. The representations of rivers, mountains, and provinces
> were carried before the Imperial car. The images of the captive
> wives, the sisters, and the children of the Great King afforded a
> new and grateful spectacle to the vanity of the people. In the eyes
> of posterity, this triumph is remarkable by a distinction of a less
> honourable kind. It was the last that Rome ever beheld. Soon after
> this period, the emperors ceased to vanquish, and Rome ceased to
> be the capital of the empire.[2]

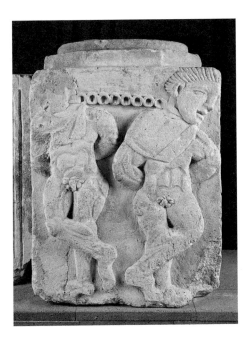

*Shackled Teutons*, 1st century A.D.
bas-relief
© Landesmuseum Mainz,
Inv. Nr. S 269
Photo: Ursula Rudischer

There are reasons to dwell on this passage, for all the flamboyance of Gibbon's prose. First, there are heuristic gains to be found in resurrecting the logic of imperial power as a way of interrogating the post-9/11, post-globalization, post-postmodern present. As well, the emphasis in Gibbon's description of the role of spectacle and representation provides an analytical focus for an inquiry into visual art. And finally, the notion of a "Persian victory" and the content of those representations—landscapes and portraits—has special resonance in the aftermath of the unprecedented circulation, in 2004, of pictures of Iraqi prisoner abuse at Abu Ghraib.

My forays into imperial history are provided not to take us away from our purported subject—contemporary visual culture in Vancouver—but rather to develop some historiographic tools with which to provide social context: on the one hand, the recuperation of imperial phantasies, and on the other, the ongoing critique or dissent of the same. "Late Empire" as a title or slogan owes its provenance to three conditions of our present-day situation. First of all, "Empire" refers to the analysis of Michael Hardt and Antonio Negri in their books *Empire* (2000) and *Multitude* (2004), in which they argued that globalization was not merely an economic *fait accompli* of the late twentieth and early twenty-first centuries, but also a process of domination, one in which the forms of that domination—from decentralized production to rhizomatic communication models—can be turned against the global ruling class.[3] This is evidently the lesson of Abu Ghraib: that every atrocity contains the seeds of its own correction. Second, the "Late" in my title refers to a pair of books important to Western Marxism: Ernest Mandel's *Late Capitalism*, in which the Belgian economist developed the thesis that capitalism in the latter half of the twentieth century was characterized by global expansion as well as greater concentration, and Fredric Jameson's *Late Marxism*, which examined the cultural Marxism of Theodor Adorno. The two texts then stand as book ends to an analysis here that attempts to be faithful both to the cultural workings of the image and to the economic and political forms of coercion legible in that image. Finally, "Late Empire," the conjoined twin of my title, insists on the "belatedness" of empire, indeed, of all empires, which is to say not only that American or British excursions into Iraq re-produce earlier imperial follies, but that, following the model of the Roman Empire, all empires are belated, in two senses: first, that the empire follows on the heels of the republic (which was as much the occasion for nostalgia in early Christian-era Rome as it is now in early twenty-first-century America), and also that such empires are always caught up in a logic of simulation and emulation (the Romans emulating the Greeks, to take the best-known example).

If rulers of fourth-century Rome thought nothing of displaying images of their conquered peoples, what is the logic of today's rulers, and how can comparing these two empires help us to understand contemporary culture? The Abu Ghraib scandal is important not only for exposing the

brutality visited upon Iraqi prisoners by American soldiers and guards; that brutality continues the brutality of war, and indeed the brutality of the very dictatorship that the US invasion claimed to be eradicating (Abu Ghraib was a notorious prison under Saddam Hussein's regime). Here it is the spectacle of that brutality that is most interesting: both for what it tells us about how culture circulates (in Benjamin's words, how it is transmitted), and what its effects are.

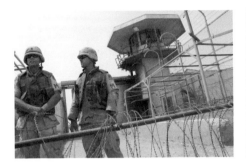 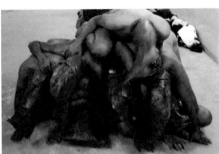

Abu Ghraib prison
Photos: AP Images

The Abu Ghraib story remains shocking, even as it fades into the mist of the recent past: US military intelligence interrogators and poorly trained prison guards—under pressure as the Iraq insurgency gained power in late 2003 and facing an onslaught of Iraqi prisoners often hauled in on the flimsiest of excuses—resorting to torture in a futile attempt to gain enemy knowledge.[4] These attempts escalated into forms of sadomasochistic humiliation and violence: from the arrangement of naked men in pyramids, to real or feigned rape, brutal beatings, and murder. And all the while, digital cameras flashed, as the soldiers warned the Iraqi men that photographs of their humiliation would be shown to their families and communities.

In time, these images made their way into emails and this means of dissemination led to the predictable leaks. Seymour Hersh—who exposed the My Lai massacre during the Vietnam War—broke the Abu Ghraib story in *The New Yorker*.[5] In April 2004, the scandal erupted around the world, inflaming anti-American opinion in the Muslim world and beyond, while a few low-ranking soldiers became scapegoats. As of fall 2006, Abu Ghraib continues to be used as a military prison by the occupying American forces; the insurgency continues as well.

So this "spectacle"—which is not truly a scandal ("Talk of scandal is thus archaic," Guy Debord reminds us[6])—demonstrates the workings of imperialism under Late Empire: images are no longer the vaunted forms of high cultural or religious production (paintings from triumphal processions in ancient Rome would typically be hung in shrines),[7] but instead are produced

by the common soldier, a form of virtual looting.[8] As well, these images are simultaneously furtive and public—they begin as representations of torture and end up shared as trophies in the realm of news media. Technology, of course, plays a role, as it does in all contemporary cultural production. Following Hardt and Negri, the revelation of the photographs—of the torture—constitutes an unintentional form of anti-imperialism: "The power to circulate is a primary determination of the virtuality of the multitude, and

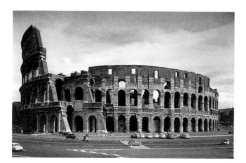

Roman Colosseum
Courtesy of Vancouver Art Gallery Archives

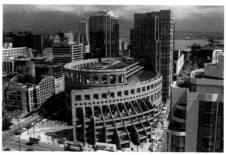

Vancouver Public Library Central Branch, 1994
Courtesy of Vancouver Public Library,
Special Collections, VPL 78133

circulating is the first ethical act of the counterimperial ontology."[9] It is, then, the movement of these images that teaches us a signal lesson on the role of visual culture—of the spectacle—in the imperial moment:

> In imperial society the spectacle is a virtual place, or, more accurately, a non-place of politics. The spectacle is at once unified and diffused in such a way that it is impossible to distinguish any inside from outside.... The liberal notion of the public, the place outside where we act in the presence of others, has now been universalized (because we are always now under the gaze of others, monitored by safety cameras) and sublimated or de-actualized in the virtual space of the spectacle.[10]

If Abu Ghraib is the triumphal procession of the contemporary empire, it indicates a vexed role for images in our visual culture: how the democratization of technology—as in the case of the 1992 Rodney King beating in Los Angeles—works against capital and its henchmen. The photoconceptualists who are most effective in revealing naked forms of power are not Jeff Wall or Andreas Gursky but anonymous photographers. And the US is still in Iraq, and is still plagued by racial oppression (evidenced at home by its belated reactions to Hurricane Katrina in 2005). But if the forementioned examples provide a sense of the global imperial context, what forms does empire take closer to home? I will now turn to a more local form of imperial culture, one which "still stands," "in ruins": the Vancouver Public Library.

## II. The Desire for Empire

Although to Renaissance architects the Colosseum was to become
the epitome of Roman architectural achievement and a living text-
book of the classical order, it in fact represents a tradition which in
Rome was nearing the end of the road.[11]

The Central Branch of the Vancouver Public Library (VPL) seems, at first
glance, to be the very antithesis of Abu Ghraib prison: one, a well-lit place
of learning and congregation; the other, a furtive space of nocturnal abuse
and incarceration. But institutions—be they prisons or libraries, galler-
ies or classrooms—nonetheless contain, in their spatiality and their ar-
chitecture, a power dynamic that symbolically reproduces the authority
of the "author" of that institution. In this sense, architect Moshe Safdie is
to the design of the VPL as President George W. Bush is to the policies that
led to the Abu Ghraib atrocities. But I am most interested in locating the
origins of the library's design in our Late Empire present: that is to say,
why did a Pacific Rim city, with its own history of aboriginal settlement
and Asian demographics, choose (or foist upon itself) a design for a major
public library that nostalgically harkens back to a European empire? The
question provides its own answer: the library design compensates a city
which fears both its First Nations past and Asian future.

In this reading, Safdie's design for the Library, announced after a
controversial competition in 1992[12] (the building itself was opened to
the public in May 1995), is representative of both the triumph of global
capital and the last exercise of power held by white Vancouver.[13] The
library is the Prima Porta Augusta of consumption—located in a mall, on
the outskirts of the now-bourgeois settlement of Yaletown (Vancouver's
warehouse district that was gentrified with a vengeance in the years
following Expo '86)—and a case of anglophilic Vancouver in denial of
the changing demographics, and changing complexion, of this so-called
"world-class" city.

Thus the library is the symptom of a contradiction between the global
and the local. While the city and province "invite[d] the world" (to Expo
'86) to act as global consumers, Vancouver's old racist heritage was never
far from the surface and percolated through the miasma of the urban un-
conscious (for example, mini-scandals such as the resentment of Asian-
Canadian-owned "monster homes" whose residents dared to cut down
urban trees to improve their views).

The contradiction plays out in the following way. First, Safdie's design
is for a building that obviously references the Roman Colosseum: not so
much as it was constructed in the first century CE, but as it lies in ruins.
Safdie himself is in deep denial about this resemblance, as well he should
be, for this simulation tapped into Vancouver's shallow Eurocentrism. In

a tenth-anniversary lecture on the building in 2005, an audience member asked Safdie (after his forty-five-minute address in which he had not discussed the resemblance) why he designed a library to look like the Colosseum.[14] Safdie responded that this was not intentional, but rather based on both formal and material considerations: given that his design was for two ellipses around a box (the formal) and that the ellipses had to be buttressed (the material or structural). Thus the "thin but somehow aggressively bland pastiche"[15] of the library demonstrates the now-familiar postmodern tenets that the cultural text is authorless (we will take Safdie at his word)[16] and quotes other, earlier forms. But this form of cultural transmission—postmodernism's affection for quotation and pastiche—collapses in upon itself.

However, Safdie's risible design is perhaps too easy a target for analysis. What interests me in the building is its demonstration of a theoretical proposition—Fredric Jameson's notion of the "absent cause":

> History is therefore the experience of Necessity, and it is this alone which can forestall its thematization or reification as a mere object of representation or as one master code among many others. Necessity is not in that sense a type of content, but rather the inexorable *form* of events; it is therefore a narrative category in the enlarged sense of some properly narrative political unconscious ... as the formal effects of what Althusser, following Spinoza, calls an 'absent cause.' Conceived in this sense, History is what hurts, it is what refuses desire and sets inexorable limits to individual as well as collective praxis, which its 'ruses' turn into grisly and ironic reversals of their overt intention.[17]

It is this very history, then, that set limits to what Safdie could do as an individual architect: the Colosseum returns, as it were, like Freud's repressed, to impose on Vancouver's centre of learning the very "grisly and ironic reversal" of its civilized intent. But if the original Colosseum stood as a barbaric centre to the ancient civilized world, we are in a very different moment of barbarism in the twenty-first century, when such legacies as residential schools and Abu Ghraib together cast doubt, indeed, on who is the barbarian and who the civilized. It is this deconstruction of the civilizer that underwrites the cultural products to which we now turn.

### III. Brian Jungen and the Desire for Globalization

Coyote thinks about that river. And she thinks about that mountain. And she thinks somebody is fooling around. So she goes looking around. She goes looking for that one who is messing up the world.

She goes to the north, and there is nothing. She goes to the south, and there is nothing there, either. She goes to the east, and there is still nothing there. She goes to the west, and there is a pile of snow tires. And there is some televisions. And there is some vacuum cleaners. And there is a bunch of pastel sheets. And there is an air humidifier. And there is a big mistake sitting on a portable gas barbecue reading a book. Big book. Department store catalogue.[18]

In Thomas King's story "The One about Coyote Going West," the trickster figure witnesses the folly of Western capitalism, made material with an absurd trickle of commodities from the sky, like so much contemporary manna. Like Vancouver artist Brian Jungen, King's coyote forces us to admit to our desire for the global, for the contemporary, for both the commodity and its critique. If the Vancouver Public Library is a symptom of the contradictions of global capitalism (homegrown racism meets global cosmopolitanism), then Jungen's running shoe masks and lawn chair whales are those same global chickens coming home to roost.

Since the mid-1990s, Brian Jungen has been refashioning consumer objects into spectacular artworks which reference their place in the museum or gallery. His best-known series is the *Prototypes for New Understanding* (1998–2005) (simulated West Coast tribal masks constructed from Nike Air Jordan running shoes), and three sculptures titled *Shapeshifter* (2000), *Cetology* (2002), and *Vienna* (2003) (simulated whale skeletons fabricated from plastic lawn chairs). And in the same way that I traced a segue (even if only in contrast) from Abu Ghraib prison to the VPL, I will begin my analysis of Jungen's work by working the connections and contrasts between the running shoe and the lawn chair.

The first connection works at the level of the museum object. Both the *Prototypes* and the whale skeletons are not only simulations of masks or skeletons: they reference the placement of those objects in the anthropological or natural history museum (too often First Nations artifacts were collected by natural history museums, as if Native people embodied nature itself). The *Prototypes*, when exhibited at the Charles H. Scott Gallery in 1999, were displayed in vitrines. And the construction of the skeletons mimics the reconstruction of a whale or other animal's bones into the "shape" of the "living" animal. Jungen's works then owe something to the "institutional critique" of galleries and museums that made its way through art theory in the 1970s and 80s, with the qualification that they are made for the very institutions they presume to critique.

But the objects also differ in their alignment with a generational politics. It is obvious that Jungen's *Prototypes* comment on the contemporary fascination with a globalized youth culture, but that obviousness may be only because our present moment is so saturated in that culture that it is difficult to mount a critique. That is to say, we need these *Prototypes*

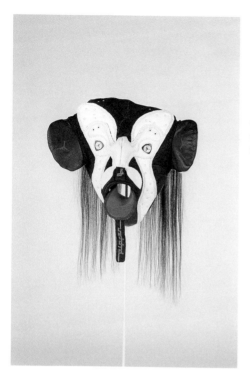

Brian Jungen, *Prototype for New Understanding #4*, 1998
Nike Air Jordans, hair
Collection of Claudia Beck and Andrew Gruft
Courtesy of Catriona Jeffries Gallery, Vancouver
Photo: Linda Chinfen

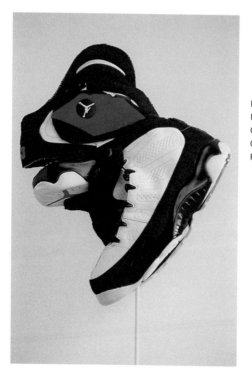

Brian Jungen, *Prototype for New Understanding #12*, 2002
Nike Air Jordans
Collection of Ruth and Bill True, Seattle
Courtesy of Catriona Jeffries Gallery, Vancouver
Photo: Arabella Campbell

to lift our faces from our cell phones and iPod screens. The world that the *Prototypes* reference is the post-1980s culture in which the African-American urban experience has been homogenized and commodified —running shoes, baggy clothing—even as that culture carries traces of the violence and class/race inequities which spawned it (the 2005 decision of the National Basketball Association to impose a dress code on players signals not only a moral panic regarding "ghetto fabulous" as sartorial choice, but also a need to reinforce that ghettoization by keeping casual sports clothing on the basketball court).[19] Remember, too, that part and parcel of running shoes such as Air Jordans at their height of their popularity was the fashion to wear them unlaced (a reference, like baggy clothing in general, to prison wear: thus making it harder to run). Additionally, a mouth, complete with tongue, in *Prototype #12*, emerges out of a sliced-up sole, thus making a connection to flapping shoes. As sculptures, Jungen's *Prototypes* are both pristine (art) and cut-up (running shoe).

Now I'll turn to Jungen's whale skeletons, his lawn chair sculptures *Shapeshifter*, *Cetology*, and *Vienna*. If Jungen's *Prototypes* reference a youth culture, then the whale skeletons in turn reference those youths' parents and grandparents—if I can be permitted a form of ageism that asserts the comfort of the plastic lawn chair as generationally different from that of the running shoe. Of course, old people wear running shoes and young people sit in lawn chairs, but the contrast remains: one is for action, one for respite. Is youth putting a foot in the ass of its elders? As well, the cutting-up of the chairs, like the slicing of the running shoes, mimics the fate of the object in the world. But make no mistake: Jungen's cuts are deliberate, surgical even, and a form of destruction that at the same time elevates the shoes and chairs into aesthetic objects.

Jungen's artworks thus contain, in their method, a dialectic of simulation and destruction. The *Prototypes* and the whale skeletons, for instance, involve the cutting-up of commodities and their refabrication, but he has also worked with plywood (*Arts and Crafts Book Depository/Capp Street Project 2004*, 2004), soccer balls (*Modern Sculpture*, 2005), baseball bats (*Talking Sticks*, 2005), and Air Jordan cardboard boxes (*Little Habitat I*, 2003 and *Little Habitat II*, 2003). In contrast, Jungen sometimes makes objects which simply simulate others: most famously, *Untitled* (2001), for which he handmade ten pallets out of red cedar, but also *Isolated Depiction of the Passage of Time* (2001), in which he stacked and cut cafeteria trays to mimic a prisoner's escape pod.[20]

Jungen's methods—his simultaneous working with and trashing of consumer culture—places his art in the context of the 1990s, when the do-it-yourself aesthetic broke through in popular culture with the quickly commodified "alternative" ideologies of 'zines, grunge, hip-hop, and fan culture. This resurgence of avant-garde tendencies from the 1970s

(or more accurately, the "original" moment of punk) in the early 1990s morphed into anti-globalization movements a few years later. Similarly, the spirit of "culture jamming" that in the early 1990s resided in the subcultural milieu was replaced later in the decade with strategies of institutionalized graphic sabotage, from Vancouver-based *Adbusters* magazine to Naomi Klein's *No Logo*[21]; from the Seattle grunge scene to the Seattle anti-WTO riots. These popular movements were met in the art world with the ubiquity of the abject, particularly in the twisted sexual politics of the Mike Kelley-Paul McCarthy set.[22] And abjection makes its appearance early in the Jungen corpus, with his appropriated drawings solicited from people in the street of their idea of Native art, installed as a wall piece in his exhibition at the Charles H. Scott Gallery[23] and also in more fugitive sites such as the cover of *Boo* #11, a Vancouver magazine. Writing on Jungen, Scott Watson has argued: "As the wall drawings point out, 'Indian-ness' is constructed by everyone. The problem of racism is felt most acutely by those who are racialized. But if a society holds racist views in common then the problem is everyone's."[24]

Unlike Kelley and McCarthy, the hegemonic avatars of abjection in 1990s art, Jungen's art derives its impetus from social marginalization. But the specificity of the work's critique loses its power if his work is pigeonholed as "Native art." For Native art, like other categorical tautologies inherited from the Identity Politics moment of the late 1980s and early 1990s (queer art, post-colonial art, Asian art) serves as much as a ghetto as did earlier categories of women's art in the 1970s, or working class art in the 1930s, reducing art to the identity of its producer. And somehow, in an art world version of what Gayatri Chakravorty Spivak calls "chromatism" (attributing causality to skin colour), Jungen's miscegenatory heritage as both European and aboriginal is erased, and his artworks are traced to the tributary origins of northeastern British Columbia.

I am uninterested in biography as a method to praise or condemn, but rather wish to stay with the abject in Jungen's work, which consists of two periods: his own drawings of "Indians" in platform shoes or on skateboards, fucking Mounties or comparing dicks; and his wall drawings. The image-repertoire of the latter included a cowboy offering an Indian a bottle of xxx liquor; crude killer whales and inukshuks; and a pair of intoxicants, one marked beer, the other Lysol.

Again, as inured as we are to the spectacle of Nikes and Michael Jordan, the subjectivity of the "drunk Indian" is so firmly a part of the Canadian imaginary (or the "Imaginary Canadian," to use Anthony Wilden's phrase) that it is necessary to re-orient our perception of the value of these drawings. They offer a commentary on the despair under which many Native peoples live in Canada—that is to say, there is a germ of truth in the racist stereotypes, with the dialectical proviso that the social condition of Native peoples is irrevocably connected to the fatalism with

which they are viewed by non-Natives, and that alcohol stands in for the entire range of commodity capitalism which both Thomas King and Brian Jungen indict. And this stereotype, or the despair that it is a symptom of, is also endemic among Native peoples: this is where Watson errs, in supposing that the wall drawings would only work if a non-Native did them.[25] Native people do not have a better means of access to self-knowledge or critique than any other group: the workings of ideology are too pernicious to let anyone off the hook.

I will close this discussion of Jungen's art not with a consideration of its causes but rather its effects: or at least, I would like to offer a suggestion as to how to connect his work with the question of Late Empire, or the global. This suggestion comes from Claude Lévi-Strauss's work in the 1950s on myth, and in particular his essay "The Structural Study of Myth," where two sets of distinct thematic elements of myth are related to each other in the logical formula A is to B as C is to D, or A:B::C:D.[26] What does this mean for Jungen? His art returns a social context to the abundance of globally-produced consumer objects that surround us. That is, they assert the true costs of globalization (the Hardt and Negri argument) in how the commodity becomes a spectacle. We might map how this works in the following way: first of all, an abundance, in terms of Jungen's material, of the low, abject, or everyday: running shoes, lawn chairs, Ikea products, pallets, living room sofas, plywood. These materials are transformed into monumental objects—not because they are now art, but because of their faux or mock highness: useless pallets, ceremonial masks, a model of a house, skeletons for display (the effect would be different if the whale skeletons were displayed in crates, disassembled; for their worth, and perhaps Jungen's intent, lies in their hanging above us). And Jungen's work is repeatedly local or site-specific: his masks reference the West Coast, for example, or the the museum or gallery as site of spectatorship. As well, Jungen's art draws on the global, from the proliferation of brands (Nike, Ikea) to shipping pallets and the packaging and stacking lawn chairs, Thus, the low material is to high art as the local site is to global spectacle.

What does this analysis finally say about Jungen's art practice? He offers us a way to think about what is often difficult to grasp: the relationship between the local and the global, or the here-and-now and the imperium. This form of thought takes place materially: in how he re-purposes consumer objects, turning them into artworks. The Late Empire is not just "out there" in the business pages of *The Globe and Mail* or in the sordid machinations of the US Army, and it cannot be blamed on youth wearing overpriced running shoes or the ubiquity of corporate chains such as Starbucks. But by offering a way of taking what is abject and making it into something spectacular, Jungen's art offers not so much a road map for dissent or critique, as a possibility of that road map existing.

## IV. Conclusion

Just as Moshe Safdie's design for the Vancouver Public Library simulates the Colosseum, seeking to borrow or bury a bloody imperial anteced-ent—mute witness to history's atrocities—beneath the behemoth of technology (a library in ruins), so Brian Jungen's work reinterprets the commodities of the everyday: the running shoe, the sofa, the lawn chair, and the gallery wall. If Jungen's interest lies with the vernacular, it is that tortured speech of the marginal—the sliced sneaker or dissected chair—that emerges, against all hope or expectation, as something grander and perhaps global, not in the sense of trade or tariffs, but human society. In these case studies we also see the role of simula-tion: torture as simulated abuse (as well as real abuse) that becomes an image; the simulation of a colosseum in which simulated battles took place; the simulated masks and skeletons that are simulating the museum objects they then become in actuality. This Late Empire under which we toil, then, is not so much a belated empire, nor at its end, but perhaps a former empire, in the ruins of which we erect, without know-ing quite why, an image-repertoire of the abused and the abusing, the tortured and the torturing, images the better to read and decipher before it is, indeed, too late.

1. Walter Benjamin, "Theses on the Philosophy of History," *Illuminations*, trans. Harry Zohn (New York: Schocken, 1969): 256–7.

2. Edward Gibbon, *The Decline and Fall of the Roman Empire*, ed. Hans-Friedrich Mueller (New York: Modern Library, 2003): 202.

3. Certain salient points characterize Hardt and Negri's analysis of Empire: a hybrid constitutionality, made up of a global pyramid (the US superpower at the top, nation states and capital flows in the middle; and popular interests ranging from NGOs and the Internet to media, religion and other components of civil society at the base); biopower, or the Foucauldean interstice of power regimes and the subject; and the "multitude" as a virtual, circulating mass. Biopower constitutes a hybrid subjectivity, which is Hardt and Negri's updating of Althusser's interpellation (in which our subjectivity is strictly differentiated according to the institutional power matrix that hails us): "A hybrid subjectivity produced in the society of control may not carry the identity of a prison inmate or a mental patient or a factory worker, but may still be consti- tuted simultaneously by all of their logics. It is the factory worker outside the factory, student outside school, inmate outside prison, insane outside the asylum—all at the same time. It belongs to no identity and all of them—outside the institutions but even more intensely ruled by their dis- ciplinary logics" (*Empire*, 331–332). This is particularly pertinent to the abuses at Abu Ghraib, in which both the soldiers/guards (some of whom, as many Americans in Iraq, were private contractors [in *Multi- tudes*, Hardt and Negri note that the shift to mercenary armies from citizen armies, as at the end of the Roman Empire and during the Italian Renaissance, signals the end of the empire]) and the prisoners themselves—whether genuine insurgents or innocent civilians—constitute such a hybridity.

4. From the International Red Cross (ICRC) report of February 2004: "The methods of ill-treatment most frequently alleged during interrogation included: Hooding, used to prevent people from seeing and to disorient them, and also to prevent them from breathing freely.... Hooding could last for periods from a few hours to up to 2 to 4 consecutive days...; Handcuffing with flexi-cuffs...; Beating with hard objects (including pistols and rifles)...; Pressing the face to the ground with boots; Threats (of ill-treatment, reprisals against family members, imminent execution or transfer to Guantánamo)." Mark Danner, *Torture and Truth: America, Abu Ghraib, and the War on Terror* (New York: *New York Review of Books*, 2004): 261.

5. Seymour Hersh, "Annals of National Security: Torture at Abu Ghraib," *The New Yorker* (May 10, 2004). www.newyorker. com/fact/content/?040510fa_fact

6. Guy Debord, *Comments on the Society of the Spectacle* (New York: Verso, 2002): 22.

7. Peter J. Holliday, "Roman Triumphal Painting: its function, development, and reception," *Art Bulletin* 79.1 (March 1997): 130–147.

8. A *Washington Post* online story, cited by Danner, contained depositions by thirteen Iraqi detainees. According to the story, in addition to soldiers often stealing/ confiscating money and other valuables during the arrest, the following abuses took place (in the interests of brevity I will give but two detainees' testimony). Thaar Salman Dawod stated, "They came with two boys naked and they were cuffed together face to face and Grainer was beating them and a group of guards were watching and **taking pictures** from top to bottom and there was three female soldiers laughing at the prisoners." Shalan Said Alsharoni: "The evening shift was sad for the prisoners. They brought three prisoners handcuffed to each other and they pushed the first one on top of the others to look like they are gay and when

they refused, Grainer beat them up until they put them on top of each other and they **took pictures** of them." (*Torture and Truth*, 231, 234; emphasis added.)

9. *Empire*: 364.

10. Ibid., 189.

11. John Ward-Perkins, *Roman Architecture* (New York: Abrams, 1977): 89.

12. See Bronwen Ledger's "A Public Affair: Vancouver Library Square Competition," *The Canadian Architect* 37.7 (July 1992): 20–27, 39. The process was as follows: twenty-eight firms responded to an initial "invitation for expressions of interest" in August 1991; of these, seven were shortlisted. Three finalists were selected in December 1991 and their proposals displayed to the public in March 1992. After the proposals were reviewed by an urban design panel and technical advisory committees, the selection advisory com- mittee chose Safdie's design. "How did it succeed? Before the final competition the three contending schemes were put on show in libraries, the city hall, and even a shopping mall, and people were invited to vote on them and write comments. Seven thousand responded and seventy percent chose the Safdie team's scheme" (20–21). Ledger argues that the restricted competi- tion process signals the need for open competitions and reveals the vexed role of the public—distrusted by Ledger as by most elites: "Can we really change our image-saturated culture and the public's thirst for the dramatic? ... [W]e must have open competitions to make opportunities for schemes that don't cater shallowly to public taste" (39). My argument, of course, is that the choice of Safdie's design revealed a political unconscious in the Vancouver polity, a fear of the "yellow hordes" or an Asian invasion. In this sense, then, I would locate aesthetic agency of the VPL with Safdie, and political agency with the people of Vancouver.

13. By "white Vancouver," I mean that Eurocentric, anglophilic Vancouver

born in the holocaust of the great fires of 1886, and which participated in the Chinatown and Japantown riots of 1887 and 1907, the authorities' refusal of Indians on the *Komagata Maru* to land in 1914, the segregation of Native and Asian peoples until the 1960s, and the internment of Japanese-Canadians during World War II. See Kay Anderson, *Vancouver's Chinatown: Racial Discourse in Canada 1875–1980* (Montreal: McGill-Queens University Press, 1991), Wing Chung Ng, *The Chinese in Vancouver, 1945–80: The Pursuit of Identity and Power* (Vancouver: UBC Press, 1999), and Michael Barnholden, *Reading the Riot Act: A Brief History of Riots in Vancouver* (Vancouver: Anvil Press, 2005).

14. Or, as Peter Davey put it in "When in Vancouver, don't do as the Romans," *Architectural Review* 201.1199 (January 1987): 21: "Why, when building an institution devoted to civilization and learning, choose as a model the Colosseum—a place devoted to bloody destruction and the gratification of humanity's basest instincts?"

15. Ibid., 21.

16. There is a full-blown psychoanalysis of Safdie's relation to the VPL: he has also claimed that because of the building's visibly high-tech interior, "you are 'sure to forget the Colosseum' upon entry." Bruce Haden, "Toga Party," *The Canadian Architect* 40.8 (August 1995): 33. Thus Safdie had to "forget" the building's antecedent and insist on its design arising out of formal/structural causes. Then, he tells the building's users that they (we) should also forget.

17. Fredric Jameson, *The Political Unconscious: Narrative as Socially Symbolic Act* (London: Methuen, 1981): 102.

18. Thomas King, "The One about Coyote Going West," *An Anthology of Canadian Native Literature in English*, eds. Daniel David Moses and Terry Goldie (Toronto: Oxford University Press, 1998): 207–8.

19. See Sean Gonsalves, "The Hypocritical NBA Dress Code," *AlterNet* (October 26, 2005). www.alternet.org/columnists/story/27386/

20. Jungen's *Isolated Depiction of the Passage of Time* is a stack of cafeteria trays on a pallet with a television inside playing the Steve McQueen film *The Great Escape*. The sculpture is based on a display at the Correctional Service of Canada Museum in Kingston, Ontario, which shows a similar stack of trays, hollowed out as a makeshift escape device by convicts. See Trevor Smith, "Collapsing Utopias: Brian Jungen's Minimalist Tactics," in *Brian Jungen* (Vancouver: Contemporary Art Gallery, 2001): 86.

21. Naomi Klein, *No Logo: Taking Aim at the Brand Bullies* (Toronto: Vintage, 2000). While Klein's text is useful for mapping out how late capitalism has shifted from merely selling products to selling brands, for a less well-known but germane book, see Tom Vanderbilt's *The Sneaker Book* (New York: New Press, 1998). Especially useful is Vanderbilt's discussion of the rise in globalized and outsourced sneaker production, including a chart—itself taken from a 1995 article in *The Washington Post*—which traces the process whereby a shoe that starts with $2.75 in labour costs and $9.00 in material ends up costing $70. The key in this accumulation is the "brand"—be it Nike or adidas—as middleman, not the manufacturer nor retailer.

22. See Jessica Morgan, "Representation to Production: Art as Social Critique," *Supernova: Art of the 1990s from the Logan Collection* (San Francisco: San Francisco Museum of Modern Art, 2003): 24–30. Morgan argues that the 1990s was characterized by a struggle between art dealing with representation and that dealing with production; in this latter group she includes Yinka Shonibare and Gabriel Kuri. We can see that Jungen's work similarly straddles the divide, playing with representation (the drawings, for instance) and also production (*Prototypes*, whale skeletons). There is also an element of uselessness in Jungen's practice: the pallets that could never be used because they are made from soft cedar, or the sheer and monumental absurdism of refashioning sneakers, patio chairs, or couches.

23. A colleague of Brian Jungen's, Jonathan Wells, approached people on the streets of Banff and asked them for their idea of what Native art is. Jungen then selected and reproduced drawings on the walls of the Charles H. Scott Gallery in 1999, then routered the drawings into the walls of the Vancouver Art Gallery in early 2006.

24. Scott Watson, "Shapeshifter," *Brian Jungen* (Vancouver: Contemporary Art Gallery, 2001): 16.

25. "[T]hey'd have to be non-native for the piece to work." Watson, "Shapeshifter": 15. This is the proper place in which to add that, as is the case for writing about so many Vancouver artists, Scott Watson's texts are always exemplary in their breadth of critical acumen and political urgency.

26. Claude Lévi-Strauss, *Structural Anthropology*, trans. Claire Jacobson and Brooke Grundfest Schoepf (New York: Anchor, 1967): 202–228. There Lévi-Strauss analyzes the Oedipus cycle of Greek myth and tragedy, and arranges various thematic elements into four categories: over-rating one's relations (or marrying one's mother), under-valuing one's relations (killing one's father), the autochthonous origins of man (the role of monsters), and the denial of the autochthonous origins (such as killing the Sphinx). He then argues a structural logic is at work: or that over-rating is comparable to under-rating just as the autochthonous origins are to their denial; in the elegant mathematics of structuralism, A:B::C:D. Two disparate conditions—relations among people, the origins of the race—are linked by the similarity of their logic. (Jungen has also related how, when he began working on the *Prototypes*, he was reading Lévi-Strauss's book on North-West Coast masks, *The Way of the Masks* [Vancouver: Douglas & McIntyre, 1988]).

# Cinematic Pictures:
# The Legacy of the
# Vancouver Counter-Tradition[1]

Sharla Sava

Jeff Wall, *Picture for Women*, 1979
transparency in lightbox
Courtesy of the artist

In the case of contemporary art in Vancouver, it is tempting to suppose that modernist controversies are too remote, both historically and geographically, to supply a relevant interpretive framework. Even in contemporary art, however, modernism remains a thorny issue. Distant from the institutional structures designed to uphold the established cultural traditions of Europe, the colonial culture of the West Coast fostered a climate in which alternative, anarchist, and counter-traditional values were able to flourish. A sense of being removed from the centre of national interest has been typical of west coast culture in both the United States and Canada. In artistic terms, it could be said that personal expression has been less governed by the anxiety of influence. With respect to Vancouver, the interwoven evolution of modernization and modernism has been both sudden and late. As well, it is only in recent decades that Vancouver artists have gained sufficient international prominence to have made an impact on debates taking place in the world of contemporary art.

While there is sufficient reason to suppose that contemporary Vancouver artists must contend with how the reception of modernist discourse informs their work, they also, of course, bear witness to the moment of its erosion. It was during the radicalized era of the 1960s that artists started to look beyond the purely formal concerns of modernist painting and sculpture in order to recover the diverse strategies initially employed by the historical avant-garde. During that period, established artistic conventions were ruptured by vanguardist strategies that dematerialized, politicized, and contextualized the traditional art object. Rather than establish competence within a singular medium, such strategies embraced the potential offered by a variety of media.

This crisis of the medium, what has come to be known as "the post-medium condition," speaks of a period dominated by wide-ranging artistic experimentation. It is the harbinger of our contemporary moment and, depending on one's vantage point, inaugurates either a welcome stage of artistic freedom or the reigning chaos of profound aesthetic confusion.[2] The aesthetic controversies with which I am concerned belong to the period of the post-medium condition. Artists in Vancouver employ a range of image-based technologies (e.g., conventional and digital photography, film, video), but their formative aesthetic emerges from conceptual art and its interrogation of modernism.

In 1997, critic Benjamin Buchloh spoke in an interview about the increasing presence of photography in the contemporary art world. The interviewer, struggling to address the transition between 1960s vanguardism and 1980s pictorialism, was interested in Buchloh's views about Vancouver, asking pointedly:

> But what do you think, for instance, of what some people call the Vancouver group, with artists such as Ian Wallace, Jeff Wall, Ken Lum and Rodney Graham?

Buchloh responded:

> That is a pretty complicated situation. The work that emerged in Vancouver in the late 1970s was very important as a critical response to the legacy of conceptual art. For me the interesting moment was its subsequent unfolding, its subsequent development and its hegemonic quality, in terms of positioning itself as an artistic practice that apparently resolved all the contemporary questions. It is interesting to look at the historical dialectics between generations or between positions. To see, for example, to what degree the legacy of conceptual art is counter-acted in the late 1970s by artists like Jeff Wall, who criticized a certain model of linguistic paradigm by reintroducing a visual or representational paradigm.[3]

I am interested in Buchloh's phrasing, particularly in the last sentence, because it attests to the rupture which separates 1960s experimentation from 1980s large-format photography. Artists like Jeff Wall do not *continue*, Buchloh says, but rather *counteract* the legacy of 60s vanguardism. He reminds us that Wall's production does not fulfill the ambitions of conceptualism; rather, it is a reaction-formation, contesting conceptualism's fundamental premises. Photoconceptualism has become popular as a term used to address this period of art production in Vancouver. Yet if Buchloh's comments are credible (and I think that they are), it has been terms such as photoconceptualism which have obscured the political and aesthetic implications of this historical transition.

Photoconceptualism gained currency around 1990, when Vancouver artist, critic, and teacher Ian Wallace published "Photoconceptual Art in Vancouver," his history of Vancouver art from the mid-60s to the late 80s.[4] There he described the continuous development of a movement referred to as "photoconceptual art." The essay marks Wallace's most ambitious attempt to address the conditions of artistic production which governed not only his own work, but also that of his students (including Jeff Wall and Rodney Graham). According to Wallace, photoconceptual art, while identifiable in the work of a few individual artists, was a result

of the encounter between late modernism and the dominant features of the modern city. His essay outlines the formative stages of this period, emphasizing the importance of the artist duo N.E. Thing Co. and exhibitions curated by local artist Christos Dikeakos as well as New York-based critic Lucy Lippard. Wallace's essay also draws attention to the artistic and conceptual precedents established by American artists Dan Graham and Robert Smithson.[5]

Wallace's reliance on photoconceptualism as the narrative thread that weaves together the history of recent art production in Vancouver is by no means anomalous. This terminology has routinely been used by critics and commentators for well over a decade. There are any number of examples demonstrating how pervasive the term photoconceptualism has become both within and outside of local circles: in 1996, art critic and educator Judith Mastai invoked a longstanding rift within the Vancouver art community when she cited local artist Gregg Simpson, claiming that "Vancouver has wrongly been portrayed as a major centre only for conceptual and photo-based art 'instead of what we should really be known for: a regional art, spiritual in nature and mainly landscape-based.'"[6] Similarly, National Gallery of Canada curator Kitty Scott discussed the vitality of the Vancouver art scene in 2002 in "Ken Lum Works with Photography," observing that "Stan Douglas, Rodney Graham, Ken Lum, Jeff Wall, and Ian Wallace, a.k.a. the *École de Vancouver*—often referred to as 'the Vancouver photoconceptualists'—are among the most established" artists in the city.[7] Another typical example taken from *Canadian Art* magazine explained: "[Ian] Wallace was mentored by Iain Baxter (of N.E. Thing Company) and went on to teach Jeff Wall, Rodney Graham, Stan Douglas, Ken Lum, Roy Arden, and Arni Haraldsson. This esteemed group rose to international prominence in the 1980s, forever linking Vancouver with photoconceptualism."[8]

The examples cited here demonstrate that the contemporary art world has come to associate Vancouver with a particular kind of art, and the current terminology is the "Vancouver School" or, alternatively, "photoconceptualism." It is not my intention to argue for photoconceptualism's insignificance within Vancouver's art history—clearly, the photoconceptual experiments characteristic of artistic practice in Vancouver emerged in response to the perceived limits of Greenbergian modernism and they make a significant contribution to the historical development of the post-medium condition. But what kind of contribution, exactly, do these experiments make? And, further, how did the legacy of 1960s photoconceptualism play out in subsequent decades?

Photoconceptualism, as a critique of representation, played a crucial role in inspiring artistic curiosity about the various ways in which dominant techniques employed by media culture could be redeployed in the context of art. This impulse toward theatricality or cinematography can be seen in various early photoconceptual projects. Within this paradigm,

every site is a potential stage-set, every car window a new opportunity to transform land into speculation.

I am thinking, for instance, of Jeff Wall's best-known contribution to the era, *Landscape Manual*, produced in 1969 and 1970. Above and beyond the photographs which appear in it, the accompanying text attests to a serious concern with the creation and production of the visual image. Wall's *Manual* is littered with references to movie cameras, photographs, slides, and projectors, and with cinematic descriptions of the landscape as well as absurdist movie treatments. The language is not about vision so much as it is about the technology of vision. For example: "On the street outside, a car passes. On the seat beside the driver a slide projector throws images of the passing landscape against the side window, on the dashboard, on the padded ceiling inside the car, or into the rear-view mirror. Interspersed with these landscapes might be images of meals eaten in restaurants, sex acts carried out in cars similar or identical to this one, etc."[9]

Another early photoconceptual work created by Jeff Wall, *Cine-Text (Excerpt)* (1971), produced in Vancouver and London, also attests to the artist's growing interest in cinematic production. Lucy Lippard selected it for inclusion in *Six Years*, her celebrated anthology of dematerialized art.[10] *Cine-Text* is a document with two columns of text in which photos have been inserted. The text on the left side reads like a film treatment, describing the interior of a factory filled with workers; the text on the right is a transcription of the proposed audio accompaniment, a thought-piece about artistic labour. Ian Wallace took the photos that accompany *Cine-Text*, and in a later essay, he reflected on his and Wall's growing interest in a theatrical landscape: "By 1970 the sense of 'location' in its specificity ... led us to sense a kind of future 'movement'. These locations seemed to act as a stage or backdrop to some sort of dramatic action.... This was the potential, if forbidden, direction of our work."[11]

In the early 1970s, this aesthetic direction had been "forbidden" by the discourse of Greenbergian modernism, which argued for the separation of visual art from dramatic content in the name of greater self-reflexive value. In a 1946 review of an Edward Weston exhibition, Clement Greenberg summarized his attitude to photography, stating: "Photography is the most transparent of the art mediums devised or discovered by man. It is probably for this reason that it proves so difficult to make the photograph transcend its almost inevitable function as document, and act as a work of art as well."[12]

Photoconceptualism, because of its reliance on the photograph as a kind of pure material document, was consistent with modernism in this respect. It too was grounded in scepticism toward the literary, allegorical, or narrative aspects of visual representation. It is not surprising, then, to find that artists such as Wallace and Wall would hesitate before imagining the turn from photoconceptualism to the dramatic picture. By 1973, however, experimentation with photoconceptualism had led the artists

away from documentary-type photography and into the potential offered by cinema.

In 1973, Jeff Wall, Ian Wallace, and Rodney Graham began to collaborate on a feature-length film. Rather than conforming to the tenets of experimental or documentary film, the young artists turned toward fictional narrative in the manner of Hitchcock. Reflecting on their collaboration years later, Wallace commented: "Jeff and Rodney and I met probably daily for a couple of months ... working out what it was going to be about, on the script."[13] Although they eventually completed their film, the artists decided not to show it publicly. Wallace explained: "Some of the images were quite strong and arresting, but it wasn't enough to carry a film. I think Jeff in the end felt that way too."[14] While their aesthetic development continued to incorporate aspects of cinema, all three artists stopped short of moving out of the world of visual art into that of the film industry. Rather, as we can now see, the parameters of visual art would expand to incorporate the potential of narrative film.

In order to track the impact of cinema on recent developments in Vancouver art, it is necessary to consider the term "counter-tradition," and emphasize that photoconceptualism is to be understood as a formative, yet distinct, aspect of the Vancouver counter-tradition. This historical transition is outlined most explicitly in Jeff Wall's essay "Traditions and Counter-Traditions in Vancouver Art: A Deeper Background for Ken Lum's Work," which was originally presented as a lecture in Rotterdam in 1990: "In my essay in the catalogue for [Ken] Lum's show, I claimed that [Rodney Graham's] 'Illuminated Ravine', along with Lum's furniture sculptures, first presented in 1978 and 1979, were the indicators of a new direction in the art discourse of Vancouver.... [A] counter-tradition, long in preparation, surfaced."[15] Wall thus dated the emergence of the counter-tradition to 1978 or 1979, a historical moment that coincided with his own return to the pictorial, after various experiments with language and a variety of media formats.

The counter-tradition is a means by which to track the innovations made by a generation of artists who, although interested in the artistic potential of photography, were unwilling to remain confined by the progressive logic demanded by fidelity to a singular medium. Wall's defense of a Vancouver counter-tradition functions in the background, shaping accepted notions about Vancouver art, even up to the present day. While it may not lead to a definitive school, movement or genre, it is a discourse thoroughly entwined with larger trends in the global art market.

According to Wall's lecture, the decade prior to 1978 is not part of the counter-tradition; it was the formative period leading up to its emergence. This periodization is significant because it leaves open the question of how photoconceptualism—which dates back to the 1960s—relates to the idea of counter-tradition. Configuring the transition from the iconoclastic, conceptualist experiments of the 1960s to the restoration of the pictorial

in the late 1970s remains highly fraught. This is because the transition carries an implicit claim about the shifting sociopolitical function of art in a society which must contend with the onslaught of postmodernity and its fanatical reproduction of the image.

In retrospect, it has become apparent that the point at which Wall's argument entered into public discussion, around 1990, was also the historical

Ian Wallace, *La Melancholie de la Rue*, 1973
silver gelatin print
Collection of the Vancouver Art Gallery
Vancouver Art Gallery Acquisition Fund, VAG 86.18 a-c

moment when the marginalized counter-tradition began to establish itself as the new *modus operandi* in Vancouver. It was after 1990 that the counter-tradition became firmly entrenched as the dominant tradition, and it is as *tradition* that younger practitioners—notably Geoffrey Farmer, Evan Lee, Judy Radul, and Kelly Wood—encounter this aesthetic position. What we will see is that the emergence of the Vancouver counter-tradition was both a product of, and a reaction against, the political aims of photoconceptualism.

At the time of his participation in the collaborative film project, Ian Wallace also produced a large-scale, photo-based work titled *La Melancolie de la Rue* (1973). This hand-coloured photo-mural remains the most poignant example of an artistic imagination deeply engaged in transforming the ideals of bohemia into content for high art. Christos Dikeakos has discussed *Melancolie* as an important transitional work in Wallace's development, because it signifies a departure from conceptualism and a move toward the literary potential of art. Here we see the tension of locality embodied in architecture: institutional architecture, suburban housing, and the marginalized squatter shack.[16] Jeff Wall argued for the significance of this work as a landmark on the road between photoconceptualism and the counter-tradition.

By 1990, when Wall was actively involved in constructing this period of Vancouver's art history, his work was well on its way to becoming established according to terms which remain aesthetically and politically distant from the vanguardism of the 1960s. Indeed, we might suppose that Wall developed the notion of counter-tradition to serve this purpose; for as

much as the concept was intended to create a distance from the tradition of lyrical modernists, including Emily Carr and Jack Shadbolt, it was also intended to refute the political imagination of the neo-avant-garde. In the "Traditions and Counter-Traditions" essay, Wall argued that the dynamic period of experimentation that took place in the late 60s, while representing a break from certain established artistic conventions, did not signal the end of the romantic tradition. For Wall, many of the local experiments of this era were still too caught up in "the romanticism of nature and the Native."[17] Inasmuch as it is a response to the post-medium condition, the counter-tradition also claims a stance of relative autonomy, shored up against those bohemian experiments, such as Image Bank, which collapse art into the more abundant realm of "cultural ecology."[18]

As Buchloh also realized, what is distinctive about the Vancouver counter-tradition is the way in which it translated the aims of conceptual art. In other cities, conceptualism became the basis of further deconstruction, but in Vancouver it inspired a concerted return to pictorial photography. In this way, the Vancouver counter-tradition became the next logical step in a continuous tradition of modern pictorial form. What the term also did, along the way, was recast the radical aims of the 1960s era. For Wall and others, the experimentalism of the 60s—what Peter Bürger has theorized as "the neo-avant-garde"—signaled a period in which transgression itself became institutionalized.[19] Neo-avant-gardism—art created for the purpose of addressing its own institutional and commodified constraints—was readily appropriated as a vehicle for the liberalization of museum and gallery systems and, as such, was dismissed as both naïve and misguided.

In a 2003 essay about Jeff Wall, Bürger suggested that the artist chose to respond to the "institution of transgression" by directly engaging with the taboos that transgression had evoked.[20] According to Bürger, Wall returned to practices that had been dismissed, such as figuration and narrative photography, in order to reveal the limitations of 1960s vanguardist strategies. His line of thought fashions a "critical" rather than a thoroughly "affirmative" project while also steering clear of photoconceptualism (that is, the neo-avant-garde). How does this reasoning unfold?

Vanguardism should remain a part of this discussion. Or we can say, at least, that some of Wall's early interviews do not disavow the notion of vanguardism altogether. For instance, in a widely cited interview from 1985, Wall commented: "I mentioned that I thought there is a 'counter-tradition' within modernity. This counter-tradition is what I identify as 'avant-garde.'" Further in the interview Wall stated: "The counter-tradition I'm interested in is not just an art movement, it is a whole political culture. And because its politics are based on the material possibility of change, art plays a prominent role in it."[21]

While understanding that the counter-tradition is employed as the means by which to refute the neo-avant-garde, it is still necessary to

position this tendency within the radical context of the 1960s. During this period, key texts from German critical theorists—Adorno, Benjamin, Marcuse—began to appear in English, influencing the artistic and political imagination of the era.[22] These texts introduced English-speaking audiences to forms of political modernism which had been suppressed by the hegemony of Greenbergian modernism. It is valuable to note the degree of enthusiasm which an artist such as Jeff Wall awards to authors including Lukács, Benjamin, or Marcuse: "An amazing series of syntheses were fragmentarily happening between 1965 until about 1973.... At that time there was a momentum to what I really think now is an ultra left view of artistic activity.... I was really influenced by it." Wall added: "For me it was crystallized down through photography."[23]

The mode of photography consonant with the counter-tradition does not fit securely within either the abstraction of modernism or the materiality of realism. For in the climate of late capitalism, neither modernism nor realism seem entirely appropriate to the cultural situation. Various strategies employing critical realism, typologies, and figuration find a renewed relevance in the years following 1968. In the postmodern era, it is through a return to figuration that realism becomes the means by which modernism itself might be renewed.[24]

Pictures such as Jeff Wall's *Mimic* (1982), *Milk* (1984), and *Diatribe* (1985) or, more recently, *A View from an Apartment* (2004–05) are compositions intended to convey typical figures whose interpretation relies on the dramatic structure of social meaning. As viewers, we search for the motives which, stemming from the interior world of the subject, have become embodied as recognizable physical gestures. As well, we look to the exterior world portrayed in the picture to see what role these gestures will play in the constitution of the public world. In each case, the picture, composed of actors posing on location, is an artificial construction of fragments which appears as a dramatic, novelistic unity while the camera, with its indexical relationship to the real, inevitably confirms an element of objective reality. A similar range of strategies is employed in Ian Wallace's picture *The Studio* (1977), or Ken Lum's *Mounties and Indians* (1989). Because the social subjects portrayed in the work are staged and directed, we can see that the use of typology approximates a theatrical, cinematic mode. But they are actors deprived of the ability to speak, frozen in arrested motion.

My reference to typology is intended to reinforce the understanding that this art admits to a certain degree of faith in representation. This faith is suggested by the theoretical premises which guide artistic production, and confirmed in the photography itself. In these pictures, however, the attempt to address public culture is also marked by a refusal to continue working within an older, more established tradition of painting or documentary photography. That is to say, the faith in representation demonstrated by this type of art also admits to a process of self-imposed

mediation. One way to explain this might be to say that the transgressions against the institution of art inaugurated by conceptualism carried the Marxist project of ideology critique into an ostensibly postmodern era. After experimenting with various critical strategies—such as photoconceptualism—some artists would come to believe that the critique of ideology need not be iconophobic; that is, it need not push the critique of representation to the limit of complete refusal. This is one way to interpret the resurgence of theatrical conventions occurring in the visual arts since the 1970s.

The debate around theatricality was, of course, inadvertently inaugurated by American critic and art historian Michael Fried. In his 1967 essay "Art and Objecthood," Fried relied on the notion of theatricality to mount an impassioned attack on that strain of contemporary art which he called "literalist." Defending the artistic conventions of modernism as "art," Fried pointed to the emerging tendency of "objecthood," which, he complained, "amounts to nothing other than a plea for a new genre of theatre, and theatre is now the negation of art."[25] At the time, Fried was referring to minimalist sculpture, but for Douglas Crimp, writing a decade or so later, theatricality was a logic that could bleed into, and reconstitute, all the modes and formats employed by contemporary art. Writing in *October* magazine in 1979, Crimp reflected on his acclaimed exhibition, *Pictures*, which featured the work of Jack Goldstein, Sherrie Levine, and Robert Longo, among others. While Fried's "Art and Objecthood" essay did not expressly address media-based arts, Crimp emphasized that the construction of pictures could not be excluded from the concerns of theatricality. Referring to contemporary, photo-based artwork, Crimp pointed out that the "the theatrical dimensions [of the art] have been transformed and, quite unexpectedly, reinvested in the pictorial image."[26]

Crimp's address of "theatrical" pictures is in some ways consonant with concurrent ideas, including the "directorial mode" in photography or the artistic turn toward "fabricated" photographs. Writing in *Artforum* in 1976, the critic A.D. Coleman drew attention to what he called a newly emergent directorial mode in art photography. He sketches out the artist's relation to photography as a continuum: at one end is the *documentary mode*, which remains committed to maintaining the apparent truth of the photo; in the middle of the continuum is *responsive photography*, which allows for the expression of the sensibility of the photographer; and on the far end, posed opposite that of documentary, is the *directorial mode*, in which "the photographer consciously and intentionally creates events for the express purpose of making images...."[27] The staged reality characteristic of the directorial mode is a result of photographers intervening in a particular real-life situation, staging dramatic tableaux explicitly for the camera, or arranging objects or still-life subjects in the studio. In this mode, the faith in photography as a source of documentary evidence is turned deliberately against itself.

Ken Lum, *Mounties and Indians*, 1989
c-print and enamel on Plexiglas
Edition 1/2
© Ken Lum
Courtesy of Andrea Rosen Gallery, New York

Anne Hoy's 1987 book, *Fabrications: Staged, Altered, and Appropriated Photographs*, also confirmed the growing number of photographers turning to fabrication during the 1970s and 80s. Fabricated photos, as Hoy defines them, have been "openly staged for the camera and/or manipulated in the darkroom." Because these photos document fake situations that nevertheless took place, they are neither true nor false: "Theatre is their model—with its surrogate reality, narrative continuity, and emotional charge—and the studio is their stage."[28] Artists creating these kinds of narrative tableaux depend on a mode of production that requires a wide range of skills. At the same time, their pictorial format is also driven by the speed and efficiency offered by technological innovation. They are not just photographers but also directors, set designers, costumers, and casting agents, and, similar to the cinema, they rely on actors, props, and constructed settings.

The resurgence of theatrical strategies in art photography is tied to the discourse of postmodernism, which reached its zenith during the 1970s and 80s. It is thus unsurprising to find Jeff Wall's work, *Double Self Portrait* (1979) and *Picture for Women* (1979), making an appearance in the celebrated *Difference* exhibition (1984). Organized by the New Museum of Contemporary Art in New York, many of the artists included in *Difference* —Barbara Kruger, Victor Burgin, Hans Haacke, Mary Kelly, Martha Rosler— are, by now, classic representatives of the postmodern deconstruction of representation. Discussing the landmark role played by the *Difference* exhibition, British art historian Griselda Pollock explained that the show operated as an emblem of 1970s cultural politics in the more conservative climate of the 1980s, which was witness to a revival of traditionalist and expressive styles of painting.[29] The Canadian exhibition, *Subjects and Subject Matter* (1985) at the London Regional Art Gallery, also served to position Wall's work in the context of deconstruction. *Subjects* exhibited photo-based works which relied on appropriation, deconstruction, and quotation in order to strategically engage the limits of mass media imagery. In her catalogue essay, curator Elke Town argued for an affinity between Wall and Barbara Kruger, on the grounds that both artists are "engaged in an enterprise that projects a stance directly critical of ... capitalist society."[30] A consideration of the curatorial imagination of the mid-80s confirms that the reception of Wall's art was, at a certain historical moment, strongly associated with the theoretical "crisis of representation" and its framing in postmodernism.

We can also see that the arguments made by Crimp, Coleman, and Hoy, in drawing attention to the emergent practices of theatrical and cinematic photography, confirm that the kinds of questions being asked in Vancouver since the late 1970s belong to a much wider turn toward pictorial narrativity. Wall's understanding of art, and by extension his definition of the Vancouver counter-tradition, is embedded in a form of cultural politics which takes a great deal from both the historical avant-garde and the critical postmodernism that championed theatricality.

What remains uncertain is how the recent turn to narrative photography, this massive renaissance of theatricality, addresses its contemporary audience. In a 2002 essay, T.J. Clark wrestled with changing modes of spectatorship in art and society, an issue deeply entwined with the historical transition between modernism and postmodernism.[31] Given that modernism, as an artistic paradigm, was attuned to the facts and possibilities offered by the everyday life of modernity, Clark wondered whether we have recently entered into an era so different (postmodernity) that it has demanded another paradigm of artistic production (postmodernism). This depends on whether the conditions of modernity have been so drastically reconfigured during the past thirty or forty years that they are on the verge of something new. Clark's grounding in modernism lends him a sceptical eye.

The advent of the mass media image, and in particular, television, signifies a level of technological advance that has transformed the social fabric. "If there is any technological watershed of the postmodern, it lies here," Perry Anderson argued, apropos of the advent, in the early 1970s, of colour TV. Whereas modernism was produced in response to the machine, postmodernism responds to "a machinery of images."[32] Modern technologies, which restructured and improved the efficiency of industry and domestic life, also offered a generative matrix inside which the modernist imaginary grew into being. Twentieth-century modernists recognized that technology posed a vast threat, both in terms of the possibility of complete annihilation and through the insidious power of its mundane rationality. By contrast, postmodern machines deal not in production but in reproduction, generating an unprecedented volume of images, a technical environment overwhelmed by this new density. Unlike the modern machine, the current regime of the image has turned social experience into what Anderson termed a "perpetual emotion machine." This is the context which makes sense of the recent resurgence of theatrical practices in art production. Art is an index of the dramatic shift that has occurred in the relationship between advanced technology and the popular imaginary.

Given that the visual arts represent a long history of engaging with the structure and meaning of images, it remains to be seen whether the renewed proximity of the visual arts to the dominant regime of the image poses a degree of opportunity or a genuine limitation to critical artistic production. In some respects, this new regime—what Anderson claimed is the basis of postmodernity—has inevitably come to stand for art's affirmation of contemporary culture, and the industries on which it relies to produce its socialized subjects. Yet it is precisely this new degree of *identification* which has made it difficult for artists to discover modes of artistic form capable of grasping, rather than being folded into, the dominant cultural imaginary. From the vantage point of modernism, contemporary artists have yet to carry through on the lessons of scepticism and negation established in response to the historical era of modernity.

Eileen Cowin, *Double Departure from Family Docudrama*, 1981
colour print
Courtesy of the artist

I am sympathetic to this critical reading of the current moment, that is, to the hesitation voiced by someone as invested in modernism as T.J. Clark. Another way of approaching this dilemma might be to say that artists have turned to the staged, mediated image in order to *engage* the tenets of dominant visuality, and in a manner which does not entirely contradict the modernist imaginary. This is the critical value of positioning the Vancouver counter-tradition within the larger discourse of theatricality that has emerged in recent decades.

Francisco Jose de Goya y Lucientes,
*The Sleep of Reason Produces Monsters*
*(El Sueno de la Razon Produce Monstrous),*
plate 43 of *Los Caprichos* (second edition), ca. 1803
etching and aquatint
Courtesy of Herbert F. Johnson Museum of Art,
Cornell University,
Membership Purchase Fund

The shape of modern subjectivity has long been determined by the theatre of representation. It is not difficult to see how deeply recent thoughts on theatricality, or the "society of spectacle," delve into the long history of debates over the ways in which modern representation shapes human agency and well-being. Influential essays from the Enlightenment period—by Rousseau, Diderot, and Schiller—attest to the threat, as well as the opportunity, which theatre was thought to present to public life.[33] That there is a formal identity between *theatrical* and *political* stages has been remarked upon since the revolutionary period in France, and it has always been a fundamental condition in the machinery of state formation. Representative democracy and modern theatricality are, according to one recent account, "conceptual siblings."[34] The old struggle between *festival* and *spectacle*, then, remains one of the fundamental conflicts of modernity. If there are any meaningful claims to be staked out in the contemporary return to the dramatic picture, their significance is deeply attached to socio-political arguments about the cultural value of representation.

Cinematic photography, by virtue of its large format as well as its realist style, offers the viewer an occasion to ponder the meaning conveyed by the dramatic gesture. In a 1994 picture by Jeff Wall, for instance, the viewer is invited to witness a solitary middle-aged man lying uncomfortably on the floor of a kitchen. The man's hair is unwashed, his pallor pale,

Jeff Wall, *Insomnia*, 1994
transparency in lightbox
Courtesy of the artist

and his skin clammy with sweat. His impassive gaze addresses us from underneath the modest table which he has taken as his improvised and miserable shelter. The surfaces of the kitchen, like the figure himself, look grimy. Through the window we see that it is night time, and that the only source of light is the cold fluorescent tube mounted on the ceiling. The title of this work, *Insomnia*, serves to reinforce a suggestion of the hidden and interior dimensions of this man's unhappy state.

One way to consider this picture is to suppose that *Insomnia* represents a shift in modern subjectivity. Setting it against a much earlier image, Goya's *The Sleep of Reason Produces Monsters* (1799), from the series *Los Caprichos*, offers a tentative scaffolding for interpretation. This etching also shows a single male figure who seems to be having trouble sleeping. It was completed in the revolutionary era at the close of the eighteenth century, when the social world surrounding Goya supported the conviction that the progress of human reason would guarantee enlightenment and banish the monsters of darkness.

*Insomnia* serves to remind us of the long span between ourselves and the ideals of the Enlightenment; a post-Enlightenment illumination, as it were. Resisting established conventions of portraiture, this generic subject remains unknown; an unimportant man. Perhaps tortured by inner demons, the contemporary subject remains in a state of sleeplessness. He cannot sleep, which is also to suppose that he cannot feel what it means to be fully awake. Lying conscious under artificial light, there is no secure means by which this man can discern between the light of reason and the darkness of private fantasy. Wall's picture has immobilized the dynamic tension between light and darkness. This figure is surrounded not by the creatures of darkness or light, but by the adequate comfort of mass-produced goods, which are utilitarian rather than transcendental. Vacant of the kind of light that acts as an allegorical guide to truth, the picture reinforces the notion that industrially manufactured fluorescence must suffice, as it has become the only kind of illumination readily available today. Bathed in such light, it is difficult to dream.

This picture addresses a valuable element of self-reflexivity. It is, perhaps, a story about the function of contemporary art in relation to the imagination of significant political action.[35] We might suppose that the figure observed in the picture—alone and immobile, lying on the kitchen floor—is that of the artist. As such, what we are looking at is the fate of modern art itself. Within this framework, *Insomnia* is also a picture that brings us back to the historical moment of the counter-tradition, in 1978 or 1979, which is the irresolute cusp of modern and postmodern. "Modernity comes to an end when it loses any antonym," as Perry Anderson observed, "the possibility of other social orders was an essential horizon of modernism."[36] It is the transition from counter-culture to counter-tradition which has placed Vancouver on the map of the global art world. I trust that this transition has not obscured our view of the horizon.

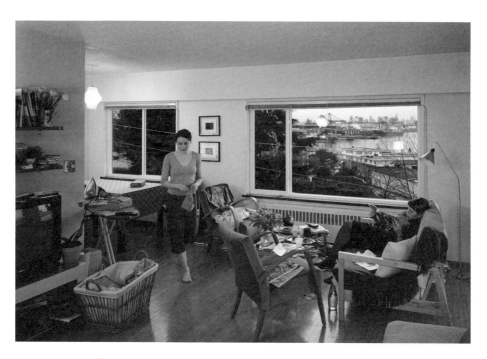

Jeff Wall, *A view from an apartment*, 2004–2005
transparency in lightbox
Courtesy of the artist

1. This essay is based on ideas developed in my doctoral dissertation, "Cinematic Photography, Theatricality, Spectacle: The Art of Jeff Wall" (Simon Fraser University, 2005).

2. Hal Foster, Rosalind Krauss, Yve-Alain Bois, and Benjamin Buchloh, *Art since 1900: Modernism, Antimodernism, Postmodernism* (London: Thames and Hudson, 2004): 534.

3. Benjamin H.D. Buchloh, "The Politics of Representation," *The Photographic Paradigm*, vol. 12, eds. Annette W. Balkema and Henk Slager (Amsterdam: Lier en Boog Series of Philosophy of Art and Art Theory, 1997).

4. Ian Wallace, "Photoconceptual Art in Vancouver," *Thirteen Essays on Photography*, ed. Martha Langford (Ottawa: Canadian Museum of Contemporary Photography, 1990).

5. This history has been made available in recent years through notable initiatives such as the exhibition *Robert Smithson in Vancouver* (2004) curated by Grant Arnold at the Vancouver Art Gallery.

6. This was a claim that Simpson had allegedly made in an editorial to the *Vancouver Sun*. See Judith Mastai, "Conceptual Bogeyman—Art and Media in the City by the Sea," *C Magazine* 49 (Spring 1996): 22.

7. Kitty Scott, "Ken Lum Works with Photography," *Ken Lum Works with Photography* (Ottawa: National Gallery of Canada, 2002): 15.

8. Deborah Campbell, "In the Studio with Ian Wallace," *Canadian Art* 21:4 (Winter 2004): 63.

9. Jeff Wall, *Landscape Manual* (Vancouver: Fine Arts Gallery UBC, 1970): 23.

10. Lucy Lippard, *Six Years: The Dematerialization of the Art Object from 1966 to 1972....* (London: Studio Vista, 1973): 213–14.

11. Ian Wallace, "A Note on the Film in Progress (Script II)," February 1974. Unpublished (Ian Wallace Archives, Vancouver).

12. Clement Greenberg, "The Camera's Glass Eye: Review of an Exhibition of Edward Weston" (1946), *Clement Greenberg: The Collected Essays and Criticism 1945–49*, vol. 2, ed. John O'Brian (Chicago: University of Chicago Press, 1986): 60.

13. Ian Wallace, personal interview (2003).

14. Ian Wallace, personal interview (2003). Wallace has indicated that this film remains in his archive and has not been viewed publicly. Wall has not acknowledged this film as part of his artistic oeuvre. The standard chronology of Graham's work states: "Graham, Wallace, and Wall receive funding from the Canada Council for the Arts toward the production of a film. Inspired by Alfred Hitchcock's *Marnie* (1964), the film is intended as a 'structuralist take on Hitchcock' with a female kleptomaniac as the central character. See Grant Arnold, "'It Always Makes Me Nervous When Nature Has No Purpose': An Annotated Chronology of the Life and Work of Rodney Graham" *Rodney Graham—A Little Thought* (Vancouver: Vancouver Art Gallery, 2004): 183.

15. Jeff Wall, "Traditions and Counter-Traditions in Vancouver Art: A Deeper Background for Ken Lum's Work," *Witte de With: The Lectures* (Rotterdam: Witte de With Centre for Contemporary Art, 1991): 80.

16. Christos Dikeakos, "Ian Wallace: Selected Works 1970–1987," *Ian Wallace* (Vancouver: Vancouver Art Gallery, 1988): 10.

17. Wall, "Traditions and Counter-Traditions in Vancouver Art": 75.

18. For an elaboration on the importance of cultural ecology to the history of Vancouver art, see *How Sad I am Today: The Art of Ray Johnson and the New York Correspondence School* (Vancouver: Morris and Helen Belkin Art Gallery, 2000).

19. Peter Bürger, *Theory of the Avant-Garde* (Minneapolis: University of Minnesota Press, 1984).

20. Peter Bürger, "On a Critique of the Neo-Avantgarde," *Jeff Wall Photographs* (Vienna: Museum Moderner Kunst, 2003).

21. Jeff Wall and Els Barents, "Typology, Luminescence, Freedom: Selections from a Conversation with Jeff Wall," *Jeff Wall Transparencies* (New York: Rizzoli, 1987): 103–104.

22. I am thinking, for example, of Marcuse's *One-Dimensional Man* (1964), or the English-language versions of Theodor Adorno's *Prisms* (1967), Walter Benjamin's essay "The Work of Art in the Age of Mechanical Reproduction" (1968), and Horkheimer and Adorno's *Dialectic of Enlightenment* (1972).

23. Jeff Wall, Serge Guilbaut, T.J. Clark, et al, "Jeff Wall—Unpublished Interview Transcript," Interview includes Jeff Wall, Serge Guilbaut, T.J. Clark, Claude Ginz, Anne Wagner. Spring 1989. Serge Guilbaut Archives, UBC Campus, Vancouver: 4.

24. Fredric Jameson, "Reflections in Conclusion," *Aesthetics and Politics*, trans. and ed. Ronald Taylor (London: New Left Books, 1977).

25. Michael Fried, "Art and Objecthood" (1967), *Art and Objecthood—Essays and Reviews* (Chicago: University of Chicago Press, 1998): 153.

26. Douglas Crimp, "Pictures," *October* 8 (Spring 1979): 77.

27. "It would be difficult to compile a complete list of those working in this mode

at this time," he says, but "there are a great many, and the number is increasing rapidly" (Coleman: 257). He mentions Les Krims, Duane Michals, Lee Friedlander, Lucas Samaras, Irina Ionesco, Ed Ruscha, William Wegman, Robert Cumming, and Bruce Nauman, among others. A.D. Coleman, "The Directorial Mode: Notes toward a Definition" (1976), *Light Readings: A Photography Critic's Writings 1968–1978* (New York: Oxford University Press, 1979): 250.

28. Hoy mentions Eileen Cowin, Duane Michals, Laurie Simmons, and Sandy Skoglund among others. See Anne Hoy, *Fabrications: Staged, Altered and Appropriated Photographs* (New York: Abbeville Press, 1987): 6.

29. Griselda Pollock, "Screening the Seventies—Sexuality and Representation in Feminist Practice—A Brechtian Perspective, " *Vision and Difference: Femininity, Feminism and the Histories of Art* (London: Routledge, 1988).

30. Elke Town, *Subjects and Subject Matter* (London, ON: London Regional Art Gallery, 1985): 9–10.

31. T.J. Clark, "Modernism, Postmodernism, and Stream," *October* 100 (Spring 2002): 154.

32. Perry Anderson, *The Origins of Postmodernity* (London: Verso, 1998): 88.

33. Denis Diderot, "Discourse on Dramatic Poetry" (1758), *Diderot's Selected Writings*, trans. Derek Coltman, ed. Lester G. Crocker (New York: MacMillan, 1966); Jean-Jacques Rousseau, "Letter to M. D'Alembert on the Theatre" (1758), *Politics and the Arts—Letter to M. D'Alembert on the Theatre*, trans. Allan Bloom (Ithaca: Cornell University Press, 1960); Friedrich Schiller, "Theatre considered as a Moral Institution" (1784), *Friedrich Schiller: Poet of Freedom*, vol. 1 (Washington: The Schiller Institute, 1985).

34. Paul Friedland, *Political Actors: Representative Bodies and Theatricality in the Age of the French Revolution* (Ithaca: Cornell University Press, 2002): 3.

35. For an elaboration on the waning of affect in relation to the history of modernism, see Sianne Ngai, *Ugly Feelings* (Cambridge, MA: Harvard University Press, 2005).

36. Anderson, *The Origins of Postmodernity*: 92.

# Adventures in Reading Landscape

Marina Roy

Margot Leigh Butler, Pages 92–93 from "Swarms in Bee Space,"
*West Coast Line*, vol. 35, no. 2 (Fall 2001)
Courtesy of the artist

Production of difference ... is itself a fundamental activity of capitalism, necessary for its continuous expansion. One might go so far as to say that this desire for difference, authenticity, and our willingness to pay high prices for it (literally), only highlights the degree to which they are already lost to us, thus the power they have over us.

—Miwon Kwon[1]

The spatial representation of capital, most notably in the form of the geographic and social configuration of the city and of an industrially ravaged natural landscape, has figured prominently in the production of contemporary artists and writers in and around Vancouver. Highlighting the manner in which ideology permeates social spaces constituted one of the most important forms of artistic critique,[2] in large part due to the long tradition of landscape associated with the area. For decades the image that dominated the popular Vancouver imagination was that of a majestic landscape, uncontaminated by industry and commerce, while in reality the city had become an important centre for trade.

In the late 1960s, a group of socially conscious artists and writers began to represent landscapes that collapsed the myth of nature and exposed the urban reality of an increasingly globalized economy. Concurrently, an analysis of the production of the "other" took on increased importance due to the need to critique new and historical forms of imperialism and inequality. Artists and writers began to reflect on how their sense of place was deeply affected by the historical and present-day relations between colonizer, colonized, and immigrant. While much of the colonial attitude can be seen as having diminished today, this does not mean that Western constructions of the world do not dominate: their economic ideals have been exported to all parts of the globe, unhindered since the fall of Communism and the new reign of neoliberalism. Embracing difference within today's context (a hybrid and/or marginalized identity and history) too often signifies new opportunities for market expansion rather than a desire to fight for justice and inclusiveness.

A large number of theoretical texts have been published on the subjects of place and identity[3] and in an increasingly consumerist, standardized, and interconnected world, these two terms have become inextricably

linked. Some of the most interesting art being produced today engages with issues of both place and identity, which in turn uncovers the complicated issues related to "belonging" and a desire for recognition within the present world order. Be that as it may, poststructuralist, sociological, ethnographic, and geographic currents of thought have done much to change the face of art and writing, all the while (it could be argued) having minimal political repercussions in staving off the forces of capitalist greed. This shift in consciousness regarding the effectiveness of culture in bringing about positive social change begs the question: how has attention to difference and place been played out in the Vancouver art community, and to what end?

Historically, the idea of British Columbia as a geographic area cut off from the rest of the country has been deeply ingrained in the popular imagination, and has fed into the region's identity as a distinct place where one can retreat into the wilderness. The representation of spectacular landscape dissimulated many anxieties related to its history. Since Canada became a country about 140 years ago, numerous historical markers—conquest and colonization, the dispossession of First Nations by colonizers, a resource extraction-based economy, the settling of Chinese and other immigrant peoples, the cultivation of an exoticized wilderness, and a taste for the sublime and pastoral—can all be cited within a fairly compressed period of art production in British Columbia. Early landscape tradition preferred a "lyrical, romantic, expressionist, subjective and above all a social and bourgeois landscape"[4] associated primarily with Emily Carr's paintings.

By the mid-1970s, the impact of a postmodern culture and global economy was being felt in Vancouver, and the newly sprawling city, with its attendant suburbs and industrial wastelands, began to be represented pictorially through photographic means (only later to be classified under the rubric "photoconceptualism"). With the drastic changes in Vancouver's metropolis, artists identified a cultural and economic shift away from regional and national concerns toward more international ones. And so, as superstructure follows substructure, art shifted from a regional to an international aesthetic.[5] In a more itinerant world and with expanding interdisciplinarity, contact with internationally recognized artists visiting the city had a massive impact on local production.[6] Throughout the 1980s and 1990s, a (mostly) photographic practice, particular to Vancouver but pointing to the global economy, uncovered omissions and instabilities written into Vancouver's local history and geographic identity, opting to portray a more pluralistic social demographic, as well as the deleterious effects of capital as the economy shifted from resource industries to service and information markets. It is interesting to note, however, that while the term "counter-tradition" was used expressly to question this idea of a "Vancouver art," as a way of rejecting "the mythic self-image of Vancouver,"[7] the international recognition that these artists

using the term eventually gained from what is now seen as aggressive pedagogical and self-promotional theorization (employing avant-garde strategies of oppositionality to tradition), ironically resulted in them being known as the "Vancouver School of Photoconceptualism."

By the end of the twentieth century, a new envisioning of the landscape materialized in the work of a younger generation of artists. But while new, this reimagining was not inconsistent with the concerns of local tradition and counter-tradition. I would go so far as to say that the new emphasis on west coast geography occurred because, being what is most distinctive about this place in a consumerist world (e.g., the film and tourist industries), this is chiefly what the global market understands and demands. It is no surprise that much legitimatized art is framed this way today. If an artist's work reflects a sense of belonging to a particular place/culture, however cynical or nondescript that image might be, then it is easier to package. In other words, while nomadism on the biennale and art fair circuit is the reality for successful artists today, this itinerant privilege is, more often than not, dependent on serving up local flavour.

A large number of texts which aimed to introduce the Vancouver scene to national or international audiences begin with a condensed description of the social, cultural, economic, and geographic aspects of the city. I have chosen quotations from two local artist/writers:

> So many photographs of Vancouver picture an ubiquitous nowhere; Vancouver texts often confirm its self-appointed status as a non-place.... Non-places must be a bit like every place. The lion's share of self-reflexive representation of Vancouver have valorized its status as Terminal City, keeping in play all the connotations of that phrase: end-of-the-line hinterland and transnational nexus.... Vancouver emerges as a utopian mixture of radicals and mandarins, disinclined to battle physical and financial colonization and transformation.
>
> —Trevor Mahovsky[8]

> A city on the edge, a "terminal city," Vancouver lies in a region that gave the world grunge, Generation X, the 1990s WTO protests, and cyberpunk (not to mention Pamela Anderson, Bryan Adams, and Microsoft), so it's no surprise that the generation of artists who emerged in the 90s in Vancouver (the slackers) have followed in the globalized footsteps of their seniors, the Vancouver school of photo-conceptualists.
>
> —Clint Burnham[9]

The articles in which these quotations appear were written within three years of one another (both for glossy magazines, one national,

one international), and in both cases a textual snapshot of Vancouver is proposed with what seems like an insider's perspective. Emphasizing the culturally hip and soulless aspects of the city, Vancouver is hyper-fetishized into a brand image.[10] This strategy of introducing the Vancouver art scene using pop-cultural tropes and a last-frontier *topoi* conforms to the reigning discourse around global cities and global cultures that necessitates a distinct identity, a way to culturally validate one's image for international recognition amidst much market competition. (It is Vancouver's image as non-place that tends to attract film production, while majestic mountains, forests, and oceans seduce tourists and future residents.) Both articles also look at the institutionally sanctioned community of artists and the generational construction of an art lineage— the dominant art narrative over the past two decades. The artist-as-intellectual or humanist, and the "slacker" or pop culture-savvy artist, comprise two well-documented successive generations. These categories are prevalent locally as well as internationally, and have precipitated the emergence of like-minded practices. The market demands as much, and in the exclusionary art market of Vancouver, with its handful of collectors and dealers, the competition to be a success is all the more tangible. The Vancouver Art Gallery's *Baja to Vancouver* exhibition[11] embodied precisely this idea of how hip, successful art is framed around locality[12]— as display of difference-as-brand within a world where, due to forces of globalization, a sense of belonging to a distinctive place seems tenuous:

> When first exhibited at Catriona Jeffries Gallery in Vancouver, Terada's [Welcome to Vancouver] sign seemingly poked fun at the way Vancouver artists are often identified, for purposes of commerce and publicity, in terms of a regional brand. (A recent article on Jeffries in *Canadian Art* asserted: "When you collect one of her artists—say, a Ron Terada or a Damian Moppett—you are ostensibly 'collecting Vancouver.'")[13]

As an insular cultural enclave, visual art has a strange economy that portends to resist the globalized capitalist structure (where all aspects of life are commodified), and yet invests in a neatly constructed scene of career success and generational succession, largely a result of the international art market, but also helped along by legitimizing factors at home. As insinuated in the quotation above, commercial art dealers in Vancouver exert a considerable influence on who gets international exposure and how local artists' works are contextualized. For all the talk of freedom from the constraints of vulgar mainstream interests (due to art's codified system of legitimating and reductivist endgame and in-game strategies), and from the strictures of overbearing art theory, so much successful contemporary art manifests a formulaic tendency. In addition to the pre-scribed look of geographic difference in art, one discovers the token use

of self-reflexive investigations of media, art historical precedence, and pop cultural quotation, a hodgepodge of stylized, revisited avant-gardisms within highly consumable works.[14] William Wood relates the phenomenon of "geographical grouping" to the

> ... neoliberal state of affairs where, following 'democratization' and deconstruction of some aspects of its social role and position, the absence of a strong agenda for contemporary art accompanies and serves its self-styled global market-reach and spectacular character in order to supply designer labels that mark packages to be consumed as signs and traded as equity, colluding in the encroachment of administered capital into every aspect of life.[15]

The above quote notwithstanding, there has been much writing which has enlightened the world about the state of Vancouver art and in particular served to (re)affirm the merits of a geographically specific art, while very little has provided a critique of this artistic trajectory and categorization.

According to Jeff Wall, "conceptual art's intellectualism was engendered by young, aspiring artists for whom critical writing was an important practice of self-definition."[16] After two decades of Cold War ideology and the entrenchment of Abstract Expressionism in art schools, the 1960s saw a younger generation of socially conscious artists asking important questions about symbolic cultural capital: in light of the worn-out art criteria, what would constitute the next logical avant-garde manoeuvre? Who could stand as a voice of authority on new artistic paradigms, and how? The availability of conceptual and minimalist artists' writings as a result of a burgeoning art publishing industry was instrumental in turning the tides of art history. Art writing and art criticism were a way for artists to process this paradigm shift in art, through linguistically deciphering the mysteries of difficult avant-garde works for the greater art public.

Starting in the late 1970s, a similar phenomenon occurred in Vancouver. Many artists took up writing in a serious way. In his essay "Radical, Bureaucratic, Melancholic, Schizophrenic: Texts as Community," artist and critic Trevor Mahovsky maps out a discursive, critical, curatorial, and pedagogical community of texts which were not only a "significant contribution to art production and critical thinking in the city," but also "transmit[ted] intellectual and cultural authority and enact[ed] a process of self-legitimation [sic]."[17] Mahovsky's essay traces the textual practices inherent to the legacy of the Vancouver School of Photoconceptualism with finesse and historical accuracy, therefore I will not repeat this well-documented history here. What is important to note, however, is the role that writing played in the construction of this artistic counter-tradition. The model of the artist-

writer-intellectual was instrumental in dictating the terms by which a new consciousness inherent to new forms of production and representation was to be framed. Artists Ian Wallace, Jeff Wall, Ken Lum, and Roy Arden wrote with incredible authority and intellectual rigour about a select group of related practices, creating a tight-knit community of theoretical discourse, resulting in what we now recognize as a movement. Much of the Vancouver School of Photoconceptualism's success, beyond its local context, is dependent on this very important factor: these artist-intellectuals took the theorization of their work into their own hands.[18] According to artist and writer Robert Linsley, the emergence of the photoconceptual pictorial mode was not just "an argument within art history," but an "acting out within art of a broader social struggle"—namely the need to represent to the public the image of the real social and material landscape of British Columbia.[19] There is, of course, a much larger discourse around landscape in Vancouver than just this male-dominant photo-pictorial impulse, but perhaps because these other discourses were not part of an aggressive intertextual community, they have not been represented to such a degree internationally.[20]

If this type of theorization and textual practice has been largely abandoned by a younger generation of artists, it is perhaps because they feel there is no longer any need. While many artists continue to write—writing being an integral part of one's art education[21]—rigorous theorization seems to have largely fallen out of favour internationally. And besides, Vancouver is now highly visible on the art world map, and its writers, curators, critics, and art historians frequently contribute to international publications as "experts" in the field of local art trends and counter-traditions. The danger, however, is that younger artists who are dependent on the critical writing of others can become disillusioned when their time in the spotlight fades (or never arrives), not realizing the potential value in developing a writing practice parallel to an artistic one. Furthermore, writing can be an act of generosity, not confined to one's own success.[22]

Since the mid-1990s, artists have arrived at a new condition under the sign of a "regionalized" international identity. One discovers a marked difference in tone—a more pop-cultural, pastoral, and/or abject aesthetic. If there were a "broader social struggle" apparent in the previous generation's work, a continuation of a humanist modernist project of sorts, in recent times one might discover what artist Jeremy Todd describes as "a kind of informed archaeology of culture."[23] What characterizes the use of landscape today is an impulse to obliterate most references to the city, instead directing one's gaze to the more idyllic or "simulacral" image of nature as backdrop.[24] On the heels of an education heavy in poststructuralist theory, this about-face in agenda could be understood as careerist (i.e. internalizing the correct posturing and formulas to make successful work) or as a defeatist response to the near total domination of everyday life by the "culture industry" (what effect did post-structuralist theory or

politicized art have on changing the world in the 80s and early 90s, any-way?). A major distinguishing feature of this newer generation's work is a turn inward, a nostalgia for the historical moment of one's youth.[25] Much art today flirts with the cool of counter- or subcultures. Investing in youth has become a way of recalling a less complicated moment in time (when the tightening grip of the consumer market had not yet strangled one's options; or is it that it hearkens to the moment when this marketing of youth was becoming more obvious?).[26] This non-participatory point of view has its counterpart in the mass media, which encourages consumers to avoid responsibility, finding that edge of *jouissance* that makes life's alienating effects more bearable. While youth culture played a big part in the utopian imagination and politics of the 1960s, the image of rebellious youth today does little more than sell products.

*6: New Vancouver Modern* at the Morris and Helen Belkin Art Gallery was a groundbreaking exhibition which confirmed the emergence of the so-called "next generation" of Vancouver artists.[27] The cover of the ac-companying exhibition catalogue displays a blurred photograph of RCMP officers and German shepherds surrounded by chain-link fencing and ce-ment barriers taken at the anti-APEC (Asia-Pacific Economic Cooperation) demonstration at the University of British Columbia in November 1997, which became notorious for its police abuses.[28] Unwittingly or not, the image served to highlight a new breed of anti-globalization countercul-tural protest with which these artists are being associated—problematic, considering the reigning cool attitude of the show, lacking in any flagrant socio-political oppositionality, not to mention the overall tempered criti-cality of the texts in the catalogue. More importantly, however, is the fact that two of the catalogue writers maintained that the works exhibited were bereft of "any direct associations with a 'local' tradition," having more in common with "contemporary artists working in places such as London, Los Angeles, and New York."[29] While this might have been the case in 1998, by 2000, issues around landscape and nature re-emerged in full force with the Vancouver Art Gallery exhibition *These Days.*[30]

A stellar example of landscape's re-emergence is Kevin Schmidt's video *Long Beach Led Zep,* first shown at the Contemporary Art Gallery in 2002 and later in the *Hammertown* exhibition at the Fruitmarket Gallery in Edinburgh that year. Schmidt's work treats landscape as a backdrop to leisure activities, and more particularly, to the selling of image.[31] Shot on the west coast of Vancouver Island, the lone figure of the artist as unsung romantic hero was complicated by an overlaying of the contem-porary image of the failed rock-star. The quasi-earnest guitar wailings of Led Zeppelin's "Stairway to Heaven" against the sublime backdrop of Long Beach, BC, at sunset is a particularly humourous take on the idea of the artist as pastoral figure.[32] In an essay in the journal *Public,* poet and essayist Peter Culley discovers many grains of aesthetic resistance and allegiance in the work:

> Kevin Schmidt's *Long Beach Led Zep* attempts to restore to the
> parched discourse of landscape a liberating trace of the sublime in
> its most vulgar sense; that sense, however degraded or symptom-
> atic, that the landscape's beauties are democratically available,
> that Friedrich and the four-wheel drive are trying to access, for
> better or worse, the same place. Neither the aristocratically pristine
> imaginary of the environmentalists nor the virtual service wilderness
> of the tourist industry, Schmidt's Long Beach is public space, freely
> inherited and held in common.... In its combination of theoreti-
> cal rigour and qualified humanism LBLZ enters the increasingly
> elegiac and recuperative discourse that has in recent years emerged
> from the critical asperities of the Vancouver School.... Like his
> colleagues [Kelly Wood and Scott McFarland], Schmidt seems less
> concerned with the rewards of institutional critique than with
> the reclamation of transcendent possibility—however fleeting and
> contingent—from a corrupt culture.[33]

Culley fashions an incredibly seductive text, as much in his use of a
colourful and complex language as in his knowledge of pop culture and
the sublime, and demonstrates a profound understanding of the value
of landscape counter-tradition as it has evolved from the local "canon."
All the same, most viewers need no convincing as to the work's mer-
it, for its thirst for nostalgia combined with the tongue-in-cheek use
of the "Super, natural British Columbia" sublime is near impossible
to assuage.[34]

Distinctive of the exhibition catalogues for *6: New Vancouver Modern*,
*Hammertown*, and *Baja to Vancouver* is that so many of the essays were
written by Vancouver novelists, poets, and essayists.[35] This phenomenon
originated in a fertile relationship between artists and writers that has
existed since the mid-80s. Several elements contributed to this, including
*Vanguard* magazine as a venue for art criticism, literary and art events
taking place at Kootenay School of Writing (KSW); and at artist-run cen-
tres such as Artspeak, the Or Gallery, and the Western Front. As in art
practices, many local writers developed a politically charged poetics that
laid bare the forces of capital at work within representations of the west
coast landscape.

In large part due to the formation of KSW[36] and Artspeak, numerous art-
ist-writer relationships were forged in the latter half of the 1980s. Many
artists and writers participated jointly in lectures and writing workshops
at KSW, as well as in their publications.[37] In *W*, one notices a large num-
ber of writings by artists, including Margot Leigh Butler, Peter Conlin,
Kirsten Forkert, Donato Mancini, and Judy Radul, to name a few. Artspeak,
an artist-run centre known for its commitment to works that investigate

visual art and writing, began as an offshoot of KSW.[38] Artspeak's strong publication record also gave first-time writers and artist-writers a chance to have their work published, and was instrumental in encouraging a *belle-lettrist* type of writing about art (as well as other forms) through the co-presentation of readings, talks, and book launches, as well as their invitation to writers to participate in its publishing program and on its board of directors.

Kevin Schmidt, *Long Beach Led Zep*, 2002
single channel video from DVD, 8 min. 42 sec.
Collection of National Gallery of Canada
Collection of Reid Shier
Latner Collection, Toronto
Collection of Mellisa and Robert Soros, New York
Courtesy of Catriona Jeffries Gallery, Vancouver

In 1988, Artspeak's Director Cate Rimmer asked artists and writers to collaborate on an exhibition entitled *Behind the Sign*. The show resulted in textual, object, and pictorial-based works investigating a variety of socio-political issues by five artist-writer pairings: Roy Arden and Jeff Derksen, Stan Douglas and Deanna Ferguson, Donna Leisen and Calvin Wharton, Sara Leydon and Peter Culley, and Doug Munday and Kathryn MacLeod. Acknowledging the spirit of cross-disciplinarity between artists and writers, the exhibition proved prescient and influential to future artist-writer collaborations. Subverting artistic individualism and disciplinary specificity, and sharing common interests in poststructuralism, local politics, and in the development of new modes of writing and art production (to countermand highly mediated, acculturated, or opportunistic

forms), these artists and writers had come to form an active, close-knit community of ideas.[39]

In the early to mid-1990s, a fertile, more non-professionalized period for art-related writing[40] emerged in Vancouver. Several artists and writers oversaw the publication of *Boo* magazine (1994–1997), including Dan Farrell, Deanna Ferguson, Phillip McCrum, Melinda Mollineaux, and Reid Shier.[41] In the eleven issues that *Boo* published, artists and writers

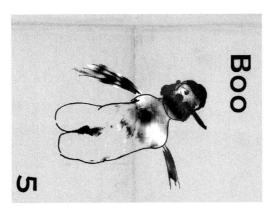

Myfanwy MacLeod, cover of *Boo* magazine #5, 1995

actively wrote about one another, and art reviews and criticism could be found alongside book and film reviews, poetry, letters, and image-text projects. Much of the writing mirrored a growing global perspective on the art world, as well as a heightened awareness of diasporic, hybrid, or pluralistic identities. Quite extraordinary were the lengthy interviews between important writers, curators, and artists, outlining in an informal but highly intellectual manner the development of their respective practices, as well as the history of art/writing communities in Vancouver. A number of articles also addressed the growing number of local exhibitions dealing with the issue of nature and landscape. *Boo* became a site not only for dialogical interaction between art and writing, but also for agonistic debate. Many letters to the editor and full-length articles were full-fledged rebuttals and polemical responses by readers to previous articles and reviews, divulging the publication's textual space as a healthy forum for much needed debate about creative production in Vancouver.

After *Boo* terminated publication in 1997, this community of artists and writers was portrayed one last time in an exhibition of Phillip McCrum's artwork *Tear*.[42] McCrum had made portrait paintings of his friends/peers (many of whom had been active in *Boo*) in the guise of prominent figures from the French Revolution, a kind of homage to a "revolutionary" creative group spirit that existed in Vancouver at that time. The exhibition catalogue brought together writings by many of the artists, curators, and writers portrayed, serving as a kind of complement to the portraits in the exhibition.

Looking back at the 1990s, one cannot help but notice the increase in the volume of writing in an ever-growing number of exhibition catalogues (both glossy and low-budget), and, after the demise of *Vanguard* magazine, occasional art writing appearing in *Boo*, *Last Call* (2001–2002), *Collapse* (1995–2002), *Front* (1989– ), *Yishu* (2002– ), and more recently, *fillip* (2005– ).[43] The literary journals *West Coast Line* (1966– ) and *The Capilano Review* (1972– ) also publish artists' (writing) projects. Keeping an art rag such as *Boo* or *Last Call* up and running in Vancouver is no small feat, and the appearance of new publications over the years has been sporadic and often short-lived, due to the difficulty in securing stable funding. As a result, there are some who believe that there is a dearth of serious art criticism and debate in this city, given the lack of stable venues for critical writing. We live in different times, but this does not mean that great efforts haven't been made to publish intellectually stimulating material; the problem is that recognition of these efforts is depressingly minimal in a time when much of the art public has its sights set elsewhere (on the pulse of international success), adding to the frustration of those trying to create a stimulating community for ideas.

The status of the artist and the nature of artistic discourse in Vancouver have changed significantly since the late 1990s. Gone is the avowal-based, heteroclite writing in publications such as *Boo*. In its place, more "professional" writing about art has become prevalent (for instance, compare *Boo*'s largely local perspective and looser format and style to *Last Call*'s and *fillip*'s greater international scope and more standardized format). What such publications as *Boo*, *Last Call*, and *fillip* do share, however, is institutional independence.[44] While this makes for a less sustainable situation, it can impart more freedom to contributors and editors; with fewer fiscal interests at stake, they can focus on what lacks in terms of most local writing about art—a diversity of perspectives and critical analysis combined with high standards of writing on contemporary issues in art. Be that as it may, art writing in Vancouver today is largely relegated to exhibition catalogues.

Catalogue writing for an art institution, whether public gallery/museum or artist-run centre (ARC), is a curatorially regulated form of writing, and in the end its own interests, as well as those of the artists represented, are being served. For years, the Canada Council for the Arts supported galleries, museums, and ARCs on a project-by-project basis. Since 1998, these institutions secured greater financial assistance through their operational funding for catalogue publications—but in the case of ARCs, this support was only readily available if they had previous experience in producing impressive publications. For instance, under Lorna Brown's directorship, Artspeak developed a distinctive publishing program because of its publishing history and relationship to writing, promoting more creative types of writing about art, as well as alternative catalogue formats. More recently, ARCs have been more successful in securing funding for publications; for

Phillip McCrum, from *A Diagrammatic Interpretation of the French Revolution based on George Lefebvre's The French Revolution: From its Origins to 1793*, 1998
oil paint, modelling paste or plaster on recovered wallpaper
Courtesy of the artist

2) Diderot, Denis
Editor of the Encyclopedia. (Stan Douglas)

8) Roux, Jacques
Demanded the death penalty for hoarders. (Jan Coyle)

9) Marat, Jean Paul
Beloved of the red hats, head of the Circular of Vigilance Committee. (Gerald Creede)

14) Rousseau, Jean Jacques
Romantic. (Peter Culley)

30) Bürger, Gottfried August
Song of reproach, "He who cannot die for Liberty deserves nothing better than chains."
(Rick Ross)

32) Brezé, Henri Évrard, marquis de
Master of ceremonies at the Estates-General, whose order was ignored by the Third Estate.
(Hank Bull)

46) Grimm, Friedrich Melchior
Duellist and friend of Rousseau. (Rory)

47) Orléans, Louis Philippe Joseph
The revolution could make him king. (Michelle Normoyle)

48) Hume, David
Rousseau's close friend. Considered him mad. (William Wood)

instance, the Or Gallery has produced a few anthology-type publications related to its curatorial programming, and the Helen Pitt Gallery is planning a similar venture to supplement its ongoing low-budget publications.

However, if writing about art in Vancouver is increasingly confined to a professional context, a reigning laudatory language could be seen to minimize the instances of critical debate and plurality of perspectives on diverse practices occurring within and *outside* the institutional framework. When language defines artistic production in mostly positive, professionalized terms, critical judgment tends to be withheld, thus diminishing the public's encounter with polemical and epistemological issues related to art. As the publication of catalogues certainly filled a void in terms of local publishing on art, creative writing also emerged to fill in for the lack of art criticism. In large part influenced by the publishing of alternative forms of writing as investigated by Artspeak, public galleries also began promoting this type of art writing by literary writers.

The criticality and historically conscious nature of the writing of Vancouver poets is, in many ways, appropriately suited to the practices of Vancouver artists. The conceptual, complex work of these poets complements the difficult issues and artistic strategies being explored by many Vancouver artists. And it is important to note that this type of writing provides a literary component to the specialized language commonly used by art historians and critics. The poets' literary aptitudes lend symbolic cultural capital, and the art they write about lends them legitimacy as art writers in turn. Much catalogue writing is, of course, produced out of economic necessity (a writer must make a living, after all), hence restricting most art writing to that of laudatory supplement. It is unfortunate that there are not more venues where critical, literary writing about art can be handsomely rewarded. Anyone well-versed in this corpus of Vancouver art-writing must also acknowledge how these writers share an understanding of representations of the social, economic, and aesthetic landscape with local artists.

Both Lisa Robertson and Peter Culley contribute writings to art catalogues and journals (and the occasional review) that reflect their strong interests in a deconstructive language writing about nature and landscape. A return to direct experience, combined with a strong historical understanding of literary genres and a critical historical consciousness of "one's embeddedness in a place," contextualizes their use of lyric and landscape.[45]

Under the name The Office for Soft Architecture, Lisa Robertson has written literary essays for exhibition catalogues in addition to her being an important, prolific local poet. Her piece about fountains in Vancouver, delivered during a panel on the subject of the city and conceptualized during her time working within the context of KSW, provides an example

of critical ideas related to landscape with which both her poetry and es-
says engage:

> Downtown in the economic district, each fountain's site is clandes-
> tinely scooped from the monetary grid, hidden among corporations,
> rather than symbolically radiating a public logic of civic identity
> and access as in Paris or Rome. Here the water features seem gently
> irrelevant, or relevant only as cheerful prosthetics to the atmos-
> phere of the logo.[46]

Robertson's contributions to exhibition catalogues act as more of a
supplement to the artwork—a reaction to the work with her own literary
interests in mind—than as a critical interpretation of the artwork at hand
(while Culley's writing is a more critical meditation on the meaning behind
an artwork, as seen in his text on Kevin Schmidt). Laden with historical re-
search, a sensual and often strange language acts as a space of resistance.
Within the context of Liz Magor's exhibition catalogue, Robertson's essay
meditates on primitive forms of shelter found in nature as a way to ad-
dress the artist's oeuvre:

> Marc-Antoine Laugier, the French architectural theorist writing in
> 1753, posed the shack or hut as the first principle of architecture, the
> idea from which all theory extends.... Laugier tells a simple story:
> the retreat from lucid pleasure to protective opacity, then to willed
> structure. Is architecture a monument to the failure of pastoral uto-
> pia, whose greeny bliss only passes, like a tempest? The shack as first
> principle seems to offer a protection against weather and time.[47]

In his book of poetry *Transnational Muscle Cars*, Jeff Derksen recon-
structs the image of the global urban and natural landscape using a lan-
guage in tension, at once poetic, historical, materialist, philosophical, and
shot through with global statistics:

> The sun glints off the chrome bodies
> of the gondolas of late capitalism
> as they labour up the mountain.
> The mountain is named
> after a commodity. Art has made this
> a nonalienated view. Is that what
> we asked it to do? If "each day" seems
> like a natural fact? And if "what we think
> changes how we act" should art not
> reveal ideology
> rather than naturalize it?[48]

In "Fixed City and Mobile World: Urban Facts and Global Forces in Ken Lum's Art," a catalogue essay for *Ken Lum Works with Photography*, Derksen's writing frames Lum's body of work in the context of urban sprawl and the social tensions, fragmentation, and alienation that result from effects of global capitalist flows. According to Derksen, the built environment of Vancouver and its spatial and social global/local tensions are at the centre of Lum's work:

> His drive is towards a cataloguing of forces, effects, and practices which, arrested, are arranged into a form that gives them materiality and density. His works with photography are about fixity and mobility: the mobility of money, the limited mobility of people and ideas, and the fixity of capital, as well as the photograph as a fixity of these processes.[49]

As is made obvious, it is as an urban geographer and theorizer of globalization that Derksen understands Lum's work rather than through the more habitual discussion of modernist, avant-garde idioms that preoccupy curators, art historians, and critics.

Derksen wrote the essay "Urban Regeneration: Gentrification as Global Urban Strategy" in collaboration with Neil Smith for the book *Stan Douglas: Every Building on 100 West Hastings* in 2003. While no mention is made of Douglas's panoramic photograph of the dilapidating Edwardian buildings on this infamous Vancouver block, the writing provides a critical context from which to view Douglas's work: the history of the Downtown Eastside (DTES) and of urban gentrification, "which evolved as a competitive urban strategy within the global economy." Under the banner of a single artwork, multiple types of research related to this area of the city, as well as the strategies employed by Douglas, are assembled in one publication. The DTES's working-class history and strong grassroots community, its decline due to the effects of de-industrialization and unemployment, the closure of the Woodward's building and the struggle for its renaissance in the form of low-income housing, the high incidence of drug abuse, HIV infection, and the tragedy of the missing sex-trade workers, emerge from the aesthetic strategies of this one photograph.

In 2003, *Stan Douglas: Every Building on 100 West Hastings* shared the City of Vancouver Book Award with Lincoln Clarkes' book of photographic portraits of DTES women, *Heroines*. The two practices could not be more distant in terms of artistic strategy, but it is no coincidence that two books focusing on the Downtown Eastside shared in winning this prize.[50] There have developed many competing, vested interests in the area and pressure from grassroots political organizations and activists has made the future of the DTES and its residents an ongoing political issue for the city. Numerous artists have created work related to the area's architecture and

urban planning, as well as the people living and working there—many
out of opportunism, many out of historical/avant-garde interests, and
many out of genuine concern.

Dissatisfied by the overriding spirit of careerism and product-oriented
practices in the art community, not to mention the growing profession-
ization of artist-run centres, many artists have turned to relational,
interventionist, situated, and participatory art practices, and to alter-
native institutions with which to work. KSW has been one such place;
others have created their own collectives and gallery spaces. For
these artists, writing, teaching, and activism have often been equally
important, as they attempt to develop an ethos of "situated" art pro-
duction and performance:

> let's expand or even explode
>          against the city as information
>
> let's perform an action in an obscure part of town. Let's go
> somewhere where people will barely leave their houses, barely look
> through the windows, only occasionally get into their cars
> and drive away.
> [...]
>                                                    We may
> make no impact, leave no trace. We may never even be part of a
> conversation, barely make a difference in someone's thoughts.
> This is the reverse of the idea that the more central the location
> the better. let's resist the dynamic of centralization that creates
> oases of "urban living" for the privileged and makes the rest of
> the city a nowhere zone, and let's resist the fear of being left out.
> let's work in the nowhere zones. let's be at the wrong place at the
> wrong time.[51]

This excerpt is from a manifesto called "against information" by Kirsten
Forkert and was performed in 2002 at KSW and subsequently published
in W6. Along with being engaged in public interventions and collabora-
tive art practices, and co-founding the collective Counterpublics, Forkert
investigates writing as a central component of her art practice. Frustrated
by the necessity to "make it" within Vancouver's art economy, Counter-
publics is dedicated to the possibility of political consciousness and/or
social change through art; one of its founding principles was the construc-
tion of a "commons" where ideas "outside the rhetoric of official culture"
and "market populism"[52] could be sounded and hashed out. One event
organized by Counterpublics, which engaged the landscape, was a guided
walking tour of the city by writer Stephen Collis, starting in a park off

Commercial Drive in East Vancouver, and ending at the Vancouver Pub-
lic Library downtown. Entitled "Of Blackberries and Libraries, or, Tracings
in the Contemporary Urban Commons," the event took participants past
abandoned and undeveloped sites (many surrounded by the overgrowth
of barbed blackberry bushes), resulting in a discussion around the term
"commons" (from common use of land to intellectual property rights and
media ownership).[53]

In the context of Artspeak's series *Expect Delays* (2002), curated by
Kathleen Ritter, and similar to Counterpublics' walk-and-talk event,
"Spending Time Together" was developed by Forkert as an open meeting
ground where people could participate in a *dérive*-like psycho-geograph-
ical investigation of the city. In keeping with the manifesto "against infor-
mation," the event focused on neglected urban spaces in Vancouver; this
group collectively set out, on foot and by public transportation, to explore
fringe spaces within the city, spaces off the beaten track that had never
been explored by any of the participants. Uncommodifiable as art, and
perhaps barely existing as art to begin with, the conversations that arose
and the experiences recalled by participants became the point of the
work itself. This approach to making art seems to relate to the phenom-
enon that writer and curator Claire Doherty calls a new situationism:

> ... as cultural experience has become recognized as a primary com-
> ponent of urban regeneration, so the roles of artists have become
> redefined as mediators, creative thinkers and agitators, leading to
> increased opportunities for longer-term engagement between an
> artist and a given group of people, design process or situation.[54]

Although an interesting alternative to product-based practices in Vancou-
ver, I'm not sure of the more far-reaching repercussions of this type of work.
In the end, it affects a limited, local, and marginalized group of people.
Participants experience a private event in a given space, and for the in-
dividuals who might inhabit or frequent this space, these participants
stand out as being out of place, even a bit of a spectacle. So what does this
achieve? What could be perceived as a possible "lack" within this type of
art practice seems of no importance to the artist, who states in her mani-
festo: "We may make no impact, leave no trace. We may never even be part
of a conversation, barely make a difference in someone's thoughts."

Margot Butler is an artist and educator whose principles of position-
ality, responsibility, and implicatedness have guided her writing and
artwork, providing it with the critical feminist viewpoint with which to
parse the interested fields of knowledge and cultural production. From
biotechnology to the socio-economic sources of violence against women,
her writing dissects a contemporary landscape that implicates us all: one,
dealing with the changing face of nature, and another, the social land-

scape of class and gender oppression where women are treated as com-modities. For example, her article "The Hero of Heroines" critiques Lincoln Clarkes' photographic project which fetishizes the bodies of women sex-trade workers from the DTES. Her essay "Swarms in Bee Space" is a lucidly written critique of biotechnology, a field that is changing the face of the biological world while being controlled by the hegemonic forces of neo-liberal ideology. Using bees as "figurations who show us how implicated we [have become] in biotechnology," Butler guides us across an historical trajectory, pointing out how these creatures have come to be cultivated by humans across history, and all the implications therein:

> Bees are beings, figurations, metaphors, narrative devices, images, sounds, allegories for model societies, indicators, shapeshifters; and they're important to genetic modification (GM), for not only are they pollinating GM crops and beeing changed in the process, they're crosspollinating GM and non-GM crops, showing up humans' hubris, &c., about 'control and containment' in the shared world, and bees are now themselves beeing genetically modified.[55]

Butler goes on to explore the effects of "bio-property," that is, life forms that have become private property, and the invention of such genetically modified organisms as the Oncomouse and Enviropig. The oppression of both humans and animals is furtively being carried out ostensibly in the name of knowledge and human progress, in which certain beings are seen as expendable or perfectible, victims of so many scientific social "experiments." At the level of society and the natural environment, the world is undergoing a series of "disappearing acts" that are replacing a diversity of life with new simulated life forms and lifestyles.

In 2005, Charo Neville curated the exhibition *Picturing the Downtown Eastside*[56] that brought together community-based art production from and about the Downtown Eastside. The exhibition attempted to bridge the divide between artists of drastically distant habituses (social/class backgrounds). As a participant in this exhibition, Margot Butler's video piece *Other Honey* was installed in the front window overlooking Hastings Street. The video is based on a drive out to the Willie Pickton's farms in Port Coquitlam where Butler was to do research on the missing women of the DTES. There, she came upon a stand selling varieties of honey from different flowers; one of the jars labeled "other honey" was "made by bees who pollinated flowers growing on the Pickton farms."[57] The video combines the image of a woman's arm waving in the air with a subtitled narrative: it recounts how the beekeeper at the honey stand waves in the direction of the Pickton farms, where the bees collected pollen for the "other honey." Using this narrative, the video provides an image of the suburban/rural landscape of Port Coquitlam with its farms and fields of

flowers and bees. It also alludes to the harrowing subtext of the sex-trade workers allegedly killed on Pickton's farms.

In the first issue of *fillip*, critic Clint Burnham, also a participant in the *Picturing the Downtown Eastside* exhibition, responded to the panel discussion that accompanied the exhibition with a piece entitled "No Art After Pickton." The article focuses on the complicated interrelationship between art and the DTES, from the elite artists living outside the DTES, but making work about it, to artist-run centres situated in the area, to the community artists living in the neighbourhood. Burnham questions the attitude that assumes artistic programs for the homeless, addicted, and poor are therapeutic, or somehow help them get ahead in life. Provocative and well-informed, Burnham cannot avoid being cynical about the parallels he sees between the management of human capital by corporate interests and the social "therapeutic" work with DTES residents, both bureaucratically banal and tragic: "It is banal in the sense that you should try to have decent meetings when getting things done ... it is tragic in the sense that it raises the question if it is possible to engage in ways that have not been co-opted (or done better) by the imperialist-capitalist hegemony."[58] In other words, there is a huge gap between the "ontological" crisis of art preoccupying trained artists and the "beneficial experience for street addicts."

This type of polemical debate around what art is, what it could be, how it functions, and how it could be taught and practiced when situated in different fields, is what the Vancouver art community needs. Criticism does not necessarily come up with solutions, and Burnham's certainly does not—although not for want of trying—and the same could be said for the need for alternative venues, practices, and/or collectives. In addition, with the influence of such exhibitions as *Picturing the Downtown Eastside*, and publications like *Stan Douglas: Every Building on 100 West Hastings* and the "Woodsquat" issue of *West Coast Line*, intersecting communities might be able to expand their influence in preventing gentrification from overtaking the DTES area. The fate of the area is still uncertain, especially in light of the construction boom leading up to the Vancouver/ Whistler 2010 Olympics.

Language defines how art is received. It can be instrumental in constructing a seemingly cohesive art scene or movement through its intentional inclusions and exclusions. It can also open art up to new avenues of meaning, perpetuating new ways of thinking, new theories and practices. Critical and imaginative writing is needed for the public to resist and influence an art and culture that continues to be overrun by market interests. A large part of this essay has focused on the textual mechanisms employed to put Vancouver firmly on the art world map—the construction of a lineage, a geographic identity, and generational difference. Vancouver has

produced many great artists, but much of the dominant contemporary art narrative circulating locally and internationally is a construction based on stylistic avant-gardisms, largely devoid of socio-political intentions. Writing and art practices have shifted with the influence of the monopolizing character of global markets, based on privatization of interests and on the market's need for brand identities. Even politicized literary writing practices are in danger of being co-opted for intellectual cachet by institutions. In writing this, it is my hope that more artists will take up critical writing as an activity complementary to art: criticality and generosity of aesthetic judgment means that artists can be active and influential in the formation of new critical work and communities, supporting those artists/curators/writers whose work merits critical attention on grounds other than careerism and fashion.

As Miwon Kwon's quote states at the beginning of this essay, the "desire for difference, authenticity, and our willingness to pay high prices for it (literally), only highlights the degree to which they are already lost to us, thus the power they have over us." Without denying Vancouver its distinct history and demographic, it is important to note that, within the context of globalization, the city shares highly pressing socio-economic and environmental problems with other cities around the world. Alternative local art practices, which address issues related to urban blight and social anomie and inequality using strategies that implicate the viewer or participant, may stand out as "minor," marginalized practices, and they may even be seen to reflect the logic of a service sector economy, nomadic and privileging private or special interest group experiences, affecting only those it targets. However, given the general climate of fashionable artistic production in Vancouver of late, these practices represent the potential to activate a strong intellectual and socio-political agenda within the art community, proposing alternative paths to those that Vancouver's official art narratives have traced, and from which we can choose to diverge.

1. Miwon Kwon, "The Wrong Place," *Contemporary Art from Studio to Situation*, ed. Claire Doherty (London: Black Dog Publishing, 2004): 32.

2. This tendency was inspired by new texts emerging in the late 1960s and throughout the 1970s: Michel Foucault's analyses of how power structures space, as well as texts about lived experience of urban space by Michel de Certeau and Henri Lefebvre. Lefebvre writes: "What is an ideology without a space to which it refers, a space which it describes, whose vocabulary and links it makes use of, and whose code it embodies?... Ideology per se might well be said to consist primarily in a discourse upon social space." *The Production of Space* (London: Blackwell Publishers, 1991 [1974]): 44. For Michel de Certeau, "Denial of the specificity of the place [of production] being the very principle of ideology, all theory is excluded. Even more, by moving discourse into a non-place, ideology forbids history from speaking of society and of death—in other words, from being history." *The Writing of History* (New York: Columbia University Press, 1988 [1975]): 69.

3. Place is a complicated concept to define, especially in its distinction from space. Space has historically been treated as an abstract and limitless entity, while place has a sense of being situated, delimited, and having a historical identity that endures and changes through time. The current interest in place in the field of visual art has recently been theorized in *Place* by Tacita Dean and Jeremy Millar (New York: Thames & Hudson, 2005).

4. Robert Linsley, "Landscape and Literature, in the Art of British Columbia," *Vancouver: Representing the Postmodern City* (Vancouver: Arsenal Pulp Press, 1994): 193.

5. "Remarkably, it is through these 'international' practices [e.g., N.E. Thing Co.] that Vancouver first comes to be represented in art, not through the nature abstractions of the regionalists. Urban reality is represented as a crisis whose local conditions and circumstances represent, in turn, more general crises recognizable almost anywhere. Issues around identity and community surface in a more diverse way in an "international" context, whereas regionalism has no new proposal for negotiating identity." Scott Watson, "6: New Vancouver Modern," *6: New Vancouver Modern* (Vancouver: Morris and Helen Belkin Art Gallery, 1998): 21.

6. For the photoconceptualists, this means the visits to Vancouver of Robert Smithson in 1969 and 1970 and Dan Graham in 1978.

7. Jeff Wall, "Traditions and Counter-traditions in Vancouver Art: A Deeper Background for Ken Lum's Work," *Witte de With: The Lectures 1990* (Rotterdam: Witte de With, 1991): 80.

8. Trevor Mahovsky, "Radical, Bureaucratic, Melancholic, Schizophrenic: Texts as Community," *Canadian Art* (Summer 2001): 50.

9. Clint Burnham, "Aperto: Vancouver," *Flash Art*, November/December 2004: 57.

10. In Burnham's text, perhaps because he is writing for *Flash Art*, Vancouver is closely associated with cultural elements specific to Seattle. The north-south connection between Vancouver and the Western States down to California has been coined Cascadia: "Cascadia—a region meant to unite BC, Washington, and Oregon—may be something of a pipe dream ... but it speaks to one part of the BC psyche." Phillip Resnick, *The Politics of Resentment* (Vancouver: UBC Press, 2000): 19.

11. *Baja to Vancouver: The West Coast and Contemporary Art*, Museum of Contemporary Art, San Diego; CCA Wattis Institute for Contemporary Art, San Francisco; Seattle Art Museum; Vancouver Art Gallery, 2004.

12. While urban realities, multinational and transnational corporations, and the information flows are what bind Vancouver and BC to the rest of the world (hence the need for an internationally viable art), what is valorized increasingly in global culture, and on the art market, is the display of difference in terms of locality.

13. Ralph Rugoff, "The West Coast and Contemporary Art," in *Baja to Vancouver*: 18–19.

14. For more on the subject of the international art market see Julian Stallabrass' *Art Incorporated: The Story of Contemporary Art* (Oxford: Oxford University Press, 2004).

15. William Wood, "The Insufficiency of the World," *Intertidal: Vancouver Art and Artists* (Antwerp/Vancouver: Museum van Hedendaagse Kunst Antwerpen and Morris and Helen Belkin Art Gallery, 2005): 65–66.

16. Jeff Wall, "Marks of Indifference: Aspects of Photography in, or as, Conceptual Art," *Reconsidering the Object of Art 1965-75*, eds. Ann Goldstein and Anne Rorimer (Los Angeles: Museum of Contemporary Art, 1995): 254–255.

17. Mahovsky: 52.

18. Other important writers such as Scott Watson, William Wood, and Robert Linsley contributed invaluable insight and legitimization to the discourse around an urban, de-featured landscape as counter-tradition.

19. Robert Linsley, "Painting and the Social History of British Columbia," *Vancouver Anthology: The Institutional Politics of Art* (Vancouver: Talonbooks, 1991): 235. Also, Miwon Kwon states: "throughout the

twentieth century, the history of avant-garde, 'advanced,' or 'critical' art practices ... can be described as the persistence of a desire to situate art in 'improper' or 'wrong' places. That is, the avant-garde struggle has in part been a kind of spatial politics, to pressure the definition and legitimation of art by locating it elsewhere, in places other than where it 'belongs.'" "The Wrong Place": 41.

20. For example, Jin-me Yoon's work has focused on issues of national and regional identity using the subjects of immigration, racial stereotyping, tourism, nature, and nation. Her series of photographs *Group of Sixty-Seven* (1996) and *Souvenirs of the Self* (1991–2000) and her video and film series *Fugitive (Unbidden)* (2004) investigate the relationship between cultural identity and geographic place. What one may see as disjuncture between race and place speaks to our preconceptions about identity and belonging. Liz Magor's wilderness-inspired sculpture, photographs, and installations conflate a mythically charged local/national landscape (again playing off stereotypes of Canadianness) with a nostalgia that quite often veers into a manic survivalism (hoarding, storing, and hiding of provisions), a seemingly anachronistic symptom that perhaps could be rationalized as a defense mechanism in the face of unstable and volatile capitalist relations.

21. See Howard Singerman, *Art Subjects: Making Artists in the American University* (Berkeley: University of California Press, 1999).

22. For instance, Ron Terada's exhibition *Catalogue* at the Contemporary Art Gallery (2002) came across as a rather cynical gesture resulting in the publication of an expensive catalogue with the help of donors; this was all made possible by the artist's successful career.

23. "In its most degraded forms this may appear as a performative declaration of connoisseurship vis-à-vis earnestly romantic or shrewdly calculated evocations of subcultural marginalia. There is also the possible repetition of structural models which might, through re-contextualization, evacuate originary historical circumstances and socio-political intentions." Jeremy Todd, "Mad Tales: Considering Allegorical Tendencies Now," *Last Call* 1:2 (2001).

24. I am thinking quite literally here of such examples as Shannon Oksanen's film *Spins* (2002), with its fake outdoor winter backdrop, or Evan Lee's panoramic photographs *S. Fraser Way, Surrey, BC, Landscape #1 and #2* (2000). It is also interesting how many works use generic, pastoral or sublime BC landscapes, such as Kevin Schmidt's *Long Beach Led Zep* and Althea Thauberger's *Songstress*.

25. This phenomenon is echoed in the popularity of bad boy/girl culture emerging from Britain (the yBas), as well as the thriving of rock/punk/alternative music, skateboard, surfboard, and graffiti cultural references in art from California and elsewhere.

26. I am thinking here of Steven Shearer's works depicting 1970s teen pop idols.

27. Curated by Scott Watson at the Morris and Helen Belkin Art Gallery, the artists were Geoffrey Farmer, Myfanwy MacLeod, Damian Moppett, Steven Shearer, Ron Terada, and Kelly Wood. Many of these young emerging artists had shown at the Or Gallery in exhibitions curated by Reid Shier just months before. Amongst the reviews/articles of 6 was Ken Lum's critical assessment in *Canadian Art* (Summer 1998): 46–51.

28. Mass pepper-spraying and arrests by RCMP mostly, but police officers also tore

down signs that demanded free speech and democracy, all supposedly due to Prime Minister Jean Chretien's demands to quell protest. The demonstrations stemmed from protesters' resentment of Indonesian dictator Mohamed Suharto's presence at the talks, whose government was known for its human rights abuses.

29. Patrik Andersson and Shannon Oksanen, "Expo Research," *6: New Vancouver Modern* (Vancouver: Morris and Helen Belkin Art Gallery, 1997): 30–31.

30. *These Days*, Vancouver Art Gallery, 2000. Shown alongside artists of the previous generation, many young emerging artists combined the landscape idiom with a pop culture aesthetic. See my review of this show in *Last Call* 1:2 (2001).

31. Kevin Schmidt does a similar thing in his work from 2000, *1984 Chevrolet Caprice Classic Wagon, 94000 kms, Good Condition, Engine Needs Minor Work, $1200 OBO 604 888 3243.*

32. Thomas Crow speaks of "the pastoral contrast between large artistic ambitions and a simultaneous awareness—figured through the surrogate of the child and consciously childish activities—of everyone's limited horizons and modest powers." *Modern Art in the Common Culture* (New Haven, CT: Yale University Press, 1996): 182.

33. Peter Culley, "A Bustle in Your Hedgerow: Long Beach, Led Zeppelin and the West Coast Sublime," *Public* 28 (2003): 108.

34. Shot in natural settings throughout the Victoria area, Althea Thauberger's *Songstress* (2002) showcased young women singing folk, rock, alternative, and new age songs for the camera, traipsing about in nature as creating a self-promotional video. *Songstress* combined the strategies of Gillian Wearing (putting an ad in the newspaper for young vocalists),

Lillith Fair rock video earnestness, and art videos' one-continuous-take aesthetic. See my review on the work, *Canadian Art* (Spring 2003).

35. Douglas Coupland, Peter Culley, Lisa Robertson, and Michael Turner are writers/ poets who have written extensively about Vancouver artists' works.

36. Kootenay School of Writing is a Vancouver writer's collective, or for want of a better name, a writer-run centre, formed in 1984 after the Social Credit government shut down the David Thompson University Centre in Nelson. For a more extended history of KSW, see *Writing Class: The Kootenay School of Writing Anthology*, eds. Andrew Koblucar and Michael Barnholden (Vancouver: New Star Books, 1999).

37. *Writing* (1981–1992); and more recently the web-based magazine *W*: www.kswnet. org/w/

38. Artspeak shared a space with KSW from the gallery's inception into the early 90s. For a history of the KSW/Artspeak relationship, read Nancy Shaw's essay "Expanded Consciousness and Company Types" in *Vancouver Anthology*.

39. For another look at the formation of this artist-writer community in Vancouver, read Reid Shier's essay "Buddies, Pals" in *Intertidal*: 80–89 and Pauline Butling and Susan Rudy, "A Conversation on 'Cultural Poetics' with Jeff Derksen" in *Poets Talk* (Edmonton: University of Alberta Press, 2005): 127–128.

40. I use art-related writing to distinguish it from art criticism proper, which had become much more of a rarity in the city after the demise of *Vanguard*. Many art critics had left to do their PhDs elsewhere, such that more poets, curators, and art historians were filling the gap.

41. Michael Barnholden, Clint Burnham, and Mina Totino also were involved in the publication at different times. *Boo* did not have stable funding, could not pay its contributors, and relied on advertising. It filled a gap within the art community, and was essentially a labour of love for the editors and contributors. The profession of art criticism was unsustainable for most writers in Vancouver and there were very few venues for writing after the demise of *Vanguard* magazine other than *C*, *Parachute*, and *Canadian Art*.

42. Phillip McCrum, *Tear*, Or Gallery in 1998; catalogue published in 2000. Many thanks to William Wood for bringing this publication to my attention in the context of this paper.

43. I exclude discussion of art reviews as printed in *The Georgia Straight, Terminal City*, and the *Vancouver Sun*. The limits of this essay do not give me sufficient space to discuss all forms of writing about art in Vancouver. I have restricted it to art writing and art criticism found in catalogues, journals, and independently published local broadsheets.

44. Although *Last Call* was published through the Morris and Helen Belkin Art Gallery at UBC, edited by Deanna Ferguson and Scott Watson, it did not publish articles or reviews about Belkin shows. Furthermore, it was a free publication and covered the local context substantially.

45. Miriam Nichols, "Urban Landscapes and Dirty Lyrics: Peter Culley and Lisa Robertson," *Public* 26 (2002): 55.

46. Lisa Robertson, *Occasional Work and Seven Walks from the Office of Soft Architecture* (Astoria, OR: Clear Cut Press, 2003): 54–55.

47. Lisa Robertson, "Playing House: A Brief Account of the Idea of a Shack," *Liz Magor* (Toronto/Vancouver: The Power Plant/Vancouver Art Gallery, 2002): 47.

48. Jeff Derksen, "Preface: Jerk" in *Transnational Muscle Cars* (Vancouver: Talonbooks, 2003): 9.

49. *Ken Lum works with photography*, eds. Kitty Scott and Martha Hanna (Ottawa: National Gallery of Canada, 2002): 90.

50. In 2002, the future of the Downtown Eastside had been a hot election issue, due in part to the Woodward's Squat. In September, a number of homeless people and community groups occupied the long-vacant Woodward's building and formed a tent city around the perimeter of the building, demanding more social housing. That same year, Larry Campbell won the mayoral election, largely due to his wish to pursue the "four pillars" approach to Vancouver's drug addiction problem, also that same year, Port Coquitlam pig-farmer Robert Pickton was arrested and charged in the murder of fifteen missing women from the DTES.

51. www.kswnet.org/w/six/w6.pdf: 9.

52. The artist's own words: www.visibleartactivity.com/kirsten/about-kirsten.html

53. The term "the commons" was made popular by Michael Hardt and Antonio Negri in their book *Multitude: War and Democracy in the Age of Empire* (New York: Penguin Press, 2004).

54. *Contemporary Art From Studio to Situation*: 10.

55. *West Coast Line* 35:2 (Fall 2001): 75.

56. Exhibition contributors included Rita Beiks, Rebecca Belmore, Clint Burnham, Margot Leigh Butler, Desmedia, Stan Douglas, Arni Haraldsson, Hermes, Sharon Kravitz, Paul St. Germain, and Susan Stewart.

57. Words from the video's subtitles.

58. *fillip*, 1: 1: 3.

*The author would like to thank William Wood, Deanna Ferguson, Lorna Brown, and Phillip McCrum for their insight while writing this essay.*

# Specific Objects and Social Subjects: Industrial Facture and the Production of Polemics in Vancouver

Tim Lee

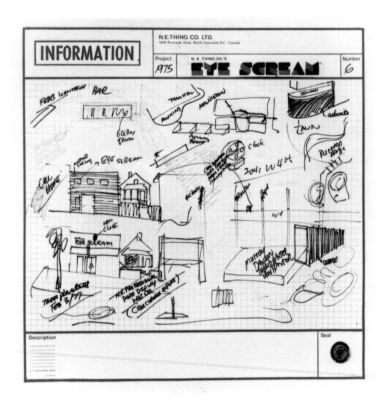

N.E. Thing Co., from *Another 2 Projects: People/Language & Eye Scream Restaurant*,
1977-1978, Vancouver Art Gallery
Photo: Robert Keziere, Vancouver Art Gallery Archives

I.

In 1979, Stan Douglas sat in a Vancouver School of Art classroom while his instructor Iain Baxter held up a phone book and said: "The artist's most important tool is not the pencil but the Yellow Pages." Upon making his statement, Baxter abruptly dropped the phone book on the table with an emphatic thud, a dramatic effect, no doubt, that was meant to give sonorous authority to his claim.[1] And it could be assumed that he should know, because he, along with his wife Ingrid, were listed in the phone book not as persons, or artists, or educators, but as a business known as N.E. Thing Co. (NETCO).

NETCO, incorporated in 1969, was instrumental in helping to inaugurate an artistic practice that reconfigured business and bureaucratic models as an unconventional source for contemporary art-making. Along with running the Eye Scream Restaurant (1977), NETCO operated a professional photography lab, designed corporate logos, participated as members of the Vancouver Board of Trade, and acted as sponsors of a pee-wee hockey team.[2] Though occupying the form of a company, these activities were nonetheless situated as art, and derived from a decidedly expanded definition that would set a variegated example of art production in Vancouver. While both Iain and Ingrid Baxter taught, and saw education as a playful way of collapsing the distinctions between art and daily life, the implication of Iain Baxter's pedagogical line took on a certain clarity of its own, particularly in the minds of a generation of younger artists such as Stan Douglas; in that an artist need not draw a line with a pencil to produce a work of art, but instead, could simply dial up a commercial fabricator to make it for him.

Donald Judd, of course, was another artist who made a professional artistic practice out of having his work commercially produced. Beginning his practice in the 1960s, Judd's minimalist boxes took on a slick and polished patina that was decidedly more industrial than artisanal, and offered a precursor to the Baxters' hands-off levity:

> A work needs only to be interesting. Most works finally have one quality ... the thing as a whole, its quality as a whole, is what is interesting.[3]

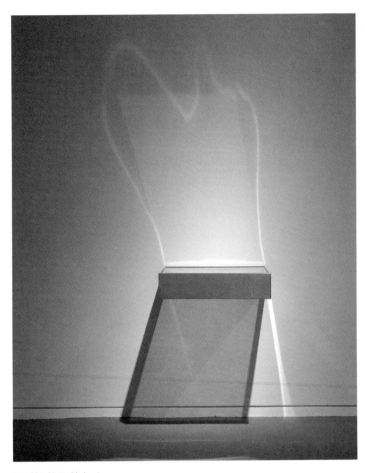

Donald Judd, *Untitled*, 1965
brass and Plexiglas
Collection of Vancouver Art Gallery, Estate of Dorothy B. Austin, VAG 85.29
Photo: Teresa Healy, Vancouver Art Gallery

Commonly misread, complicated by its own significance, and displaced by future criticism, Donald Judd's much-discussed essay "Specific Objects" is often confused as a dogmatic tract archly pronouncing the hard-edged virtues of minimalism—at the expense of the hand-bound traditions of high modernism—and not understood as a complex survey that elaborated on certain aspects of art-making at the time. Describing the "specific object" as a hybrid form that existed somewhere between painting and sculpture, the main assertion of Judd's position—similar to Frank Stella's dictum, "What you see is what you see"—is that a visual understanding of an autonomous art object could be made commensurate with its bare means of material support. The notion of comprehending art through the empirical instruments that constitute its very being is a modernist one, but the overriding distinction that Judd brings is the possibility that a "specific object" could be produced not by the traditional processes and materials of a beaux-arts academy, but through a wide array of new materials that in turn could offer up a new range of artistic potentials.[4] As a guiding principle for a new kind of art—a literal and self-evident art consisting of materials like plastic, Plexiglas, shiny metals, and enamel —new materials were given emphasis by new processes that led to a new aesthetic of art that was invariably industrial. All of this produced an enormous shift; with art objects now consisting of non-traditional (yet still illusory) materials, the move from high modernist and artisanal *madeness* toward commercial and industrial *facture* helped inaugurate an open and expansive field of art production that located itself not in the atelier confines of the individual artist, but in the mechanized factories, tech labs, and business ventures of modern commerce.

Much art produced in Vancouver over the past few decades has followed this paradigm, ranging from the commercial/state/information agency aesthetic of NETCO. to Ron Terada's neo-pop replicas of public signage and Myfanwy MacLeod's manufactured monuments of an anxious self. Rodney Graham's power-driven spectacles of nature also figure here,[5] as do his enigmatic *Freud Sculptures* (1986–), which comically insert neuroticism and the unconscious into Judd's dryly inflected, machine-tooled forms. Among other things, Graham's canny version of a sculptural joke prefigures an interesting model. Asserting itself almost as a local artistic template, Judd's virtues of wholeness, new materials, and perceptual *interest* through industrially produced art has become a central artistic strategy continually re-attributed in this city by a number of artists. Held in certain regard, Judd's perfect, factory-made "specific object" (like that of other minimalist artists such as Robert Morris) has somehow sustained itself as an operative local standard. The fact that much of the work produced in this city "looks good" is matched by an even more thorough sense of professionalism. Meticulously thought out, schematically planned, and then farmed out for fabrication, the overwhelming sense of resourcefulness and industrious thinking on the part of Vancouver artists

Myfanwy MacLeod, *My Idea of Fun*, 1997
custom inflatable with fan unit
Collection of Vancouver Art Gallery
Courtesy of Catriona Jeffries Gallery, Vancouver

has somehow hinged the expert look of the work with a keen sense of formal and intellectual rigor: slick boxes made by even slicker artists. And from today's perspective, the 1960s modernist urge for complete formal autonomy, coupled with the levity of having the work professionally produced, is not only seen as emblematic of a standard, but accepted as a classic orthodoxy.

Differences, however, accrue, and a contingent byproduct of the new hard-edged and pre-stressed norm is that the professed autonomy of what Judd termed "the thing as a whole" might latently emphasize a recognition of the formal over any potential reading of the social. Haphazardly, Judd merely implied social commentary by having his works fabricated without having to critically address aspects of labour, capital, and economy on which the infrastructure of his works were based. Irreducible and devoid of polemical content, critics promptly recognized the exhibitionism of these works as a symptom of social reduction towards the mystified state of a commodity soliciting fetishization—in other words: *specific objects* without social purpose.[6]

All of which brings into question the state of manufactured art today. By now, we know the values imparted by "Specific Objects" as much as we are aware of its conceit. Artists everywhere have since attempted to interrogate minimal art's problematics while retaining its look and central approaches, and further adapt its principle of perceptual interest through the *döppelganger* strategies of pop and conceptualism.[7] Locally, at least, the discontinuity between the severe perfectionism of fetish objects and an almost casual disregard for polemic has been seen as a potentially redeemable gap enabled by a "counter-tradition" of formal completeness coupled with social responsibility—and the problematic split that existed between industrial facture and social thinking has become bound by a grand praxis that deliberately conjoins manufactured process with political content. This new belief, however, can bring new complexities, all of which arise through a questioning of how, during the process of commercial production, can artworks simultaneously critique the manner in which social meaning is produced and advance commentary on the vexed relationship between artistic production and polemics? The works I examine here wrestle with the double-bind between facture and responsibility through an awareness that can be described as not just plainly introspective but entirely self-conscious.

The enduring effect of various contestations, challenges, and differences of opinion surrounding not just "Specific Objects" but the entire genre of minimalism would, since its inception, continue to accelerate, refract, and grow, and through the continuing debate gradually transform Judd's essay into the wrought proportions of a manifesto.[8] Yet what remains is the more general truth that Judd wrote "Specific Objects" under the more modest auspices of a survey rather than a policy platform—a motivation signaled almost entirely by his interest as an artist.[9] Similar to

Judd, the directive of thinking about how other artists think about making art is crucial for this essay and should be read—like Judd's original article —not as a treatise but rather as an investigative survey on a certain aspect of art production in the city.

II.

With a relatively short tradition of art situated around the subject of the city (and its subsequent drift into the suburbs/desert), historically, the relationship between subjectivity and subject in Vancouver has found a model in the twin archetypes of Robert Smithson and Dan Graham. Both of these American artists offer comprehensive visions on the intersections between a range of subject matter (for instance, the dialectic from nature to city, the aesthetic program of high minimalism, and fragmentary states of consciousness) and its representations through photography and journalism. Omniscience, and the prismatic thinking involving a myriad array of subjects, is key.[10] Scott Watson's 1991 essay "Discovering the Defeatured Landscape" explains how the trajectory of local practice both amalgamates and readapts the ideas of Smithson and Graham, and follows through on an accelerated path of artistic expertise split in two dimensions: the pictorial and the polemical.[11] Watson deftly summarizes the unruly path toward a "local and official academic style," and charts the development of what he calls an "urban semiotic" by examining how pictorial depictions of the landscape become progressively aestheticized through photographic technical mastery, and how a new-found largesse of scale—achieved through large-format commercial techniques— attaches its formalizing will to a painterly rhetoric and an increasingly politicized subjectivity.

This shift from a fragmentary and throwaway style—born of the photojournalism in both Smithson's "A Tour of the Monuments of Passaic" and Graham's "Homes for America," and further regenerated locally in Ian Wallace's *Magazine Piece* and Jeff Wall's *Landscape Manual*—can be described as an aesthetic leap from the montaged and random toward the more masterly expressions found in Wallace and Wall's later work, and as a shift of the formal made concurrent with a growing omniscience of consciousness.[12] In effect, the making of large pictures might demand a more grand philosophical perspective, and Watson identifies the voice emanating from these photographic constructions, which depict the social realities of the defeatured landscape, as both mournful and authoritative; and further intoned by a world-view that is increasingly pessimistic.

Omniscience, melancholy, and doubt are drives that combine to form a certain pre-eminence in the work of Stan Douglas. The common consensus on Douglas's work is that he consistently succeeds in envisioning a strange perspective on the terrible beauty of things. This contradiction

between uncommonly stunning pictures and the vulgar truths they represent appears frequently in his work, and exemplifies the socio-aesthetic thinking behind Douglas's incredibly complex world-view. By turns, his analytic approach entails a rigorous interrogation of an image's aesthetic function: in particular, how visual representations are created and culturally received; how they develop into what we know as genres; and how genres, in turn, emerge as systems of representation that are ideological.[13]

Stan Douglas, *Every Building on 100 West Hastings*, 2001
c-print
Courtesy of the artist and David Zwirner, New York

The more general idea is that every system must emerge from a context, and the various contexts that provide illustrative case histories for Douglas's fieldwork are many. Since 1985, when he first exhibited his photograph—the split-and-unified montage of *Panoramic Rotunda*—Douglas has given acute vision to the twentieth century's far-flung and fractured meta-narratives: 1968 Paris and the free jazz movement in *Hors Champs* (1992); Potsdam *Schrebergärtens* and the uncanny in *Der Sandmann* (1995); urban blight and the gothic in *Le Detroit* (2000); labour and low-income housing in *Win, Place or Show* (1998); the oil industry and economic globalization in *Journey Into Fear* (2002); and an ongoing fascination with repressed and marginalized histories that exist in many of his other photographs, films, and video works.

Sad stories all. That alienation and melancholy are such persistent themes in much Vancouver art, and especially in Douglas's, underlines the dual affect modernity has in disenfranchising a segment of society and inflicting a melancholic subjectivity—that may or may not be the artist's own. And indeed, Douglas's *Every Building on 100 West Hastings* (2001) has the odd effect of providing an absorbing perspective of a street weighted with a palpable sense of despondency. Ineffable, melancholic, beautiful: the range of these interpretive moods has a strangely mirroric relationship to the compacted simultaneity of multiple perspectives condensed into one single, delirious vista. The general experience of viewing the photo could be said to look right but feel wrong. The process of taking twenty-one separate images of a single block on a street in the Downtown Eastside and unifying them in one seamless picture does indeed produce a spectacular effect, and its status as high formal composition would seem to elaborate on a local tradition of pictorial mastery and polemical interest

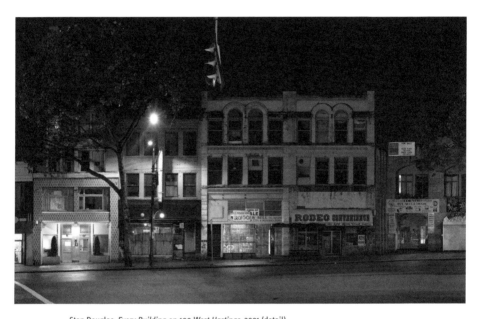

Stan Douglas, *Every Building on 100 West Hastings*, 2001 (detail)
c-print
Courtesy of the artist and David Zwirner, New York

through the commercial tropes of highly aestheticized digital technology. Yet this seamlessness, so integral to the panorama's bravura dimensions, is what I want to single out as a rarity when compared to much of Douglas's other work—its formal function does not reveal the nature of its facture through rupture, but rather, through the implausibility of a view that could only be made possible through deceptive montage. By comparison, what makes *Every Building on 100 West Hastings* an aberrant example is that Douglas usually succeeds in his work by achieving the opposite; by locating a genre, identifying its system of representation, and doubling its convention of display in an elaborate effort to reveal its duplicitous structure—the revealing of the seams as a sort of upending of a closed system. With this, the process of doubling in Douglas's work could be understood as a process of disclosure—the underlying strategy is that we first have to be confused in order to better understand. The fact that this systemic procedure continually repeats itself as an artistic strategy is an indication of how Douglas perceives the standard practices of traditional media to be taken for granted, and how our responses to these complex systems are non-reflexive, normative, and given.

Significantly, the upending of conventional viewing is motivated by the notion that disorientation can become an unconventional route for understanding; and like the perspectival displacements inherent in the film and architectural work of Dan Graham, Douglas's response is to effectively draw attention to an influx of disturbing processes (with the formal acting as an allegory for the social) by making a spectacle of it.[14] And indeed, it is the inverse of spectacle that Douglas attempts to make—a process that paradoxically aims to contradict the contradictions of its facture. In other words—and this could generally describe the impetus of all of his work—the artist will follow a system of representation and exaggerate it in the hopes of revealing its duplicity. We recognize the idioms of Douglas's work simply because we recognize them as historical genres, but sometimes our identification crosses divergent areas and produces a misrecognition that we must negotiate.

Misrecognition, particularly in Vancouver, is something weirdly conventional enough to become ordinary. The all-too-common joke with regard to film and television production in the city is that Vancouver always finds itself playing a city other than itself. This, of course, contributes to the postmodern schizophrenia of recognizing certain landmarks and locations as someplace else. Yet the logic of misrecognition also plays a role in contorting our understanding of the multiple genres that *Every Building on 100 West Hastings* can represent. Whether identified within the confines of art, cinema, or commerce, Douglas designates a reading of types in his picture by offering wry commentary on the very mobility of these recognitions; and representative of the complex entanglements between varying idioms, the templates of commercial and artistic practice for *Every Building on 100 West Hastings* is indeed varied.

One of the professional personae that Douglas assumes with the photo is probably the most indicative of his practice in general. Acting as film producer/director/cinematographer, Douglas makes his photograph by treating the location of the public street as a closed film set—making the elaborate effort to block off road access, rig the lighting, and set up the camera.[15] A highly structured set-up, much closer to professional film production than traditional art making or documentary photography, resulted in a picture highly descriptive of cinema: the effects of lambent, cinematic lighting in concord with the even regularity of the street-lights objectified the street with an eerily detached clarity while making the block an anonymous site of a media-generated spectacle. As such, Douglas's work echoes the illusory power of television and movies that induces misrecognition; a blinding mechanism of sorts, highly symbolic of the prowess commercial re-visualizations have in yielding fact towards fiction.[16] This diversion of attention through spectacle—both so powerful and so convincing—has the potential to mask the localized history of the street while imbuing the locale with a transcendent aura. Yet the Hollywood treatment of Vancouver as an anonymous any-city-anywhere is thwarted by the explicit details of the picture and specificity of the title. With this, *Every Building on 100 West Hastings* paradoxically upends this fake recognition of Vancouver acting as a municipal stand-in, while still deferring the reference of the street toward someplace else.

Thus, from Vancouver to Los Angeles, and a traversal accommodated by a title that immediately makes purposeful art historical reference to Ed Ruscha's *Every Building on the Sunset Strip* (1966)—a deadpan, elongated photo-book portrait of the famous LA thoroughfare. Whereas Ruscha's dry, conceptual art template proffered a nonsense vision with a totalizing perspective, its blank archetype offers itself up to Douglas as a model to be relativized. What we see in comparison is a series of transformations, both formal and social: Ruscha's project, in its seeming randomness and its de-skilled amateurism coupled with asocial commentary, offers no *obvious* means of legitimacy beyond its own anti-aesthetic production. Both poorly photographed and showing us everything while revealing nothing, it remains—thirty years later—difficult to parse any deliberate meaning of what remains a compellingly absurd enterprise.[17] Yet this lack of social and aesthetic connectedness that makes Ruscha's work such an ostensible abstraction is actively transformed by Douglas's highly formalized and more directly socially engaged version. If the action and meaning of *Every Building on Sunset Strip* could be qualified as deferred—and this marks the critical value of Ruscha's practice—*Every Building on 100 West Hastings* is significant for its own sense of determination.

This shift from a detached to an invested practice also signals a deeper renovation in subjectivity. The indifferent "phantom producer" of Ed Ruscha, operating at the edge of an artistic milieu (as in *Real Estate Opportunities*, for example), moves toward the more full-fledged status of "professional

Stan Douglas, *Panoramic Rotunda* (second version), 1984–86
12 black & white photographs, wood, hardware
Courtesy of the artist and David Zwirner, New York
Photo: Robert Keziere

producer" embodied by Douglas.[18] By turns, the variants of this persona take on the guises of various commercial occupations, one of which is the real estate speculator—similarly to Ruscha—as a surveyor who tracks the urban landscape photographing empty lots and vacant buildings, venturing on its capital worth and potential economic future. By comparison, the implication of Ruscha's assumed subjectivity as a commercial arbiter is made clearly visible in Douglas's picture. In *Every Building on 100 West Hastings*, six of real estate agent Fred Yuen's "For Sale" signs dot the block as a constantly reappearing formal device connecting the horizontal landscape. Acting as both a pictorial element and a common marker of economic speculation, Yuen's repeating red signs make it possible to imagine the panorama as emanating from the provisional gaze of a real estate agent: looking becomes surveying, or, so much for the spectacle of urban blight—real estate never sleeps.

A quick perspectival switch, then, from the reflections on pictorial geometry to that of the passage of time, and a way of seeing that picks up on a Robert Smithson-like mnemonic device. Viewing the locale of Hastings Street through the process of entropy: neighbourhoods are built, fall, and are then subject to future economic speculation. One of Smithson's more famous metaphors describes the construction site as "a ruin in reverse," an idea that parsed the inevitability of buildings on a long, slow, and eventual decline towards disintegration. And indeed, the speculative economic value the Hastings block currently represents is somewhere between gentrification and poverty. Yet, the state that the block of 100 West Hastings currently represents is not one of final catastrophe—far from it—but its in-progress status signals yet another stage of development and degeneration.

Perhaps appropriately, the terminal, deadpan gaze of Ruscha's real estate speculator—here in *Every Building on 100 West Hastings*, embodied in the signs of Fred Yuen—couples with the persona of the filmmaker to provide subjective variants of the "professional producer" that Douglas means to mimic and efface. And certainly, the term "professional producer" connotes a certain stoicism on its own; in particular, a dry and calculated coldness seemingly at odds with the humanist empathies of loss and melancholy. This, in effect, is a key contradictory measure of Douglas's practice—of making a spectacle in order to undo our normal apprehension of it. There is the difficulty in negotiating the objectivism of the anonymous producer versus the subjectivity of the artist; the two would seem to be traditionally at odds, with the latter trumping the former, yet Douglas has made it a point to foreground the historical anonymity of media practices at the expense of his own artistic position. As Douglas has notably asserted:

The camera is inflected by me but it presents much more than me, even though I put this thing together and I take responsibility for it. How I might express myself is not very interesting at all. I want

to talk about the possibilities of meaning that these forms and situations present, rather than talking about myself.[19]

Douglas's statement is generous. By effectively effacing his own position in order to provoke awareness in his audience, he espouses a type of liberal humanism that aims to generate ethical discourse through rational thinking. Yet to discourage a reading of an "I" in his work is something that, in fairness, could prompt a dimension of speculation upon the imperceptible ways in which the artist might make his presence visible. A speculation, which in turn, might also emanate from the similar complexity of trying to position Douglas's exact relationship with his subjects: subjects that are, for better or worse, disembodied. As such, looking at how the artist represents people provokes a line of inquiry that becomes ever more complicated by its realizations. The project of exposing artifice in order to make the viewer aware of its construction, is also a means of exposure that is troubling and hard to define. And given the manner in which the artist will dissolve his self in order to better communicate with others, Douglas's elaborate efforts at communication and understanding nonetheless exist in the noble humanist tradition that is oddly contrasted by the very means in which viewers might empathize.

In strange ways, *Every Building on 100 West Hastings* offers its aesthetic significance by binding the seamlessness of the panoramic composition of a street with the erasure of its inhabitants. The efficacy of human disembodiment is both a salient feature and consistent measure in much of Douglas's photographic work. A random survey of his photos of Potsdam, Detroit, and Vancouver would affirm that the presence of people is almost entirely intangible; what we are given instead are traces and symbols of, and stand-ins for, activity. The conventions of Hollywood film, documentary, and objectivist photography assert themselves again as potential models of explanation for this phenomena. The artist's aim to transform and reorganize the audience's reception of these cultural forms comes, in large part, through a corroborative impetus to expose the discontinuity that can exist between human presence and the precise values of modern technology that dominate them. For Douglas, the aesthetic pleasures of disembodiment serve a particular role as a found strategy with potentially profound historical repercussions, as the visible lack of people is meant to direct critical attention toward other discreet and less literal facets of past human presence (such as the archaeological rock markings in Nootka Sound, or the run-down, derelict buildings in Detroit).

The process of thinking about this particular approach—which invokes the parables offered by disembodiment—is certainly complex. It is, in both its formal reach and philosophical extent, a tricky means of negotiating meaning that is as convoluted as the work is elaborate. And again, the foregrounding of the complexity of the work's facture—in its site location, its set-up and composition, and erasure of its inhabitants—

declares the potential knowledge that can be gleaned from the intrica-
cies of its system. The situation that presents itself is certainly formal. Yet
oddly enough, if the technology of Douglas's panorama is made apparent
through the invisibility of its facture, an emphasis on this surfeit of perfec-
tion—embedded in the very seamlessness of the picture—is also the very
detail that unerringly pronounces the hard-edged stringencies of its for-
malism, and its reception as a flawlessly shot and rendered photograph.

The foregrounding of formalism in *Every Building on 100 West Hastings*
works, in a circuitous way, toward offering an askance explanation of the
absence of people in the picture. A general survey into both how actors
are present in the Douglas's videos and how people are absent from
his photographs might, for instance, reveal a specific type of treatment
that emphasizes the use of people as mere formal props subject to some
sort of representative system. For example, the arrangement of actors
in *Win, Place or Show* and *Journey into Fear* is such that their perfor-
mances are not only subject to the stage and editorial directions of the
artist, but "randomized" beyond all human control by a computer as if
they were caught in an unforgiving mechanical loop—a nominal push,
of sorts, beyond Sol LeWitt's dictum that "the idea becomes the machine
that makes the art."[20] This process is certainly conspicuous, for asserting a
high degree of determination in the initial stages of the works' production
and then yielding final control to the computer, the whole routine seems
almost non-human—but it works. This conscious decision—to make art
like a machine—indexes a high degree of formal control that is not only
central to Douglas's practice, but also integral to his persona as a "profes-
sional producer." The functional centre of the Hastings photo—signaled
in the erasure of the seams—exemplifies this formalizing will, while also
indexing a similar logic of absence. That fissures, like individuals, are pain-
stakingly and purposefully wiped out, collapses the distinctions of both as
mere pictorial elements, leading one to believe that the presence of either
would be seen as annoying aesthetic distractions. This formal practicality
is indeed jarring, and leads to parallel questions on why the artist might
not tolerate the spontaneous presence of people in his work, and the
ambiguity of how the unstructured presence of human beings might always
be trumped by the purposeful need for an austere formalism.

All of which points to the great contradiction in Douglas's practice, a
double-bind between a stringent formalism and the production of a po-
lemic that posits, ironically enough, that a will to control the social lives
of people is a project of bad faith that will inevitably lead to failure. It is
this paradox that is so compelling and perplexing; to arouse questions
regarding how an aesthetic control of people can function as allegory
for its political dimension, and how this imperative can be envisioned
in a manner in which the artist will use non-humanist strategies for lib-
eral humanist purposes. The twist—and it may be, appropriately, both
a Hitchcockian and Warholian one—is such that the artist will produce

art like a machine in order for us to think for ourselves. It may be that we have to negotiate this conflict between a rigid order and a free will so that we can generate meaning on our own. Still, these are questions that arise from how the artist's will to disappear into the intricacies of a system might assign culpability to the very ways and means of these representative systems, while not assuming the same responsibility for himself. Once again, if it's "pay attention to the system and not the artist," it's because the problems of the system warrant attention, and the artist prefers to remain an anonymous witness.

This position is, certainly, a cold one, partly because it is so distant it can only offer a logic of overarching reason instead of commiserative empathy. Yet, however challenging and disturbing this viewpoint may be for us, Douglas's reluctance to become identified with his subjects, his refusal to offer a wholesale plan for social transformation, his steady insistence that he does not have a program, and his resolve to produce a perfectly engineered art, could be understood as the prudence of an artist who recognizes the potential dangers that subjectivity may pose when it offers to become part of the literature. And while Douglas's disposition borders on an austere absence, the approach of artist Ken Lum is known for being quite the opposite: most notably, for being qualitatively personal, and using the look and finish of industrial facture to theatricize a quotient of emotional pain. Douglas's determination through mechanical observation, then, offers a productive contrast with the idiosyncratic stance assumed by Lum, who brings a patently more personal and biographical motivation to his practice.

III.

In a shift from one artist who avoids his authorial presence to another who asserts it, Ken Lum's autobiography plays a major role in his practice, operating both as a showcased private history and the vital source for what has been regarded as an authoritative subjectivity meant to reverberate with a wider public. Working, in equally accepted and contested measures, as one subjected subject who narrates the lives of subjected others, Lum continues a complex project of relocating his lived experience through a series of broad social observances that often re-imagine an array of private stories and narrative scenarios with a fixed and common tenor. None of this comes without some controversy. In the catalogue for his survey exhibition organized by the Winnipeg Art Gallery in 1990, Lum provided a series of statements that intimately detail the highly personal circumstances from which his work emanates. Captioning the series of works they are titled after, his texts "On Portrait Logos," "On Furniture Sculptures," and "On Language Paintings" respectfully declaim a painfully rendered anecdote, a poignant reminiscence, and a thoughtful observance that cast the artist

in an opaque and subjective light. Featuring stories and reflections that de-
scribe Lum's grandfather Lum Nin working as a "coolie" for the Canadian
Pacific Railway, as well as Lum's catalogue-inspired childhood fantasies of
redecorating his family's home, and his later international sojourns around
nomadic neighbourhoods in major cities, these performative texts combine
to offer a forthright portrait of what is considered by Jeff Wall as Lum's au-
thentic and complex subjectivity.[21]

Lum's statements, along with "4 Essays on Ken Lum," a lengthy tract
written by Wall and also included in the exhibition catalogue, have helped
typify the candidly plainspoken and academically discursive halves of
the artist as subjective hybrids of a singular whole. While Lum's auto-
biography provides his background as crucial knowledge, it also serves
as a literal (known) and allegorical (displaced) text that unambiguously
augments the critical tropes of his subjects (i.e. nomadism, placeless-
ness, and modernity) with special urgency. Concordant with this, Wall's
text—as simultaneously academic, personal, rigorous, speculative, and
discursive—provided the mutual function of developing a masterly in-
terpretation of his former student and his work, while also positioning
himself as the teacher who has schooled his novice learner with all the
necessary accoutrements of the social and historical avant-garde.[22] Key
to this is the contention to the establishment of a critical reflection of the
artist as the "subject who has survived subjection."[23]

Through a remarkably intricate and varied body of work, Lum has per-
sistently played off the imagined distance of personal subjectivity from
social commentary and, in turn, from the artistic avant-garde through
fabricated artworks that orient critical attention to socio-political-formal
conditions that envelop them all. It is these mixed identifications in Lum's
work that inspires such curiosity—by turns, it is furniture you can't sit on,
paintings that look like signs, and signs that look like paintings. And if,
as viewers, our sense of the bewilderment surrounding the first or sec-
ond glance is provoked, it's only because the artist has been so adept at
prompting the minor shock that comes when real objects are reconfig-
ured as sudden abstractions, and when useful objects are transformed
into useless art.[24] Yet—like the back-and-forth confusions in viewing
Douglas's work—frustration can often lead to reflection; and through the
repeatedly bizarre configurations of the work—abstract, corporate lo-
gos abutting generic portrait photographs and manufactured glossy text
paintings—it seems that the artist can be just as addled by the condi-
tions surrounding his work as his viewers. In strange yet perceptive ways,
Lum is keen on having our incomprehension mirror his own uncertainty
about the vexed relationship that divides social experience from the
formal values of contemporary art. The dialectic that operates on many
levels—between the "I" of personal subjectivity and the "we" induced
not only by the social contract of a post-industrial democratic society, but
also by the potential distance social meaning has from the high genres of

art—culminating in a jarring and anxious response that for Lum befits an anxiety of misrecognition.

Anxiety, of course, found some of its loudest expressions in minimalism, most famously as the source of a critique argued by Michael Fried as a phenomenological byproduct of theatre.[25] Fried's argument—now as it was then, and when Lum began to make his work—is well known.[26] Yet while Fried's contentions were fixated on questions surrounding

Ken Lum, *Untitled (Red Circle)*, 1986
fabric and wood
Collection of Vancouver Art Gallery
Acquisition Fund, VAG 91.29 a-l
Photo: Trevor Mills,
Vancouver Art Gallery

art's autonomy, what is significant is how the discourse, debate, and criticism surrounding minimalism remained mostly formal and how the asceticism of its argument, interest, and history could be further subject to a form of criticism that is decidedly social. Such is the manner in which Lum's *Furniture Sculptures*, for instance, ironize not only the typology of classical minimal art of the 1960s, but the very nature of the debate surrounding the movement as well. If minimalism started with accepting facts: the stasis, self-completeness, and cleanliness provided by industrial forms and materials, Lum worked to accept and then upend them through a recognition of the very means in which the movement's formal autonomy signaled an exhaustion of any potential form of social meaning. In an extensive reading of the *Furniture Sculptures*, Jeff Wall describes Lum's critique of minimal art:

> The object is ordered according to a 'self-evident' logic, in which the relationships of the elements are reduced to their most basic expression, resulting in an intensely experienced formal order, one which expresses modernity more precisely, than statuary or the mechanomorphism of 'modern sculpture.'[27]

Cast in a dry matter-of-factness that deliberately misshapes the fixed pragmatism of minimal art's primary forms, the critical attitudes of Donald Judd and Robert Morris—as formal positions both serious and sanctimonious—is trumped with great comic effect by Lum. Through the inaccessibility of his rearranged couches, Lum's easy gesture effectively reveals the bogus autonomy of the specific object as an empty structure: with its topless ends and air-filled enclosures as the materialization of a

historical void—the perfect summation of the minimal epoch as a vacant era. Indifferent and unmoved toward the social, the void associated with the clean boxes of Judd and Morris was later seen by Lum as a negated space meant to be filled with social meaning, personal experience, and emotional pain: all messily chaotic and unconcealed expressions that minimal art forcefully meant to repress.

This polarity—clean, neo-classical formal structures versus the *avant-régressif* couplet of personal sign and social significance—combine as principal extremes in Lum's work to create a complex amalgam of industrial form and polemical content. Lum's *Furniture Sculptures*, along with the *Portrait Logos*, *Language Paintings*, and *Portrait Repeated Texts*, level the divide between tropes that previously gained their autonomy through the conscious repression of others, by conflating them into an elaborate schema that mainlines imagined personal narratives, professional facture, and a lively confrontation with art history into parallel lines of understanding. Lum's particular world-view is that histories—whether micro or macro—run simultaneously and can never be disconnected from another, and that ideologies—whether they be artistic, social, or political—have the comprehensive potential to be mutual and non-competitive. Lum's work plays on the understanding that individual personal stories can potentially narrate larger social dramas through media that communicate in wide and, hence, general terms.[28] For Lum, the modernist tropes of generality, formal honesty, and humanist universality provides the broad-spectrum lens of looking at the world that further enables an easy connection between the contrasting tropes of commercial advertising with modernist painting and sculpture. Lum plays on the idea that universality can find its most illustrative applications in both signage and oil-on-canvas, and distinguishing the rough parallels between the two can lead to more specific comprehensions of either.

All of this results in an odd contradiction: Ken Lum is an artist who makes a project of professionally producing non-professional graphic design. His recent *Shopkeeper Series* (2000–) uses the formality, language, scale, colour, and principles of both high modernism and modern commerce, and imports the dialectic of a personal history and a grand social narrative in order to explore them. Like his earlier work, the *Shopkeeper Series* mimics a familiar archetype—here, the commercial signage whose presence is ubiquitous on main thoroughfares in every North American city—in order to re-mystify them. Representing a cross-section of a decidedly modest variety of businesses (e.g., beauty shops, thrift stores, bakeries, and strip joints) that are almost exclusively family or independently run single franchises, all of the individual works that make up the series follow a formula that can be distilled down to three attendant parts: the depiction of name and business-type; inserted movable text that advertise special deals or sale slogans; and the exclamation of a political statement or personal tragedy that ruptures the traditional usage of the sign.

Through the forced mix of text, it's obvious how the differences between sign-as-sign and sign-as-art unfold and how interior narratives append the commercial in order to create a jarring conflict. Each sign follows a repeating pattern. For instance, the text in *Parvi* (2000) reads:

> FREE HOME DELIVERY
> TRY OUR
> HOME MADE PATES
> PRAISE BE TO ALLAH

While *Ebony Eyes* (2000) proclaims:

> THIS WEEK ONLY
> BONUS MANICURE WITH FACIAL
> WALK INS WELCOME
> ALL POWER
> TO THE PEOPLE!

And *Jim and Susan* (2000) pleads:

> CLEAN & COMFY RMS
> SUE, I AM SORRY
> PLEASE COME BACK

That the language is bold and quotidian, both in its advertising slogan (the set-up) and its private drama (the punchline), evokes something about these expressions that is bland and familiar. Indeed, the phrases register as simple platitudes. However, the poignancy (and humour) of two vernaculars tangled together to create amalgams that play with cultural stereotypes, and what we know about them, is crucial—the deadpan presentation of the text bluntly renders ambiguous its ironic or sincere status. It may be that Lum takes a private concern—the authenticity of an individual in modern society—and turns it into a desperate act of public self-confirmation, as though the only way that one of Lum's characters can convince himself that he is not, ultimately, a social abstraction, is to inscribe his reality, abruptly and painfully, through open display. Lum's imagining of a personal story is invested with public consequences, and his art makes a game of being honest with his subjects even as the signs call attention to themselves as artificial statements seeking to articulate a certain truth. This side-by-side veering between certainty and doubt, in a circuitous way, works in its favour: Lum's artistic acts are both fiction and reality; each are manifestly constructed, but in ways that do not automatically invalidate their authenticity.

Ken Lum, *Parvi Fresh Meat & Poultry*, 2000
lake paint on aluminum, Acryglas and flexible Acryl-letters
Edition 1/3
© Ken Lum
Courtesy of L.A. Gallerie—Lothar Albrecht, Frankfurt, Germany

Ken Lum, *Jim & Susan's Motel, Kitchenette, Cable T.V., Indoor Pool*, 2000
lake paint on aluminum, Acryglas and flexible Acryl-letters
Edition 1/3
© Ken Lum
Courtesy of L.A. Gallerie—Lothar Albrecht, Frankfurt, Germany

Questions of authenticity—so crucial towards Fried's formulation of modernist autonomy—are intractably connected to questions of how the social realism of Lum's signs is dependent on its formal madeness (it looks like a sign, yet is not an actual sign). The key difference is the work's presentation not outside on the façade of a building (even as a public project), but within the confines of a gallery. Our normal orientation with real signs *in situ* is from below. To maximize street visibility, signs are mounted at a relative height so that they can be visible to both pedestrians and traffic. Lum's signs, when presented in the gallery, are purposely hung low, to square perspective with the viewer and affect a one-to-one relationship. The series of transformations—from readymade to manufactured, street to gallery, high to low—reads as a deliberate yet subtle process that edges the signs closer to the status of something like painting. Much of Lum's past work exhibits this art historical consciousness. For example, the *Furniture Sculptures* pattern themselves after Robert Morris just as the *Language Paintings* mimic the pop art of Ed Ruscha.[29] It is, however, important to note that this appraisal of the signs as paintings is meant to be more evocative than outright, even as the conventional gallery presentation of the works themselves mandate this reading. Yet the *Shopkeeper Signs* are indeed characteristic of not only the medium of painting but also a certain painting tradition, as their formal properties of shape, colour, and scale are directly proportional to the modernist standards of artists such as Mark Rothko and Andy Warhol. Just as Lum's *Furniture Sculptures* anthropomorphize minimal sculpture, this impersonating quality is also reflected in the figurative dimensionality of the wall pieces—a scale mimetic of a figure standing within the painting with his or her arms stretched out.[30] Understated and aware of their presence, the signs display an empiricism of concepts, lengths of measurement, and material use of the body for a physical reorientation of modernist tropes—manipulations are made in relation to physical limits and measured in proportion to human scale. Again, I think it would be a mistake to read the comparison between Lum's signs and the paintings of Rothko and Warhol as explicit. Yet these references embodied by the work are both suggestive of, and defer to, not only an optical association with the standards of high modernism, but also its tangential tropes of disclosure and withdrawal, the construction of mystery, and the resonances of personal tragedy so deeply embedded in Lum's signs. By any measure, and like most affective art, the works do orient themselves around contemplation—or, more particularly, a level of thought which often functions in an interior capacity.

Herein lies the tension I want to examine—and the *Shopkeeper Signs* characterize this observation—of the debate between the virtues of empathy versus the problem of altruism. Lum's work, I believe, exhibits both. On one hand, he badly wants us to understand the lives of un-narrated others. Yet by recasting his subjectivity and reconfiguring his voice to "speak" for them, the attendant danger is that the artist might impart to himself

the self-nominated authority to speak for those less assimilated than himself. My questioning here is not centred on politically correct notions of legitimacy or the artist's right to depict experiences different from his own, but rather how the culmination of Lum's work might be seen as a sort of abstract reduction of social types. The complication is if the imagined voices emanating from Lum's signs are recognized as archetypal, as representative of clichés, and not as specific individuals themselves—they also leave less room for aberrant details, and the particularities that are present in everyone's own lives. This leveling of distinctions is peculiar, chiefly because it enables a type of benevolence that can allow Lum to conjure the worldviews of a wide, multi-ethnic populace, while potentially simplifying our understanding of them at the same time. Hence, *Ebony Eyes* espouses a 1960s rhetoric of black "Power to the People"; *Parvi* makes a public declaration of Islamic piety; and *Jim & Susan* seem to be going through the classic sitcom troubles of domestic instability. Through these gestures of altruism, Lum's *Shopkeeper Signs*, in many ways, are emblematic of his position as "counter-narrator," who—through a learned omniscience—aspires to become a universal voice of authority by leveling the unique social categories of class, gender, and ethnicity with a singular perspective.

This impasse—between the attempt to articulate the life histories of those whose voices remain muted by their marginality, and the potential generalizing of the very subjects he is trying to render with a complex understanding—is a conflict ironically generated not only by the artist's own experience and subjection, as a cipher, but also by the rigid format of the signs themselves, and a language of advertising that makes a project of working with clichés. The argument, of course, can also go the other way: perhaps it is not the artist but the communicative forms that Lum uses that disintegrate individual specificities into broad social patterns; which in turn, evolve into social banalities; which form into social material Lum reconfigures through ironic humour. With this in mind, it is important to note how the realism in Lum's work is an impressionistic one: a notion that applies to not only the re-imagining of social types, but also to the processes of re-modeling cultural objects (such as small business signs), and how this method can lend itself to reclaiming certain practices in art history. Lum has stated:

> What I try to achieve is a degree of 'realism' whereby the signs
> look persuasive enough as found objects, yet have an affectivity
> that only a clearly demarcated work of art can bring (which is not
> possible with simply a found object). My works defer the moment
> of recognition as pop surfaces, whereas pop art announced its dif-
> ference from the source immediately.[31]

Having something fabricated to look like a found object strikes as an anachronism, and yet here are Lum's signs-transformed-into-art-and-

Ken Lum, *Ebony Eyes, Beauty Salon, Unisex Hair, Nail & Skin Care*, 2000
lake paint on aluminum, Acryglas and flexible Acryl-letters
Edition 1/3
© Ken Lum
Courtesy of L.A. Gallerie—Lothar Albrecht, Frankfurt, Germany

(re)presented-as-signs. The theoretical functionality of the signs themselves indicate their ambiguously shifting status—produced, to odd effect, to look like any other sign, yet finally, they merely *perform* the function of signs while their liminal use-value is trumped by presentation as art. Indeed, implicit in this process of construction and displacement is a certain playfulness. That Lum also consciously plays with canonical tropes of art history—and with the tradition of a beaux-arts academy—further infuses the social enterprise with an avant-garde logic. His self-reflexive concern with placelessness and art history can be understood as a canny reconfiguration of art forms that traditionally repress these subjects. Donald Judd's characteristic urge for formal autonomy is used by Lum as a socially vacant model to be radically confronted and critiqued. By contaminating the polemical autonomy of a set of social themes with the cold, formal expressions of art works that traditionally refute them, the registered discontinuity of these two antipodes—collapsed under the rubric of one commercially derived framework—functions in provoking a mystified reaction on the part of the viewer; a bewildered response that might also mirror the artist's own recognition of this conflict.

In an attempt to solve these internal contradictions, Lum, like Douglas, perceives the distance between art, industry, and society as a problem potentially reconciled by the construction of formally perfect art works that masquerade as commercial products born of a culture incognizant of its own awkward reality. When offered Judd's original proposition—that *a work needs only to be interesting*—both artists respond with their own interpretations, each with its own attendant virtues and complexities. The very efficacies of both artists' practices can also be used to measure their conceit and the theoretical underpinnings that connect one another. My questioning of Douglas—how does the artist affect a humanist response on the part of the viewer through a formal arrangement of people?—can also be extended to Lum. If Douglas is too cold and detached, Lum is his correlative other: an artist who identifies with his subjects, imagines their lives, and speaks for their experiences. Whether cold and non-humanist or personal and benign, the positions of both Douglas and Lum carry their own merit of being uncompromising. Artists of their sophistication can be intimidating, jarring even, yet both realize that is the best and only way they can make their art actually work. Aggressive artists are only too well aware of the conceits of their positions and that an assertive individual practice can function to separate oneself from others. The fact that both of their work is so formally and rigorously achieved is a lesson certainly picked up by other artists working today. Entranced by both the look and demeanor of professionalism and by working essentially from within the standards of an industrial norm in order to alter our understanding of art, Douglas and Lum nonetheless help place ourselves within these divides, to recognize our own complicity and involvement, and acknowledge, even if we cannot embrace, our own formal and historically determined enchantment.

1. This is an anecdote related to the author in an interview with Stan Douglas (September 2005). Entering as a first-year student at the Vancouver School of Art (now the Emily Carr Institute of Art & Design), Douglas describes Baxter's demonstration as an introduction to a foundation drawing course.

2. Nancy Shaw describes the varied professional activities of NETCO at length in her essay "Expanded Consciousness and Company Types: Collaboration Since Intermedia and the N.E. Thing Co.," *Vancouver Anthology: The Institutional Politics of Art* (Vancouver: Talonbooks, 1991): 85–103.

3. Donald Judd, "Specific Objects," *Donald Judd Complete Writings, 1959–1975, Gallery Reviews, Book Reviews, Articles, Letters to the Editor, Reports, Statements, Complaints* (Halifax/New York: Nova Scotia College of Art & Design Press/New York University Press, 1975): 187.

4. Judd writes on the then-potential for industrial techniques in art as limited due mainly to cost, yet freely speculates on its future availability and the directly aggressive, objective results of industrial production. Judd, "Specific Objects": 188.

5. For instance, *Illuminated Ravine* (1979) and *Two Generators* (1984).

6. For examples of criticisms on minimal art's literalist appeal through empirical experience and ocular pleasure, see: Gregory Battcock, "Marcuse and Anti-Art," *Arts Magazine* 43:7 (Summer 1969): 50; and Ursula Meyer, "The Eruption of Anti-Art," *Idea Art*, ed. Gregory Battcock (New York: Dutton, 1973): 116–34.

7. I am thinking of such artists as Mona Hatoum and Charles Ray.

8. I would like to point to two competing definitions of "interest" in Judd's essay. While James Meyer understands *interest* as a neutral term activated by a general judgement of quality, Frances Colpitt follows *interest* as implying a positivism associated with value, whereas *disinterest* is its opposite, negative condition. See James Meyer, *Minimalism: Art and Polemics in the Sixties* (New Haven, CT/London: Yale University Press, 2001): 140; Frances Colpitt, *Minimal Art: The Critical Perspective* (Seattle: University of Washington Press, 1980): 123.

9. More examination than edict, Judd's investigation into the work of John Chamberlain, Frank Stella, Lee Bontecou, Dan Flavin, and Claes Oldenburg has the patina of an artist who writes with the straight intentions of understanding.

10. *Omniscience* is used here to connote a wide-ranging consciousness associated with the work of Robert Smithson and Dan Graham, particularly the elastic and expansive manner in which both artists conceive an array of formal and social systems, and how newer knowledge might be determined by a deliberate upending of its conventions and norms.

11. Scott Watson, "Discovering the Defeatured Landscape," *Vancouver Anthology: The Institutional Politics of Art*: 247–291.

12. Ibid: 263.

13. For a description on how Douglas reveals the history of representational techniques as a history of social relations, see Scott Watson, "Against the Habitual," *Stan Douglas* (London: Phaidon Press, 1998): 36.

14. Tim Lee, "Liner Notes: Dan Graham, 1969," *Correlated Rotations* (Vancouver: Artspeak, 2005): unpaginated.

15. William Wood, "Secret Work," *Stan Douglas* (Vancouver: Vancouver Art Gallery, 1999): 117.

16. Rodney Graham's *Fishing on a Jetty* (2000) offers a humorous, shrewd, and complex travesty on how cinematic, touristic, and artistic representations of Vancouver all collaborate and conjoin to induce a strange familiarity with the city.

17. While certainly accommodating an array of social implications, my argument toward *Every Building on the Sunset Strip* as not being *explicitly* social comes when measuring Ed Ruscha's photographs of a street with his similar photo projects of a litany of various subjects including stains, palm trees, swimming pools, records, and girlfriends. Collectively considered, it might also be posited that Ruscha's projects investigate aspects of the pastoral (e.g., the simple genres of landscape, still life, and portraiture) and their relation to the artist and everyday life.

18. By this, I mean an expert practitioner of a commercial vanguard, or what Benjamin Buchloh describes as an anonymous purveyor of the ideological apparatus of culture industry. See Benjamin Buchloh, "From Faktura to Factography," *October* 30 (1984): 83–119.

19. "Interview: Diana Thater in conversation with Stan Douglas," *Stan Douglas* (London: Phaidon Press, 1998): 24.

20. Sol LeWitt, "Paragraphs on Conceptual Art," *Artforum* (Summer 1967): 79–83.

21. Ken Lum, "On Portrait Logos: On Furniture Sculptures: On Language Paintings," *Ken Lum* (Winnipeg: Winnipeg Art Gallery, 1990): 9–11.

22. William Wood and Trevor Mahovsky have each offered a more thorough review of these texts while giving complicated insight to their authority and reception. See: William Wood, "Some Are Weather-Wise; Some Otherwise: Criticism and Vancouver," *Vancouver Anthology: The Institutional Politics of Art*: 133–169; Trevor Mahovsky, "Radical, Bureaucratic, Melancholic, Schizophrenic:

Texts as Community," *Canadian Art* 18:2 (Summer 2001): 50–56.

23. Jeff Wall, "Four Essays on Ken Lum," *Ken Lum*: 37. Moreover, Wall describes how the productivity of a new national population has resulted in images that offer critical visions—factors that are "among the things to be found in the interior of Lum's work."

24. In 2000, Lum's *Untitled (Language Painting)* was voted by the public as the least-liked work of art in the Vancouver Art Gallery's collection.

25. Michael Fried, "Art and Objecthood" (1967), *Minimal Art: A Critical Anthology*, ed. Gregory Battcock (Berkeley: University of California Press, 1995): 145.

26. That minimal art could be critiqued through its refutation of High Modernism's signifying traits—the emphasis on form and materials; the relationship between the maker and the made; its aspirations for universality; and its enduring grace—are contentions that are fixated on the question of art's autonomy.

27. Wall, "Four Essays on Ken Lum": 40.

28. Michael Turner describes the effects of formal/social conflation and the bipartite knowledge imparted on both family names and federal multicultural policy in Lum's *Ollner Family* (1986). See Michael Turner, "Untitled (Ken)," *Ken Lum* (Vancouver: Contemporary Art Gallery, 2001): 10.

29. "The specific art object of the 1960s is not so much a metaphor for the figure as it is an existence parallel to it. It shares the perpetual response we have toward figures. This is understandably why subliminal, generalized kinesthetic responses are strong in confronting object art. Such responses are often denied or repressed because they seem so patently inappropriate in the face of anthropo-morphic forms, yet they are there. Even in subtle morphological ways, object-type art is tied to the body. Like the body, it is confined within symmetry of form and homogeneity of material; one form, one material (at the most two) has been pretty much the rule for three-dimensional art for the past few years." Robert Morris, "Notes on Sculpture, Part 4: Beyond Objects," *Continuous Project Altered Daily: The Writings of Robert Morris* (Cambridge, MA: MIT Press, 1993): 54.

30. "The vertical canvas, his standard format, 'answers' the viewer, returning his or her stare, and recalls Rothko's touching image of a figure stretching its arms before his paintings." Barbara Novak and Brian O'Doherty, "Rothko's Dark Paintings: Tragedy and Void," *Mark Rothko* (Washington: National Gallery of Art, 1998): 272.

31. Lum in email correspondence with Stephen Wright in Stephen Wright, "Excluded By Design: Ken Lum's Shopkeeper Series," *Parachute* 118 (04–05–06): 40.

# In Another Orbit Altogether: Jeff Wall in 1996 and 1997

Shepherd Steiner

Jeff Wall, *A villager from Aricaköyü arriving in Mahmutbey−Istanbul, September, 1997*, 1997
transparency in lightbox
Courtesy of the artist

What is decisive is not to get out of the circle but to come into it in
the right way.

—Martin Heidegger, *Being and Time*[1]

The years 1996 and 1997 represent a complex moment in the photography
of Jeff Wall. Within the space of these two short years, Wall's notion of
what photography is—or can be—undergoes a minor revolution. It is a
moment marked by the unexpected turn to black and white photography;
a moment in which one sees Wall placing an increasing pressure on the
problem of documentary photography; and finally a moment in which
instability and worry over meaning begins confidently gesturing toward
something other. Added to these complications, which variously gesture
toward a prehistory circumscribed to photography and not to the likes
of painting or cinematography, one would be wise to note that the si-
multaneously desiring and judging economies of Wall's work are, at this
moment, as happy looking forward as backward. If some works hope for
an imagined future, others long for the just past; in this sense, even the
beautiful undergoes a makeover, or more succinctly, given photography's
resources in 1996 and 1997, Wall recognizes that the promise of happiness
turns (spins off) in at least two directions.

We need to gain a foothold in both of these orbits. But global or ex-
trinsic models of criticism cannot make the kind of micro discriminations
required to discern these systems, much less their directionalities: the
retrospective and projective potentialities of these greatly undervalued
economies are glossed over, if not utterly erased, by the dominant mod-
els of interpretation in circulation today. Specular structures of this va-
riety require a far more sensitive, reflective means of judgment, and we
need to make ourselves right at home in these circles. After all, when it
comes to revolving structures one does not want to get only half in or half
on the thingamajigs. Machines and whirligigs that turn are dangerous!
One could fall out or twist an ankle, for instance. No, we want to get in
close, and only formal and intrinsic criticism has the necessary resources
at its disposal to do so. But there are serious limitations to engineering a
smooth entrance even here.[2] Simply getting around the hermeneutic circle
travelled by earlier formalisms, like that of the new criticism, is no longer
sufficient. Totality is a trap and constant horizon that one must negotiate.[3]

For not only are such hermeneutic economies utterly lost in the deep folds of general equivalence, but the circulation of resources in such economies lie in the shadow cast by their own version of equivalence or totality. In other words, one can enter into the circle and be fooled into thinking that the encounter engineered has enabled one to shine the full light of truth on the form at hand. As Paul de Man reminds us: "Understanding can be called complete only when it becomes aware of its own temporal predicament and realizes that the horizon within which the totalization can take place is time itself. The act of understanding is a temporal act that has its own history, but this history forever eludes totalization."[4]

One should hear the double beat of dialectic in de Man's phrasing. Its rhythm marks out the minimum velocity required for getting into Wall's orbit circa 1996 and 1997: an orbit that brings time and hope together through the question of labour and against an alienating culture in the utopian tradition of Ernst Bloch.[5] Now that each one of us is equally subject and enlightened representative for our own notions of governmentality, it seems the necessity of entering into the circle of the others' laborious economy and probing for the outside of even this, is acute. Only close reading—by which I mean a rhetorical reading focused on the working or functioning of tropes or tropological systems—gets one up to speed. Only close reading provides a way into the micro-orbits of this other notion of economy. Nothing else is sensitive enough to the variable tropological systems Wall's photography puts into motion, or indeed capable of attending to the central place we occupy as viewers in these rotating, precarious, and constantly eclipsing solar systems. Through scrupulous mimesis and attention to detail, our aim then is to open up the secret ways we live in the shadow of Wall's photography. The challenge is to enter into the circle of these exemplary economies the "right" way. One at a time, of course, but also openly in anticipation of dialogue, in hopes of making it turn from sunshine to shadow and back around again "down the valley of the shadow" (in Edgar Allen Poe's words) to the shade's reply and beyond. Following the "torturous" logic of Jacques Derrida's *Voyous (Rogues)*, and against the good intentions of the many right-minded dictators of meaning in our midst, we can call the gesture of putting this "free wheel" into motion a democratic act.[6]

Take *Volunteer*, one of Wall's first black and white photographs from 1996. It is an exemplary work and there is perhaps no better introduction to the variable aporia faced in the black and white photographs as a whole. It is a kind of nothing picture, more about holding things back or in—and hence the ambiguity of meaning—than any particular meaning as such. Not only am I tempted to describe the volunteer himself as stewing or maybe beating himself up about something, but grey tones predominate, and more than in any of the other black and whites, colour itself seems constrained or repressed. In fact, the only things that *Volunteer* is clear on are the disappearance of colour on the one hand and the fact that the figure

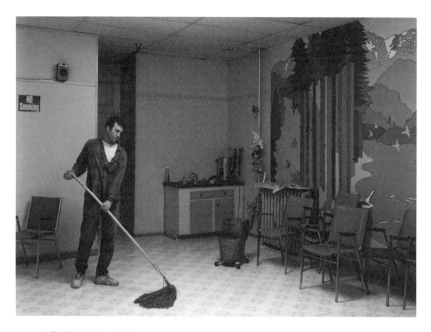

Jeff Wall, *Volunteer*, 1996
silver gelatin print
Courtesy of the artist

Jeff Wall, *Passerby*, 1996
silver gelatin print
Courtesy of the artist

is cleaning on the other. The work turns on these two moments. Look at the volunteer himself mopping up, apparently lost in his thoughts. If we leave him to his thoughts—something that seems appropriate; look at his pose and pace, it irritates—our eye comes to rest on the mural, something that we imagine to be in colour. Do not be fooled into thinking one has an edge on the work or a jump on intention by virtue of passing judgment on the figure, either. In narrating the picture thusly, one's own grasp of the work is complicated by a corresponding loss: what I would describe as the simultaneous move from knowingness to feeling. In other words, if one thinks oneself to have gained the upper hand on the work by turning to the mural, the mural gnaws away at one just the same: what colour I give it—and what manner of experience I bring to the task—makes the picture move: and what's more, move away from me.

In being moved from the figure to the mural, one narrates both the death of sense-making and brings on a particular theory of photography that has a broad currency for looking at black and white pictures in general. In turning away from a presumed site of intention to that of an assumedly unseen contingency, one reproduces the effects of what looking at historical black and white photography can be like—as an excess. The comparison between *Volunteer* and the snapshot like effect of *Passerby* (1996) is helpful here. In the latter, there is virtually no trace of artistic intention—excepting perhaps what we "seek out" in this awkward shot as the tripartite composition of the work itself, which divides the surface into a dark part, a light part, and a glistening black and white part. These rhyming parts, which are dark, light, and glistening black and white, seem suspiciously considered. Moreover, the harsh lighting, aimless enough to come from car headlights rounding a corner, casts an unexpectedly lewd shadow on the wall, and consequently disparagingly colours the figures and the event which just transpired as a sexual encounter. In the shadow cast by this presumably amateur lighting job, we brush up against what the critic Gregor Stemmrich describes in another context as "the artistic use of the *idea of the punctum*."[7] (I think we need to be wary of Stemmrich's blanket use of the idea in Wall's corpus as a whole. I also think we need to be attentive to what Michael Fried identifies as the inherent latency in Roland Barthes' famous term.[8] Practically speaking, one should also worry about the stability typically assigned the term: for one can never be sure that the *punctum* exists in any firm [i.e. contrastive] relationship to the *studium*.)

Remember, that for Barthes "this prick, this mark made by a pointed instrument ... refers to the notion of punctuation."[9] Set against the *studium*, what Barthes describes in terms of "training ... not immediately, 'study,' but application to a thing, taste ... a kind of general, enthusiastic commitment, of course, but without special acuity," the *punctum* "rises from the scene, shoots out of it like an arrow, and pierces me." He says that a "photograph's *punctum* is that accident which pricks me."[10] All

of which adds up to say, that in face of *Passerby*, "the artistic use of the idea of the *punctum*" does not so much zero in on the notion as the critic wields the term *after* photography, but rather points to the way that Wall the photographer deploys the term *before* photography, for use by future viewers. Another way of putting this is that if one does not overcome the *punctum* as a sign that speaks to the viewer, one glosses it as a mark or moment of punctuation (Barthes' word) and risks being *punk'd* (Kutcher's word) by what de Man calls reading.[11] The point being that in *Passerby* the photographer was not necessarily blind to the *puntum*. On the contrary, we find the photographer to be potentially deploying a provocative and humorously literalized version of the punctum in harmony with the hurried flash effects of night photography and in the field of a highly schematized formal composition.

In the example of *Volunteer*, the presumed accident of the colourless mural is given less weight by the symbolically loaded figure which decidedly tips the scale of the entire work toward intention. In brief, one cannot see the mural outside of any relationship that has not already posited the volunteer, simply because the viewer *uses* the volunteer to get to the mural, and in being moved from the volunteer to the mural one has read. Just when the viewer thinks he or she has gained some distance or clear-sightedness on language, it turns out he or she is in the deepest grip of language, in the thick of reading, rhetoric, or tropology. Large claims, but claims for expression—or language as power (simply, the capacity to move one) which is what is at stake here—always are. The small fact that Wall talks about *Volunteer* in terms of a particular scene at the end of John Huston's 1972 film *Fat City* makes them all the larger.[12] After all, does not reference curtail feeling, or, is the crucial thing here to recognize the fact that in Huston's final scene two boxers talk about happiness? The same worries apply to the fact of cleaning: a thematic sprinkled throughout Wall's corpus that always begs for critical interpretation.

To substantiate the claim for expression and dispel these worries, we need to acknowledge a number of things, i.e. firstly, the negative place assigned black and white photography in the corpus. Like the *Diagonal Composition* works, the black and whites take up a position beside Wall's main corpus of work. By virtue of both the specific pressure a work like *Volunteer* places on "the before," and more generally the existence monochrome ekes out as an apparent archaism or obsolete technology *vis-à-vis* colour photography, the black and whites are a complement or book end to the artist's investigations into after-effects. In Wall's case, taking up monochrome photography beside his extant works in cibachrome is roughly coincident with a new depth of engagement with the medium of photography itself. As he himself puts it, originally excluding monochrome was part of a generational hang-up with the aesthetics of art photography in the 1970s.[13] Coming to terms with the exclusion or blind spot of black and white, then, seems to have impacted upon his own particular

use of the language of photography and more specifically the repressed history of that language at a particular moment.[14] Secondly and consequently, the monochromes should be seen as part of a rethinking of his prior commitment to linking up photography to cinema and painting[15] in terms of what he calls "the photographic mimesis of photography."[16] Meaning that, in spite of Wall's reference to Huston's film, Volunteer approximates the effects of what looking at historical photography is like as a pure act,[17] something that the Cyclist (1996) rethinks in a different way, and which Citizen (1996) reconfigures in a different way again.

Thirdly, the monochromes are part of a contemplation on developmental questions concerning the medium: they address both the question of development or darkroom process as well as the development of the medium from darkroom photography to digitalization. On the threshold of digitalization, it seems that it was necessary to return to the origins of photography. How to approach an earlier moment in photography from a late moment in the medium's development is the crux. Volunteer, The Cyclist, and Citizen all provide different solutions to this question. Of all the works from 1996, The Cyclist is perhaps most transparent in thinking the semiological horizon of the documentary tradition itself, one of Wall's declared intentions in taking up black and white photography.[18] The Cyclist posits this tradition as decidedly French. Given the overhead street lighting and the obscured head of the "resting" figure that reads as a beret, one is instantly "moved" to the streets of post-war Paris via Robert Bresson, or perhaps Brassaï—an effect corroborated by the art brut backdrop.[19]

Citizen rethinks the hermeneutic horizon of documentary in terms of the fiction of real history—I mean as a reveal of social relationships at a particular moment of history. Thus, one's relation to the sleeping figure is distinctly interpretative or bookish. Aided by the off-putting depth of field, one circles around the citizen without ever penetrating the subject—something that the series of three photographs in Stephen Waddell's A Resting Worker Cycle (2000) make perspicuous, and perhaps posits Waddell's work as the most insightful interpretation of the photograph to date. The fact is that the mimetic illusion in Citizen is so great that we feel compelled to tiptoe around the figure. One does not want to disturb or rouse him: it would be out of place. Perhaps one moves toward the figure reading ("studying the constitution," Wall suggests) in the extreme background. In any case, one leaves this "free wheel" behind so as to indulge in historical and political discourse that merely circulates around the figure, that takes the figure as a point of departure for discussion. Predictably enough, the corollary of believing the documentary work to be transparent serves up a dialogue on democracy, public space, and the exercise of variable rights by a citizenry. In this regard, Citizen is an important reworking of Diatribe, but in distinction to the latter journalistic work, gets dialogue to move in the public sphere without moving it permanently away from the question of photography at hand.[20]

Judging from *Volunteer*, yet another solution to approaching the just past of the medium seems to have been simply burying intention in a be-fore of the work instead of an after—something that puts the viewer in a position to imagine the death of black and white photography at the hands of colour sometime in the future. Inasmuch we can describe the figure (which we pass judgment upon) from the perspective of the mural (which we look toward) in terms of an archaeological effect, something that cor-responds to literally turning the figure of the volunteer into a trope. The tension between these two pictorial incidents complicates Wall's earlier notion of cinematography by way of the supplementary question of time. That is, if at one time the placing of things beside each other automati-cally assumed a synchronous notion of time, in *Volunteer* things have changed.[21] This is double time, volunteer time, overtime without pay.[22] It presumes a kind of unity, or a promise there of that escapes economy, especially that of the work—a day world ruled by the time clock.

Proving all of this is not as difficult as it may seem. The motif of clean-ing is evidence enough. In *Volunteer*, the problem is not only that cleaning seems a loaded or symbolic activity, but that the cleaning is being done in an odd manner, and occupies one's thoughts as such. If he *is* cleaning up after hours, or "after others," he is not working too hard. In fact, he is barely pushing the mop around. Look at his right fist and look at his raised heel; it is a touch posed. He might well be dancing. This sensing of intention on the part of the artist, is intended to leave one cold, and have one look elsewhere. It is at the precise moment one uses intention as a casting off point for further reflection, over right, that one stumbles upon Wall's interest in the figure of cleaning as an archaism—or ques-tion of depiction. Though cleaning will not acquire its full-blown status as a thematic deserving an artist's note until 1999,[23] it is worth recall-ing that *Volunteer* was originally shown beside *Housekeeping* (1996), a picture of a figure leaving a hotel suite newly cleaned. The volunteer in *Volunteer* is a figure of what has been called the trace. Why? Because, the figure acts out what happens when we read. One could say that as a volunteer, he is happy to be of use, and by the looks of things happiest when used: that is when double time kicks in.[24] Like the figure's cleaning in *Morning Cleaning, Mies van der Rohe Foundation*, and *After 'Invisible Man,'* this figure provides a negative moment of engagement that leads one to something other. "Its possibility," as Jacques Derrida writes in *Of Grammatology*, "is by rights anterior to all that one calls sign;"[25] and that one cannot safely call the sign (here a *punctum*) a sign without worrying about the designation is implicit to Derrida's statement. In mopping up the ground upon which a first footing in the picture is established, the volunteer is transparent about turning an interpretative thematic into a question of response. This picture is all about expression or feeling, and in fact the figure cleaning—who acts out a kind of erasure—presumes this eventuality. If imagining colour in a grey mural is not about injecting

Stephen Waddell, *A Resting Worker Cycle*, 2000
no. 1 in series of 3 photographs
colour photograph
Courtesy of the artist

emotion into the volunteer beside it and before it, what is? In coming clean about erasure, the shape of the signifier is marked out: it is filled up by what is both beside it syntactically *and*—if one builds a notion of development into the space between the figure and the mural—by what is after it as well.

If we turn to *A villager from Arıcaköyü arriving in Mahtmutbey—Istanbul, September, 1997* (1997) we see what is at stake from a different perspective. One might rightly describe the work as a documentary photograph, and certainly the date and the location in the title is helping this designation along. For some reason, I intuitively call it a document of hope. In spite of the neutral colours that look as if they are coated in a layer of dust, presumably from the non-stop industrial traffic on the margin, I take it to be a picture of the possibility for happiness. Jean-François Chevrier describes it as a "really beautiful image."[26] No doubt he is picking up on this same spirit.[27] In any case, a boy—a villager—arrives at the outskirts of Istanbul. The thematic of migration for work, or the move from the rural world to the urban is called up and not least by the title. One detects a certain hopefulness in the open road before him, maybe in his stride, perhaps more curiously in the compensatory lean for his heavy bag. (In the big city, now, he will disguise his roots, perhaps with a casual hand placed in his pocket or a comfortable look.) More than anything, one gets the feeling of hopefulness from the furtive sense that he is smiling. In fact, I've always believed him to be beaming, that he cannot contain himself. After all, the future of the barren *mise-en-scène* that surrounds him, and which awaits further development, might well be his. He focuses these speculative energies, as figure and through details: the easy bend of his leg, and more forcefully in the flex of his arm, all of which carries one up close and directly to his face. But none of this comes easily: one strains—or rather, imaginatively reaches—to speak of it.

Wall characterizes the work as "almost-near documentary." Apparently, he had visited Istanbul some months before, discovered the place, and then returned to make the picture, something that would take one month of work in the city. During this time he "found the boy on the street corner (nearby) in a group waiting for jobs."[28] Wall would be his first employer, the picture being a re-enactment of the boy's own arrival in the city two weeks before. Imagine the boy's good fortune. His first job! I can only think of that line from *Lawrence of Arabia* when Peter O'Toole's servant says something like "Lawrence, Allah smiles upon you!" In any case, the title of the work—and the work itself—springs directly from the boy's own experience and history. But then, we are confronting representation here, and no matter how seductive this story may be as a confirmation of the hope one finds within, one has to entertain the possibility that transparency, the indexical nature of photography, or human empathy is not perhaps the symbolic transit feeding us this narrative line. Inasmuch one must also be attentive to Wall's characterization of the picture

as "almost-near-documentary," something one can define (with some help) as not quite "claim[ing] to be a plausible account of, or report on, what the events depicted were like, when they passed without being photographed."[29] Presumably, the specific site that Wall had originally chosen for his own reasons tears the picture away from the scene of the boy's original hopes upon arrival in Istanbul two weeks previously, not to mention the actual event as it would have transpired. But even if cinematography gets in the way of straight photography, it is clear that the motif-heavy site helps direct our response to the picture, the neo-realist landscape even helping to tug at our heartstrings the right way. In addition, we know from interviews that Wall's motivations in making the work were partly garnered by an interest in troubling the popular fiction implicit in nineteenth- and twentieth-century realism, that the new arrival comes to the capital and, through a process of disillusion-ment, becomes "cosmopolitan."[30] What of this calculated attempt to figure hope? And if calculation were not bad enough, why figure it through a figure that might be easily misconstrued as ambiguous in its message? He could be leaving.

But there is more. The scale is all wrong. The boy seems too small for the scene. Perspective, which plunges off camera right, falls away too quickly and takes the figure with it. The electricity and telephone poles overhead dwarf him, and they seem to do so almost mockingly. In com-parison to their height, he does not measure up. Which provides all the more reason to strain; strain for some fugitive identification with the vil-lager that the picture is not so willing to give up. The hope that falls into place in order to fill this gap is not entirely one's own; it is rather strangely facilitated by syntactical elements in the picture.

Take the T-junction marked by the minor road leading left: there is a fugitive sense that one imaginatively squares up to it. Along with the horizontal "speed" of the detailed suburb behind, and the confusion of overhead power lines which make up two rectangular backdrops that the boy walks beside, like alternative scenographies, the diagonal of this road seems to facilitate and invite a second entrance to the picture. This impossible perspective, seen from an acute angle off camera right, looks as if it might open up on a triangular vista that travels leftward. Once isolated, this supplementary perspective seems to offer a line of sight powerful enough to rival the imperializing view and vanishing point that sweeps in from left of centre, curves smoothly around the corner, and travels into the distance. This subsidiary perspective seems to place one within an almost tangible proximity to the villager: from this perspec-tive, a boy who is walking tall and with what one imagines to be a smile for the camera. The crisscross of lines and diagonals, the tight relation between figure and backdrop, the broad curve of the road, and on succes-sively smaller scales, its echo in his bent leg, its reiteration in his flexed arm, the cut of his lapel, and finally collar, all make one want to zoom in

and up on his face from the extreme right-hand side as if the image were inscribed with a smile from an *over there*.

In the context of Wall's wider practice, I take this to be a particular variation of what I would call a pictorial imagining of *beispiel*: an exampling of the desire to inhabit a perspective wholly other than one's own. If you are skeptical, *River Road*, also from 1997, is a good example. It shares a roughly similar set of concerns, though the effects of *beispiel* in this work are not focused in a figure but instead aim to trouble the perspective of the viewer. In looking at *River Road*, one orients oneself at a perpendicular angle to the light box by way of an antiqued edge that pulls one to the centre, and secondly by virtue of the diagonals within the picture. Here, the two perspectives carry distinctly domestic and economic connotations: I like to call the developmentally repressed angle of vision in *River Road*, the hillbilly perspective. If the bourgeois art lover in me prefers to view the scene from straight on, as if from the shoulder of the road, this comfortable perspective counsels against turning in to the driveway in order to come face-to-face with the owners of the property. The truck itself has all the presence of a pit bull straining at the end of its chain! These warnings noted, the picture literally asks one to square up to these folks, even admit them as roots. Two T-squares—one in gravel and dirt, the other in snow—show the viewer how to do so. If *River Road* manages to fold an "underdeveloped" perspective into a more cultivated or "overdeveloped" perspective and identify this with the viewer's experience, *A Villager from Aricaköyü* manages to make this doubleness a function of the figure itself.

It is, as noted earlier, an exampling of the desire to inhabit a perspective wholly other than one's own.[31] In spite of the hope that this other undervalued perspective promises, one must be careful not to mistakenly plug the other into this tropological system too quickly. Wall's work asks to be judged on these grounds; and it expects to be excused of guilt by virtue of the symmetrical system of exchange put in play. But nothing is finalized in this apparently closed economy. Certainly this machine or system works, but desire for the other only mounts up, and if the relatively free circulation of desire, first for one perspective and then for the other, is pressed, hermeneutic delirium will quickly set in. Not because desire for the perspective of the other is fulfilled, but precisely because the promise of the other's perspective is continually deferred. If one is to escape this hermeneutic prison—a prison that is little more than a metaphor of self—we have to escape the recuperation of meaning that this very particular metaphoric system of desire and judgment provides. The burden of criticism under such constraints is to show the way in which the example bumps up against a hermeneutic limit as well as surpasses this limit, for a random unsystematizable moment.

In the example of *A Villager*, the analogy forged between mind and nature is everything. The analogy is what allows the background to enter

the boy and be figured forth (and remember this is a landscape on the margins, rich with possibility for development or speculation). The interesting thing is that to comment meaningfully on the villager through the villager's relationship to the scene, the figure has to be introduced into a system of metaphor. And this symmetrical relay of properties, all focused on the boy as hope, depends on a negative or asymmetrical moment; something that is characteristic of language at a high level of self-reflection and a purely linguistic act of imposition that permits one to say whatever one wants to say.[32] Asymmetry is where intention becomes obscure. It depends on something exterior to the logic of tropology: in this example, catachresis, an abusive trope that both grounds as well as escapes the symmetrical recovery of hope in the figure. As Andrzej Warminksi tells us, catachresis is a trope that is not really a trope, because a trope of tropes; here, in fact, a catachresis of metaphor. As in the case of classic catachreses like the head of a cabbage or the face of a mountain, it humanizes and dehumanizes at the same time. As an abuse of trope, catachresis is not only internalized by the tropological system, but its use by metaphor exists beside its status as non-trope, and thus is also outside the system.[33] In other words, if in the example of A Villager, catachresis gives a face to the figure that is hopeful, this trope lays beside an abuse of trope, something in this case which would imply a violent and mutilating act on the landscape. This syntactical version of beispiel is not so easily recuperable to the system of dialectical exchanges of which hope is the product. Catachresis as the "syntax of tropes" is what keeps the tropological system from being closed off as a system; it is where system comes undone.[34]

Look again at the two wooden telephone poles in The Villager, and the line strung between them. Together, they stand as little less than stage props that help hold up, or more appropriately pin a smile on, the sky. This grammar operates in complete freedom with regard to reference; not only is it within and beyond, that is syntactically beside the question of hope, but neither does it exactly partake of photography's indexical relationship to the world. Slightly amplified by what seems a standard wide-angle lens, this wiry smile tacked on to the landscape is an interruption of sense-making. And it is only one line among many that require reading. Besides the title itself that makes the predicament of figural language clear by stuttering, "a villager from a village arrives at a village,"[35] the formal element of the smile is repeated in the broad curve of the road and the general lay of the land. These material facts of production—mere remains to be read and not seen or phenomenalized as with the figure of the boy (where meaning is focused)—are ritually covered over by aestheticization. The turn away from materiality to meaning, here the expression of hope, is a moment of what Paul de Man calls "aesthetic ideology."[36] In the example of A Villager, base compositional elements—little more than empty grammatical signs—stutter their way

into finding a systematizable place in the figure and on the face of the vil-
lager. Inscribed into the origin of the text, they disrupt it. They resist both
the index and the recuperation of sense in the figure. They operate on the
level of the letter, on the level of an inscriptional model of language that
is uniquely photographic.

1. Martin Heidegger, *Sein und Zeit* (1927), I, chapter V; quoted in Paul de Man, "Form and Intent in the American New Criticism," *Blindness and Insight: Essays in the Rhetoric of Contemporary Criticism* (Minneapolis: University of Minnesota Press, 1971): 30; Martin Heidegger, *Being and Time*, trans. John Macquarrie and Edward Robinson (San Francisco: HarperSan Francisco, 1962): 195.

2. More on the questions of extrinsic and intrinsic criticism can be found in Paul de Man's seminal essay, "Semiology and Rhetoric," the opening chapter of his book *Allegories of Reading*, while a running commentary and useful expansion of these questions can be found in Andrzej Warminski's "Ending Up/Taking Back." See Paul de Man, "Semiology and Rhetoric," *Allegories of Reading: Figural Language in Rousseau, Nietzsche, Rilke, and Proust* (New Haven: Yale University Press, 1979): 3–19; Andrzej Warminski, "Ending Up/Taking Back," *Critical Encounters: Reference and Responsibility in Deconstructive Writing*, eds. C. Caruth and D. Esch (New Brunswick, NJ: Rutgers University Press, 1995): 11–41.

3. For an excellent discussion of hermeneutics see Paul de Man, "Form and Intent in the American New Criticism": 20–35; and Paul de Man, "The Resistance to Theory," *The Resistance to Theory* (Minneapolis: University of Minnesota Press, 1997): 3–20.

4. de Man, "Form and Intent in the American New Criticism": 29.

5. See Emmanuel Levinas, *God, Death, and Time*, trans. B. Bergo (Stanford: Stanford University Press, 2000): 92–105; also Ernst Bloch, *The Principle of Hope*, vol. 3, trans. N. Plaice, S. Plaice, P. Knight (Cambridge, MA: MIT Press, 1986).

6. Jacques Derrida, *Rogues: Two Essays on Reason*, trans. P. A. Brault and M. Naas (Stanford: Stanford University Press, 2005): 6–18.

7. Gregor Stemmrich, "Between Exaltation and Musing Contemplation, Jeff Wall's Restitution of the Program of *Peinture de la Vie Moderne*," *Jeff Wall Photographs* (Köln: Walter König, 2003): 153–154.

8. Michael Fried, "Barthes's Punctum," *Critical Inquiry* 31 (Spring 2005): 539–572.

9. Roland Barthes, *Camera Lucida: Reflections on Photography* (New York: Hill and Wang, 1981): 26–27.

10. Ibid: 27.

11. de Man, "Resistance to Theory": 12, 15, 17.

12. Jeff Wall, "The Painter of Modern Life: An Interview between Jeff Wall and Jean-François Chevrier," *Jeff Wall: Figures & Places—Selected Works from 1978–2000*, ed. R. Lauter (Munich: Prestel, 2001): 184.

13. Jeff Wall, "Frames of Reference," *Artforum* (September 2003): 189.

14. In a curious spin on these questions, Wall's turn to black and white stands as one of the few moments in this sprawling corpus where one might rightly read in an autobiographical content. The *mea culpa* of Wall's largely biographical essay on the various historical dramas that led him to embrace the notion of cinematography, "Frames of Reference" is something of a confirmation of this. Historically speaking, taking up black and white photography goes hand-in-hand with the realization that his original choice for cibachrome over monochrome was a case of ideological blinding. It should remind one that Wall's theory of photography is couched in the subjective, and is thus cushioned against any truth claims made on the medium's behalf.

15. Though indications of his misdirection crop up in conversations more wholly seated before 2003, this misreading is most explicitly tracked in Jeff Wall, "Frames of Reference": 188–197.

16. Jeff Wall, "Photography and Strategies of the Avant-Garde: Jeff Wall in conversation with Boris Groys," *Jeff Wall: Figures & Places*: 139.

17. In other words, cinema will not be the ground of photography any more; photography will provide its own ground. Reference becomes misleading.

18. He writes: "Part of my interest in taking up black & white photography was to rethink my relation...to the assumption that uncolored photographs signify something we call 'documentary.'" Jeff Wall, "The Painter of Modern Life: An Interview between Jeff Wall and Jean-François Chevrier" : 182.

19. Of the *Cyclist*, Wall writes: "The cyclist is resting; he's gaining strength, however little it may be, to move on." Jeff Wall, "The Painter of Modern Life: An Interview Between Jeff Wall and Jean François Chevrier": 184.

20. See Thierry De Duve, "The Mainstream and The Crooked Path," *Jeff Wall* (London: Phaidon, 1996): 41, 44.

21. Because the mural, as a site of unintentional effects, outperforms the figure as a locus of intention, the spatial relationship between the figure and the mural is complicated through a temporal relationship. This is very different from the symbolic or simultaneous relations engineered between figures and places in a single figure colour photograph like *Milk* or *Trân dúc Ván*.

22. Interestingly, Wall says such "drop-in centers ... are run by unpaid volunteers. Volunteer work has something enigmatic about it, in relation to a world dominated by the principle of exchange and paid

employment." Jeff Wall, "The Painter of Modern Life: An Interview Between Jeff Wall and Jean-François Chevrier": 184.

23. In that "note," Wall writes: "I've realized that over the past few years I've made a number of pictures on or somehow related to the theme of cleaning, washing, or of housework. There is much to say about dirt and washing. It is an opposition like 'the raw and the cooked.' I like things to be clean and neat. A serenely well cared-for place can be very beautiful, like the garden at Ryoan-ji in Kyoto, or my darkroom when everything has been washed and put in perfect order." Jeff Wall, "A Note About Cleaning" (1999).

24. "This man cleaning up after others, strangers, is for me maybe the most explicit image of the happy house I could make." Jeff Wall, "The Painter of Modern Life: An Interview Between Jeff Wall and Jean-François Chevrier": 184.

25. Jacques Derrida, Of Grammatology, trans. Gayatri Chakravorty Spivak (Baltimore/London: Johns Hopkins Press, 1976): 62.

26. Jean-François Chevrier, "A Painter of Modern Life: An Interview between Jeff Wall and Jean-François Chevrier," Jeff Wall: Figures & Places: 184.

27. After all, aesthetic beauty might well be the incarnation of hope if not the promise of happiness, or at least this is what the aesthetic superiority of the symbol over that of allegory has long

suggested. Paul de Man, "The Rhetoric of Temporality," Blindness and Insight: Essays in the Rhetoric of Contemporary Criticism (Minneapolis: University of Minnesota Press): 187–228.

28. Jeff Wall in correspondence with the author.

29. Michael Fried, "Being There," Artforum (September 2003): 53.

30. Jeff Wall, "A Painter of Modern Life: An Interview between Jeff Wall and Jean-François Chevrier," Jeff Wall: Figures & Places: 185.

31. One might discern a similar distanciation or dialogue with oneself, by virtue of the grime and dirt that spots the print. Scott McFarland tells me that in 1997 lab conditions in Istanbul were not of the "ultra clean" standards one expects from print processing in Europe or America. The not quite even development in the context of global modernity is revealing: Wall's openness to it, or willingness to retain the traces of it and not airbrush them out, is destabilizing.

32. Chevrier says the picture "is not so much a case of dramatic action of the type depicted in the pictures of the 1980s, but rather of situation. The shift relates to an increasing interest in the language of sites. Wall has not abandoned the possibilities of a pictorial tradition dominated by the concept of 'painted theatre'. This tradition has enabled him to define or redefine the photographic picture as a

synthesis of pictorial composition and cinematographic 'mise en scène'." This seems about right; minus the generalization about work from the 1980s, it is partly what is at stake. However, we need to refine the vocabulary considerably as well as focus on the specific pictorial dynamics of the work and the way these blind one to the photograph as material text or linguistic artifact. Jean-François Chevrier, "The Metamorphosis of Place," Jeff Wall Catalogue Raisonné 1978-2004 eds. T. Vischer and H. Naef (Basel: Schaulager, 2005), 17.

33. Andrzej Warminski, "Prefatory Postscript," Readings in Interpretation: Hölderlin, Hegel, Heidegger (Minneapolis: University of Minnesota Press, 1987): LIV–LVI.

34. A. Warminski, "Prefatory Postscript," Readings in Interpretation: LVI.

35. This is how Can Altay translates the title from Turkish to English and in terms of local geography. He tells me that köy is a village, and that Mahtmutbey in addition to being a village on the outskirts of Istanbul, can also refer to a gentleman: an additional hint that the boy as a figure of hope is inextricably related to the speculative future possessed by the specific location.

36. Paul de Man, Aesthetic Ideology, ed. A. Warminski (Minneapolis: University of Minnesota Press, 1996).

# Vancouver Singular Plural: Art in an Age of Post-Medium Practices

Randy Lee Cutler

Kathy Slade, *Embroidered Monochrome Propositions (O series)*, 2002
embroidered thread on linen, 12 framed panels
Courtesy of the artist
Photo: recorder photography

It is technology and the media which are the true bearers of the epistemological function: whence a mutation in cultural production in which traditional forms give way to mixed-media experiments, and photography, film, television all begin to seep into the visual work of art (and other arts as well) and to colonize it, generating high-tech hybrids of all kinds [...]

—Fredric Jameson[1]

Vancouver is an urban showplace of mediated cultural enterprise. From a vital film industry with a reputation for special effects, an ever-expanding economy in game design, and a diverse community of multi-disciplinary artists, the city is a breeding ground for media innovation. During the past decade or so, the artistic engagement with digital culture represents a relationship between art and technological media that moves beyond the discrete category of "new media" and into a more expansive conception of contemporary aesthetics, what I call "Art in an Age of Post-Medium Practices." As Fredric Jameson noted above, technology is everywhere, mutating traditional forms and seeping into the visual work of art.

The term "new media" has many associations, including interactive arts, the digital economies of commercial applications, a spectrum of communication networks, and online communities. In the context of art, new media generically describes work created with digital technologies, including telecommunications and computer platforms with practices as diverse as Internet art, interactive installations, and mediated performances. Despite the range of iterations, new media is unsatisfactory as a label, for several reasons. First, the appellation "new" conveys an imperative toward the latest technologies as they relate to telecommunications, mass media, and digital modes of delivery. Accordingly, a fear of obsolescence becomes central to its modus operandi without much regard for an evolving relationship with artistic practices. Secondly, the term is generally applied to the Internet, cell phones, robotics, computers, etc., while disregarding its continuity with the traditional arts. With its constant re-categorization, new media is impossible to rename, and yet its continued use suggests a particular paradigm of innovation. In an effort to move beyond this impasse and explore art practices that do not slide easily into the category of new media, I adopt a more idiosyncratic

approach that understands digital technologies as part of an array of "post-medium practices" and constitutive of art in general.

Post-medium practices describe a range of artworks that include computer technologies, electronics, installation, sculpture, audio, and video projection. In other words, art practices whose medium is so expanded that it no longer has much to do with traditional art historical genres and their hierarchies. While interdisciplinarity might cover some of this territory, I use post-medium to refer to art work that melds both digital and electronic technologies with traditional materials while simultaneously reframing their conventional applications. Not only do post-medium practices use a given technology to critique and subvert standardization, they have become a key component in the creation of much contemporary art. Although my emphasis here is on art practices that use digital media, the repurposing of electronic signals in general inform this discussion.

In her 1999 book *A Voyage on the North Sea: Art in the Age of Post-Medium Condition*, Rosalind Krauss uses post-medium to refer to art practices that are no longer medium-specific or exclusively about their own essence, and in turn engage with more than their own material frames of reference.[2] Importantly, I use post-medium practices as opposed to Krauss's post-medium condition, to not only address what lies outside the frame but also what points to the frame and technological support. The addition of digital and electronic technologies into the equation repurposes Krauss's analysis, adapting the term post-medium to discuss works of art that employ numerous strategies, with a pronounced focus on digital engagement.[3] While post-medium practices might seem rather elastic, I prefer it to the overly charged and perhaps now outmoded appellation, new media.[4] Thus, the elasticity of post-medium practices takes the discussion beyond what Krauss originally intended and perhaps anticipated.

The increasing dominance of post-medium practices is enabled by the relative accessibility and quality of consumer-grade digital resources. The availability of a range of computer hardware and software has allowed artists to create digital documents for the twenty-first century. Perhaps another way to consider post-medium practices, particularly in the context of Vancouver, is as a transformation and evolution of Intermedia. The collaborative art strategies of Intermedia made its mark in the late sixties with a range of experimental practices. In part a response to the rise in cable television and video technology, Intermedia was an artistic reaction to the control of mass information by the politico-economic structure.[5] In 1970, Michael Goldberg, one of its Vancouver advocates, wrote: "Small format VTR [videotape recorder] offers us the possibility of slowly displacing the information power trippers; not by our plugging into the consumer distribution matrix, but by destroying it. A new level of awareness is growing with increased human interaction through new tele-

communication grids."[6] At its inception, Intermedia artists investigated non-traditional media and their techniques such as video, performance, and installation, and discovered alternate applications and content for the technological apparatus.

## Art: A Case for Plurality

For many years now, the field of contemporary art has been expanding beyond traditional media to embrace the visual codes and devices of mass culture.[7] Importantly, post-medium practices are not simply a rejection of specific media so much as an endorsement of art in general through integrating the conceptual, formal, and aesthetic concerns of historical and contemporary art strategies. In this way, post-medium practices represent the plurality of the arts without traditional hierarchies or categories. In his essay "Why Are There Several Arts and Not Just One? (Conversation on the Plurality of Worlds)," Jean-Luc Nancy makes a case for plurality when he states: "One is content to affirm that plurality is a given of the arts. To tell the truth, one does not even affirm it; one observes it—and who would not be forced to make this observation?"[8] Much art criticism seeks out the classification or hierarchy of the arts while tacitly perceiving this fundamental ontology of artistic practice, what Nancy calls "the unity of this plurality," as either jejune or simply uninteresting. But a work of art, regardless of its medium, is in dialogue with art in general. For Nancy, the case for plurality is a broad philosophical concept, part of what he calls "being singular plural." In his book of the same name, he attempts to rethink community in a way that does not privilege the individual subject or subjectivity.[9] Being singular plural translates as always and necessarily "being with," in other words, existence is essentially coexistence. The notion of being singular plural is a rich terrain for rethinking the existence and integrated relationship between digital culture and Vancouver art in an age of post-medium practices. In borrowing the term singular plural, I wish to consider how a work of art is always related to other works of art and, with the example of digital media, to other languages and forms of cultural expression.

## The Contiguous Space of Art and Technology

In his essay "Transformation of the Image in Postmodernity," Fredric Jameson considers the centrality of technology in aesthetic experience and how it structures knowledge, which he calls the epistemological function. Jameson suggests that in our times, the methods of obtaining knowledge, information, and experience are dominated by technology and that experimentation and mutation are part of a process that blurs and even

ruptures disciplinary boundaries. Of course, technology is a broad term that can include tools and machines as well as the knowledge of their use. I use the word technology here as shorthand for digital technologies or digital media, specifically the manipulation of digital information for the purposes of aesthetic inquiry. I am interested in the ways in which Vancouver artists shape and subvert digital applications and their electronic circuitry in order to critique its conventions and instrumentality. Instead of ordering information, post-medium practices often reveal the aesthetic potential of information within an historical trajectory of artistic inquiry.

As digital technologies continue to insinuate themselves into traditional art historical genres, Vancouver's contemporary art scene has taken on an "open source" model of production. Rather than work within a specific material tradition, many artists operate across media reflecting cross-disciplinary strategies. Conventionally, open source refers to computer systems whose informatics is available for use or modification; it has also become an aesthetic figure for the repurposing of digital information toward innovative outputs. With the evolution of analogue to digital processes, art practices around the world have mutated into an ever-expanding field, absorbing and sampling a range of influences, from popular culture and advertising to medical imaging and security systems. The explosion of new technologies—whether satellite television, computer imaging programs, gaming, or personal electronic devices—has shifted the cultural terrain, creating a contiguous space where both reality and art perpetually morph with technological forms. For many artists, the challenge is to use digital platforms in ways they were not originally intended.

### Vancouver Singular Plural

In Vancouver, while there are few dedicated exhibition opportunities for digital art, there are many digital communities, including those that explore the political implications of information technology, others that bring digital platforms to audio experiments in order to "sonify" space, and still others that are embroiled in interactive arts producing baroque forms of mediated practice.[10] Media art in particular has been linked to progressive politics that includes early Vancouver video, collaborative models such as the Intermedia co-operative, as well as hybrid experimental narratives in film.[11] Using a selection of exhibitions in Vancouver during the past decade, with a focus on the last five years, this essay explores examples of artwork that critically engage digital technologies while challenging the conventions, genres, and traditional hierarchies of the visual arts. But first, we need to describe some of the regional conditions of Vancouver singular plural.

Home to a major port on the Pacific Ocean, Vancouver has become a thoroughfare for the transportation of billions of dollars worth of goods and services from around the globe. And Vancouver, or Hollywood North as it is often called, has become an important location for many television and film productions. According to Hollywood North FilmNet: "BC is a place where business, government, labour and the community work together to support the province's billion-dollar film industry."[12] In addition to a lucrative film industry, the city is also home to numerous video game companies, game development services, and the like. Information technologies permeate the culture of Vancouver, reflecting both its twenty-first-century economic base as well as a heightened desire for communication in a region enclosed by the Pacific Ocean on one side and the Rocky Mountains on the other. Despite the central place of entertainment and information technologies in the local economy, there is little support from either the BC Arts Council or other provincial funding bodies for elaborate interactive artworks. The Canada Council for the Arts' budget has become limited in response to an increasing number of requests. The general funding categories—visual arts, media arts, and inter-arts (interdisciplinary work, performance art, and new artistic practices)—make it clear that *many* complex digital productions cannot be funded by government bodies. Indeed, the provincial and federal funding agencies continually have to respond to changes in material practices with new categories and/or hybrid programs. As practices converge and realign, some categories may well become outmoded and obsolete. Art, media, design, and interdisciplinary practices have broken down and often blurred into each other, making for an inventive and complicated application process with regard to funding. Perhaps post-medium practices account for some of this plurality.

In 1995, the city's population had increased by more than 500,000 since 1981—a 47 percent jump. At the start of 2006, the population of the Greater Vancouver Regional District was approximately 2.2 million. YVR, the airline industry airport code for the city, represents a node in a network as much as an eco-locale for travel agents. Recently, Canada-China as well as Canada-India corridors have opened up as a result of expanded bilateral air transport agreements that will increase passenger and cargo flights. Vancouver is a key player in these developments. One only has to walk down the street—urban, suburban, or rural—to witness the intensification of digital culture in popular experience. Communication devices such as cell phones, MP3 players, and BlackBerries have all amplified the electronic signals that circumnavigate the planet and our daily realities.

Operating within a globalized economy, to what extent is Vancouver art immersed in the phantasmagoria of digital technologies? Is there a regional response? Or is local artwork merely a symptom of larger processes and conditions? How has the institutionalized art world responded to these innovations? Recent forays into digital media have evolved out

of Vancouver's consistent engagement with Intermedia, interdisciplinary and experimental practices, collaborative models, and community access. Indeed, examples like Indigenous Media Arts Group show how digital platforms can intersect with cultural politics. And The Upgrade!, an international series of gatherings concerning art, technology, and culture, has a node in Vancouver at the Western Front with monthly presentations and exchanges of ideas. The Surrey Art Gallery has also been important to the relationship between new technologies, public art, and community. Furthermore, artist-run centres such as Video In, grunt gallery, and the Western Front have contributed to the continued consideration of cultural diversity, access, and mutating art practices.

There are indeed many sites in Vancouver where the languages of digital media are accessed and recoded toward unique configurations. While the Vancouver Art Gallery (VAG) and Presentation House Gallery (PHG) have contributed to the exhibition of post-medium practices, both venues tend to curate the ubiquitous video projection. Toronto artist David Rokeby's installation The *Giver of Names* and *Watch* at PHG in 2001 was a welcome exception. Indeed, *Watch* (1995) intentionally subverted perception through the surveillance system of the work.[13] Both pieces used computers and sensors to examine the promise of technology and our ambivalence toward it. At its best, Rokeby's art, usually described as new media, created a contemplative space for experiencing consciousness and perception. And Stan Douglas's exhibition at the VAG in 1999 illustrated innovative applications for the figure of open source in contemporary art. For example, his *Win, Place or Show* (1998), a recombinant work which uses a split screen to show endless digital configurations, would take 20,000 hours of live projection over two years before any one combination of images is repeated. In addition to the computer-generated, random ordering in his work, Douglas's process samples freely from a range of sources using the projected screen as a location for the condensation and displacement of a fractured narrative.

Photoconceptualism and video projection, both of which incorporate digital platforms, generally operate more as illusionistic painting or "digital realism" than mediated practices that substantively engage with innovation and critique around digital technologies. One could argue that the issue is not at the level of practice but how work is curated and discussed. The foothold that photoconceptualism has in the Vancouver imaginary is due in part to the international ambitions of individual artists, the collecting practices that form what narratives get told, and a cultural network that continues to privilege male artists. Is the dominance of photoconceptualism an example of the convergence of traditional and emerging forms? Or do the old hierarchies and exclusions of the fine arts still apply? Interestingly, while it took more than 100 years for photography to be accepted as an art form, far less time had to pass for digital productions to be exhibited in the contemporary museum. In an artist talk,

Douglas suggested that skills and literacy from watching television and film are brought to reading work in a gallery.[14] Perhaps the acceleration of post-medium practices—if not the ubiquitous video projection—is the result of its familiarity within our everyday lives. These under-interrogated relationships are implied in my concentration on Vancouver artists who critically engage digital technologies through a range of outputs, formats, and aesthetic configurations.

### As Above, So Below

In 2000, Artspeak presented *A Set of Suspicions*, a series of exhibitions and events by artists investigating ideas of threat, security, and surveillance. The first work in the program, Daniel Jolliffe and Jocelyn Robert's *La Salle des Nœuds (pedestrian movements)*, 2000[15] comprised a GPS receiver, electronics, and a Disklavier piano. Like all the works in the series, *La Salle des Nœuds* used the gallery space to index off-site locations, specifically the mobile "watching machines" that orbit the earth. Formally, the installation was quite stunning in its presentation of a grand piano as a sculptural object. This configuration was conjoined with the alternating minimal to cacophonous soundscapes produced by the piano. Upon closer inspection, the viewer might recognize the GPS device positioned at the entrance to the gallery and make a connection to the "music" produced by the piano. Ostensibly, the work filtered and transcoded the traditional use of satellite data (technological coordinates to aid in warfare) by inverting the positions and movement of the satellites into music as cultural artifact.[16] *La Salle des Nœuds* visualized and aurally translated cultural approaches to technology that are normally invisible. It highlighted the technologized society that we inhabit and redirected the information flow away from instrumentality and toward subjective interpretation.

Circumscribing institutional spaces, such as the gallery, can inform much of the work of the post-medium condition. Rather than celebrate mastery through a discrete object, this mode often emphasizes artwork specific to the site on which it occurs. This approach challenges existing genres and methodologies by linking the work to everyday phenomena and ephemera. Jolliffe and Robert's *La Salle des Nœuds* initially offered itself as a sculptural object that was transformed by an electronic system charting exterior forces. Furthermore, gallery visitors had to use their perceptual abilities to decipher the work, only to realize that the mechanics operate in tandem with the translation of relations and social processes of bodies, large and small. Regardless of the artists' codes and transmissions employed, the installation operated in real time as engaging aural and material experience that made spaces and flows "visible" to the viewer.

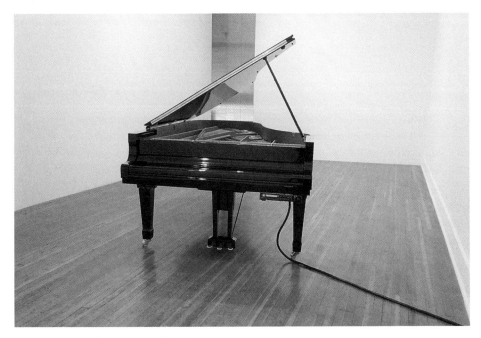

Daniel Jolliffe & Jocelyn Robert, *La Salle des Nœuds (pedestrian movements)*, 2000
Yamaha Disklavier piano, computer, GPS receiver, custom electronics
© CARCC, 2006

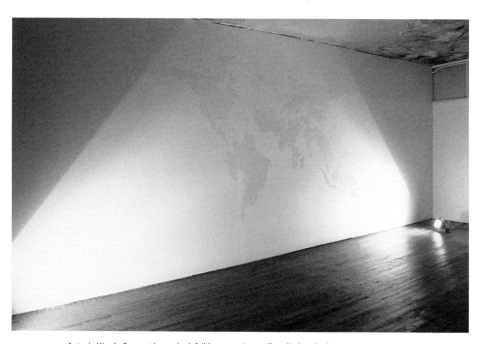

Antonia Hirsch, *Forecast (annual rainfall by country)*, 2005 (installation view)
clear varnish on wall surface
© Antonia Hirsch, 2005
Courtesy of the artist

It is not an overstatement to suggest that the sublime beauty of cos-
mological phenomena and the weather have inspired much art, from
sixteenth-century Dutch and French pastoral landscapes with their real-
istic perspectives and lighting effects via optical instruments, to Georgia
O'Keefe's fascination with skylines and cloud formations. With an arsenal
of new materials and strategies, meteorological information has assumed
innovative forms of representation that examine our relationship to
isobaric pressure and similar concepts through scientific and indexical
notation. In light of the extreme weather, particularly storms, precipi-
tation, and droughts—the subject permeates our daily conversations.
Antonia Hirsch's *Forecast (annual rainfall by country)* (2005), shown at 69
Pender Gallery in the same year, explored the aesthetics of a world map
recalibrated relative to the annual precipitation in each nation. The work
consisted of an almost invisible map painted with clear varnish on the
gallery wall. Using digital mapping software, she applied mathematical
scaling and statistics to underscore the already skewed approximations
in cartography. The raw data, obtained from the Food and Agriculture
Organization of the United Nations, the CIA's *World Factbook 2003*,
and worldinformation.com, was fed through Hirsch's pseudo-scientific
process that included computing, editorial decisions, and a modicum
of irreverence. As Hirsch has stated, "these maps graphically illustrate
the ideological bias that underlies 'factual' information."[17] Measuring,
recording, and, by extension, the control and manipulation of meteoro-
logical information are made subtly evident.

Employing a standard system of knowledge—the map—Hirsch's series
aestheticizes the "objective" neutrality of scientific language. With *Forecast*,
she made visible ideologies and economies implicit in the spatial logic
of geography and externalized the information, giving it a visual syntax.
There is an interesting similarity between the drift of fixed landmasses in
Hirsch's map projects and the general idea of mutation in post-medium
practices. In many of the works discussed here, artists direct the viewer's
gaze outside the exhibition space, up toward the skies and even further to
the movement of satellites. Hirsch's work, which often engages with scien-
tific tools that suggest medical diagnostics, navigation, and meteorological
measurement, draws viewers into their own slow and measured readings
of cultural artifacts. Her diverse practice not only considers the specific
user base of a given software, but also takes into account the original and
reconfigured contexts and economies for their applications. The issue is
not simply the subversion of digital technology but its specific history and
culture, which is then reframed within a fine art context. Importantly, the
work of art is not inserted back into a technological environment, but rath-
er located in a space that allows for more nuanced readings.

## Doing It for Themselves

While digital technologies shape much contemporary artwork, techno-theory has been formative to many Vancouver artists. In 1994, the Western Front responded to pressures from both provincial and federal funding bodies to differentiate its programming from other artist-run centres. It already had a music program with cross-disciplinary practices as well as the rich history of Intermedia since the late 1960s. At the same time, a collective project called Monster Central was formed, comprised of artists, curators, and cultural critics who shared interests and concerns regarding women and digital technology. Rumour has it that when the Western Front offered workshops in digital technologies in the early 1990s, a group of women decided to get involved in what they perceived as a "boy's club" and learn the tools of the trade. Initiated as a reading group studying theories around technology, the then-anonymous members of Monster Central became involved with local performances, publica-tions, and an Internet teleconference. As one of its members, Monique Genton, has stated: "They met regularly to review current media and to discuss how they, as women, could explore issues such as gender and sexuality on the Internet, improving women's access through an artist-run centre, and how the model of monster/woman/machine forms a potential means of gaining agency in the digital domain."[18] This was a strategic moment for artists who came together to assist in the research and production of emerging media.

The continued investigation of technoculture by women artists in Vancouver reflects larger issues raised by theorists like Donna Haraway and Sadie Plant that address science, technology, and Socialist-Feminism. Part of a more recent generation of artists, Kathy Slade has contributed to the conceptual practices of post-medium production. *Embroidered Monochrome Propositions and Other New Work* (2002), at the West-ern Front, presented a number of minimalist textile works incorporat-ing Slade's interests in, among other things, the history of craft and pop cultural sources. The monochrome "paintings," embroidered by machine, draw upon histories of decorative art, labour, and fine art, among oth-ers, and evoke both the global condition of women's sweatshop labour as well as the origins of computer technology. Mathematician Ada Lovelace (1815–1852) created one of the first computer programs and anticipated the enormous potential of computers, including the automated weav-ing loom. Sadie Plant's *Zeroes and Ones: Digital Women and the New Technoculture* (1997) traces a brief history of Lovelace's involvement with Charles Babbage and his Analytical Engine, and recognizes the funda-mental role that women have had in the manufacture, development, and use of technology. With a welcome sense of humour, Slade evokes Plant's argument that sophisticated machinery produces more female work and creates radical change in the status of women workers within the new

economic structures.[19] Rather than an exclusively positive or negative spin, Plant foregrounds the complex relationship between women and mechanization. The ambiguity is not lost on Slade. Her work, including the *O series* (2001) and *Movie Samplers* (2002), also riffs on the semiotics of sampling. A sampler is an embroidered cloth with a design, motto, or letter of the alphabet that serves as an example of needlework; it is also an electronic device used to digitally manipulate audio segments. As Jonathan Middleton has written: "Slade is as much a DJ as a visual artist—conflating and combining material from otherwise disparate sources to create new meanings, and to modify previous readings to a particular political end."[20] Like the aesthetic figure of "open source" production, Slade works across media repurposing manufacturing processes as well as reframing women's history.

## Performance, Improvisation, and Co-existence

A significant output for post-medium production is work that explores bodily presence in relation to mediating technologies. When the living body is juxtaposed with mediated forms, the result can be an idiosyncratic expression of improvisation and repetition where complexity, multiplicity, and human presence become modalities ripe for interpretation. Through its use of the live event, performance art can materialize ideas by making them immediate. As a medium, performance highlights not only the quality of process, but also the liveliness and presence of the audience's imagination. The collective affect of performance art can serve as an antidote to the distancing effects of technological communication; its immediacy often produces discomfort, confusion, and a strong sense of embodiment.

A unique approach to identity and digital technologies can be found in the work of interdisciplinary artist Laiwan. In her large-scale *Quartet for the Year 4698 or 5760: Improvisation for 4 Film Projectors* (2000), the artist, along with virtuoso clarinetist Lori Freedman, created a multimedia installation at the Morris and Helen Belkin Art Gallery in 2000 using film with audio, live performance, music improvisation, computer media, and the Internet. Musical improvisations were fed digitally into a computer for translation into musical notation and then printed by a dot matrix printer onto paper. Ambient sounds from the film projectors and the exhibition space (e.g., the rotating door at the entrance to the gallery) were also entered into the system. Because the amount of information was at times too much for the computer to process, the work varied from fully functional, delayed to silence. As a result, the apparently flawed composition required interpretation on the part of the viewer to make sense of the stops and starts. Like any work of art, *Quartet* emphasized the intertwining of physical and mental experience. Bodily

presence was therefore another component in the installation in order for the work to make sense. With *Quartet*, Laiwan explored "commonly held assumptions and expectations for computer technology to interpret into textual form, a meaningful translation of that which is subtle and felt subjectively (such as music)."[21] Rather than communicate a specific narrative, the work depended on how viewers read and experienced their own assumptions.

Laiwan, *Quartet for the year 4698 or 5760: Improvisation for 4 Film Projectors*, 2000
16 mm. projectors, audio, circular screen, computers, dot matrix printer
Courtesy of Morris and Helen Belkin Art Gallery, Vancouver
Photo: Howard Ursuliak

In its improvisation and spontaneity, the installation critiqued the limitations of machines. By collating analogue and digital information systems as well as highlighting the shift from industrial to information-based economies, *Quartet* posed more questions than it could answer. Exploring relationships between bodily presence and technology, and employing a variety of media, the composition was open to chance, improvisation, and repetition. Due to the complexity and duration of the piece (film loops, audio, projector mechanisms, and computers), deterioration and information overload were intentional components of the composition.[22]

The notion of improvisation and repetition of contradictory elements of media-based art are reflective of a humanist approach to technology and communication. Warren Arcan has pushed these concepts in such works such as *Oopsy Daisy* (2000), shown at Artspeak in 2000, and the performance *Superchannel* (2004) at grunt gallery. The layers and trajectories implicit in *Superchannel* evoked the flows of information that individuals in industrialized nations negotiate daily at the local level. And like Laiwan's *Quartet*, the work invited multiple readings and entry points that addressed minority communities. At the start of *Superchannel*, each audience member was given a remote audio device, the kind used during large conferences for simultaneous translations of a presentation. The seven-channel, wideband receiver or Simultaneous Translation Device played seven separate channels of prerecorded tracks that included

songs, guytalk (or men talking), bird calls, Cree word forms for love, an
ecstatic female quietly moaning, philosophy read by a feminized com-
puter voice, and samples of the above.[23] As Arcan performed cryptic,
ritualized gestures—pacing, sighing, dramatically readying himself for
something—the audience would select an audio track to accompany the
visuals. The soundtrack informed how one read the artist's gestures, but
it was provisional; the channel could be changed at any time. When the

Warren Arcan, *Superchannel*, 2004
DAT player, wireless conference headsets
with seven channels (mono)
Courtesy of grunt gallery, Vancouver
Photo: Merle Addison

experience got too intense or uncomfortable, one could surf, raiding the
possible configurations of sound and image. The result was both an indi-
vidual and shared, that is, a singular plural meditation on the subject of
love, communication, and viewer engagement: audience members were
an interconnected hive, co-existing through the synergies of their own
auditory and visual experiences. While the artist initially shaped what
the audience heard, the entire experience was actually a plural nego-
tiation between Arcan's samples, individual listening styles, and group
engagement.

   The navigational structures of communication technologies offer a com-
plex model for moving through information and experience. In Arcan's
performance, the hand-held device became a "material metaphor"[24] for the
frequencies and networks that we negotiate and enact on a daily basis. In
this way, the fluidity of human desire and expectation was made manifest
in the network of possibilities, signal switchers, and routers structuring our
engagements with technology. With the co-existence between performer,
the audio device, and audience, transit seemed to reside both inside the

subjective imagination and outside among the collective audience. The electronic and emotional architecture of Laiwan's *Quartet* and Arcan's *Superchannel*, with their multi-directionality, multiplied viewers' own bodily capacity to move through space and time regardless of their entry point. These works of art articulated the vectors that connect objects to subjects, humans to technology, expression to representation. Whether a discrete object, an installation, or a performance, post-medium practices can create environments for viewers to expand their perception of the frame, extending the experience beyond the image/object/site.

Aspects of post-medium practices are works that repurpose electronic signals away from traditional forms. Fiona Bowie's *WAX/WANE* (2000), part of the exhibition *These Days* at the Vancouver Art Gallery in 2002, exploited the potential of video with an anti-representational work by presenting a live event (a media jam at the Western Front) within a re-duced register of audio and visual signals. Tucked away in a small niche, the audio reached viewers before any visuals could explain the apparent ruckus. Once around the gallery wall, viewers were met with the snow and static of failed video reception. The illusionistic potential and ubiq-uity of video as mimetic projection was transformed into a technological gesture. Anticlimatic and disturbing, *WAX/WANE* seemed to critically, if obscurely, comment on the operating conditions of the medium itself. While the original context for the audio was unclear and perhaps even unimportant, the work underscored the aesthetic of limitations, flaws, and deterioration, again intentional components of the work. Marina Roy has suggested that "The breakdown of communication and the absence of the visual seem[ed] to mask a deeper meaning related to the subsump-tion of the body by the autonomous whims of technology."[25] The viewing experience was thwarted by context and expectation.

As a work of post-medium practice, Bowie used the video as a ready-made object which, rather than heighten the visual, drew attention to one's presence in space and time. Fundamentally distinguishable from the instantaneity of advertising and image culture, it highlighted expec-tation by throwing perception squarely on our own desires where the audience was poised between the source of the video's luminescence and the image projection. Krauss would describe this strategy as redemptive. It represents "the idea of the countertype—as a dialectical after-image of a social role now reified and corrupted under capitalism."[26] It is a form that somehow erodes its own specificity, begging the question whether the work of art is the object, the narrative, the digital effects, the con-vergence of image and sound, the abstraction of the form, or any other number of possibilities. The multiple readings of *WAX/WANE* and indeed other works discussed in this essay highlight the diverse potentialities of post-medium practices without the need for a resolution of differences among them. Post-medium practices are decidedly plural and open in their imaginable formations.

No Endings, Just Circuits

In adapting Nancy's phrase into Vancouver singular plural, we recognize that all art-making takes part in the larger expression of creativity and community, challenging the idea of specificity for all the arts. Our present cultural moment, for the most part, terminates the individual arts as medium specific and instead accentuates the artist's improvisation with a variety of digital technologies. And by drawing on and sampling a range of materials, processes, and strategies, emerging practices have adopted the figurative model of open source. Within the context of a local economy that foregrounds entertainment and information technologies, Vancouver artists reframe and subvert digital applications and their electronic circuitry in order to critique their conventions and instrumentality.

Over the past decade, through a mixture of elements including the legacy of Intermedia, feminist-influenced interventions, and the cultural diversity afforded by artist-run culture, Vancouver artists have contributed to the mutation of artistic practices. By mixing and remixing the signals of traditional materials with emerging technologies, post-medium practices offer liberatory implications for art and digital culture. Like any work of art, the results of post-medium practices acknowledge the prevalence of mediated culture while providing a critical experience to move through it. Medium, intention, and co-expression are in simultaneous circulation. Through innovative experiments, post-medium practices offer new possibilities for an active engagement with digital technologies and imagined worlds.

1. Fredric Jameson, "Transformation of the Image in Postmodernity," *The Cultural Turn: Selected Writings on the Postmodern, 1983–1998* (London/New York: Verso, 1998): 122.

2. Rosalind Krauss, *A Voyage on the North Sea: Art in the Age of the Post-Medium Condition* (Thames and Hudson: New York, 2000): 11. Krauss uses the term post-medium to discuss the work of the Belgian artist Marcel Broodthaers where she states "The specific mediums—painting, sculpture, drawing—had vested their claims to purity in being autonomous, which is to say that in their declaration of being about nothing but their own essence, they were necessarily disengaged from everything outside their frames."

3. I should state here that post-medium practices are quite distinct from the recent fascination with post-production. Nicolas Bourriaud's term, and book, *Postproduction* (2003) is a response to the increased supply of works with a subsequent focus on cultural recycling and alternative models of art production. Its argument, that materials are shifted to a secondary position, is distinct from this discussion of art that is critically engaged with digital technologies.

4. This position is echoed, if only obliquely, in the recent exhibition *The Art Formerly Known as New Media* (2005) at the Walter Phillips Gallery, which eschews the term "new media," without offering a replacement.

5. Mike Goldberg, www.radicalsoftware. org/volume1nr4/pdf/VOLUME1NR4_0059. pdf

6. Ibid.

7. Claire Bishop in the Tate Modern and Open University's Webcast, "Installation Art and the Post-Medium Condition: Expanding Concepts of Sculpture" also

elaborates on how mediums have collapsed into each other producing a single totality or a visual field that is contiguous with our own space. www.tate.org.uk/ learning/studydays/sculpture/sculpture6. htm (accessed May 29, 2005).

8. Jean-Luc Nancy, "Why Are There Several Arts and Not Just One? (Conversation on the Plurality of Worlds)," *The Muses* (Palo Alto, CA: Stanford University Press, 1996).

9. Jean-Luc Nancy, *Being Singular Plural* (Palo Alto, CA: Stanford University Press, 2000).

10. Of course, there are still more examples from the School of Interactive Arts and Technology at Simon Fraser University in Surrey, BC, to the industry-oriented New Media BC, Electronic Arts Canada, and Radical Entertainment. Importantly, one could argue that these contingents, while creating some dialogue between the various media players, are more oriented toward the commercial end of the spectrum.

11. See the essays on these subjects in *Vancouver Anthology*, ed. Stan Douglas (Vancouver: Talonbooks, 1991).

12. See www.hollywoodnorthpr.com/ industry.html

13. A series of conferences entitled *Body, Mind and Technology* took place in parallel with the exhibition where speakers gave talks around the theme of the body's inscription in a technologically mediated space.

14. Stan Douglas, Artist Talk presented by the Contemporary Art Society, Vancouver, September 27, 2005.

15. The piece was originally called *La Salle des Nœuds (pedestrian movements)* and later changed to *Ground Station*.

16. See the artists' statement at www.danieljolliffe.ca/sdn/sdn.htm

17. This is from Hirsch's unpublished Map project description.

18. See www.moniquegenton.com/ Monster/Monster.html

19. This includes the role of third-world and non-Western women, shifts from male identity-through-work to female plural-identities-through-function. Sadie Plant, *Zeroes and Ones: Digital Women and the New Technoculture* (London: Fourth Estate Ltd., 1997): 38-43

20. Jonathan Middleton, "Introduction," *Kathy Slade* (Vancouver: Western Front, 2003): 4.

21. Laiwan, www.belkin-gallery.ubc. ca/laiwan/project_description.htm

22. Laiwan describes it the following way: "Playing with the idea of the millennial year (4698 and 5760 are the Chinese and Jewish calendar years respectively for the year 2000), ... the musician was asked to freely improvise. As a result, sub-themes of the work may surface: contemplation/ spontaneity; contingency/history; what has passed/what is to come; temporality/ duration; bodily presence (live music)/ mediated absence (on film); emotional intelligence/artificial intelligence; and body/machine." www.belkin-gallery.ubc.ca /laiwan/project_description.htm

23. Interestingly, Arcan describes this negotiation of signals as "an aboriginal model of communication." He elaborates by suggesting that certain "intuitions or conceptual effects" are used. While he doesn't speak Cree, Arcan knows enough about its structures to get insights into language and word construction:

> One of the features of Cree is that
> it has two broad grammatical
> categories: the animate and the
> inanimate. [...]What I experienced
> when learning a little about Cree
> is one worldview meeting another,

sharing some features, but so clearly not sharing others.... This kind of grammar has a direct homeopathic effect on anthropomorphism and on centrisms in general. These effects are further enhanced by the language's stem structure. In Cree, one has a root word and meaning is made by attaching inflectional endings. According to my "Student's Dictionary of Literary Plains Cree," the average Cree stem is rarely identical to an English word, meaning the word is built from the stem with the inflectional meaning.... There are not English conventional Subject-Verb-Object relations in Cree. Further, word order in Cree has been described as 'free,' meaning there are no syntax regulations when it comes to forming sentences. It takes more analysis on my part to really name what I'm getting at, but I also like the experience of being on the lip of this language. (personal correspondence with the artist)

Of course, one can make this claim about any language: even communication not free of syntax allows for numerous readings. But Arcan's engagement with Cree syntax, however loosely applied, does seem to mirror the infinite vectors of a de-centered network of communications. As Arcan proposes, "So the 'abo model that allows for a-human communicants' (like person to stone), makes a very pleasant dodge of many creaky and drafty western constructs." (personal correspondence with the artist)

24. Katherine N. Hayles with Anne Burdick, *Writing Machines* (Cambridge, MA: MIT Press, 2002): 42.

25. Marina Roy, "Review of These Days," *Last Call* 1: 2 (2001).

26. Krauss, *A Voyage on the North Sea*: 45.

# Dealing (with) Cultural Diversity: Vancouver Art, Race, & Economies

Sadira Rodrigues

Natasha McHardy, *Picnic*, 2003
resin cast, oil paint
Courtesy of the artist

How do strategies of representation or empowerment come to be
formulated in the competing claims of communities where, despite
shared histories of depravation and discrimination, the exchange of
values, meanings and priorities may not always be collaborative and
dialogical, but may be profoundly antagonistic, conflictual and even
incommensurable?

—Homi K. Bhabha[1]

Vancouver, in the last twenty years, has witnessed considerable chang-
es in its economic, cultural, and social makeup; many of these changes
have been framed by the issues of race relations, or what we often
mean today when we use the term "cultural diversity." Whether we
consider Vancouver's economic partnerships within the Asia-Pacific re-
gion, or the British hand-over of Hong Kong to China in 1997 coinciding
with Vancouver hosting the APEC (Asia Pacific Economic Cooperation)
Summit, or the fact that as I write this nearly forty-nine percent of the City
of Vancouver's population is considered to be from an "ethnic minority,"[2]
there have been incalculable ways in which Vancouver has had to deal
with cultural diversity. This has also meant that Vancouver's artistic and
cultural institutions have not only been witness to such changes, but
have been charged with addressing concerns of diversity in their pro-
gramming, staffing, funding, and mandates. In my opinion, two significant
governmental changes, beginning in the late 1980s, informed the way
Vancouver's artistic institutions deal with cultural diversity today. The
first of these changes was the creation of Canada's Multiculturalism Act
of 1988, to which present definitions of cultural diversity owe their gen-
esis; the second was the subsequent changes in funding allocations and
policy language by the Canada Council for the Arts, our largest national
arts funding institution.

   Canada's Multiculturalism Act imagined Canada not as it was at the
time: precariously global, fractured by cultural and linguistic battles, and
fighting to maintain a sense of singularity against the demands of the
global marketplace and the growing strength of the US economy. Instead,
the Act promoted the idea of a national culture that celebrated cultural
pluralism, while masking tracks of inequity that continued to prevail. And
to ensure that Canadian society adhered to the demands of the Act, a

policy was also drafted to enforce multiculturalism in instances of discriminatory activities.

In the Act's immediate wake, all governmental agencies and programs were reevaluated to ensure compliance with issues of multiculturalism. The Act's statement that arts, culture, and heritage activities play a central role in creating a definition of *nationhood* meant that the scope and intent of multiculturalism also included Canada's contemporary art institutions and practices, Vancouver included. A significant example of this came in 1989, when the Canada Council for the Arts identified cultural diversity as one of the principal challenges it would face in the 1990s. The following year, the Council engaged consultant Chris Creighton-Kelly to assist in developing policies and strategies to deal with cultural diversity.[3] For the Council, the policy sought to resolve historical inequities experienced by artists from racial communities, specifically those of Asian, African, Latin American, and Arabic heritage. In the following few years, the Council created new programs and reevaluated existing programs to ensure the participation of marginalized artists and institutions. In 1991, the Council hired its first Equity Coordinator and created the Equity Office to facilitate funding access for Canadian artists and organizations of all racial and cultural backgrounds to Council programs. The changes that would follow at the Council, in the name of cultural diversity, were structural, systemic, and undeniably significant. Through the Equity Office, the Council has dispensed more than $25 million in funding to culturally diverse artists, curators, writers, and organizations to date.[4] And despite the supposed "arm's-length" relationship that the Council was to have with both government and recipients, the Council "initiated and pro-actively supported [processes] on equity,"[5] and charged Council officers and peer assessment committees with their enforcement in assessing funding allocations to artists, writers, curators, and institutions. In 1997, the Council redrafted its Peer Assessment Policy to institutionalize the representation of culturally diverse artists on peer assessment committees. In the following years, the Equity Coordinator, along with the First Peoples Coordinator, reported directly to the Director of the Council, advising on programs and policies across the institution. So it comes as no surprise that in 2001, the Canada Council for the Arts was a finalist for the Canadian Race Relations Foundation's Award of Excellence.

The Canada Council has not been the only public arts funding organization to address issues of access and equity. In British Columbia by the early 1990s, the Office of Cultural Affairs at the City of Vancouver and the British Columbia Arts Council, as well as private institutions such as the Vancouver Foundation, also began to evaluate their programs and procedures, looking to increase the participation of visible minorities. The ensuing policies on cultural diversity, both national and regional, were enacted through a shift in program language, staffing and board membership, mandate appraisal, and funding procedures.

What is most significant about these various changes is their ramifica-
tions on Canadian cultural institutions at the ground level. The question
of how these institutions have dealt with cultural diversity is an impor-
tant one. After all, public and private funders play a critical role in the
lives of almost all cultural institutions. As a result, directors and curators
of arts organizations—whose existence is largely reliant on the contin-
ued support of public funding—have begun to ask important questions:
What are the criteria for determining whether a project or exhibition has
elements of cultural diversity? Are there certain "quotas" of diversity that
should be maintained? Is it possible to naturalize these concerns so they
do not require their regulation through funding structures?

I want to make clear that it is certainly not my intention to suggest that
the concepts of race relations, cultural diversity, and multiculturalism are
either the same or interchangeable. Since the creation of the Act in 1988,
the debates and contestations between multiculturalism and cultural di-
versity have been marked by challenge and compromise. Multiculturalism,
as defined by the Act, is the recognition of "race, national or ethnic origin,
colour and religion as a fundamental characteristic of Canadian society."[6] It
is a concept that defines racial and ethnic *otherness* in the Canadian popu-
lation in order to ensure equity and access for all in the economic, social,
cultural, and political life of Canada. Multiculturalism represents the ideas,
documents, and procedures developed and implemented through govern-
mental policies and programs that construct certain meanings based on
racial and ethnic difference, and work toward addressing discrimination
on the grounds of the very difference it demarcates: on the one hand, the
desire to eradicate racial discrimination; on the other, the necessity to reas-
sert *difference*, as guarded by the Act's policies. While multiculturalism is
intended to include all minorities experiencing exclusion or discrimination,
in large part, it has come to denote race and the notion of "visible minori-
ties." In this sense, policies of multiculturalism assign certain meanings
and values to differences constructed along the lines of race in opposition
to a mainstream dominant culture. It points to the optics of involvement;
that people of colour are involved is as critical as the actual changes.

In recent years, the term multiculturalism has evolved into cultural di-
versity, signifying an understanding that multiculturalism as an official
governmental policy is fraught with fissures and limitations. For many
artists, writers, and other cultural workers, multiculturalism is an insti-
tutional policy that seeks to rectify historical inequities in quantifiable
ways. Some believe the changes made by funders in the service of multi-
culturalism are a form of "affirmative action" producing "state-sanctioned
culture"; they also raise questions about the efficacy of creating special-
ized programs targeting particular communities. Because artists' and au-
diences' cultural backgrounds are factors of policy decisions, there are
some who caution that artists are being judged and promoted according
to their ethnicity, and not on the basis of their creative work, "integrat-

ing the individual into the state through an uncritical adoption of racial self-categorising and the like."[7] For others, cultural diversity places values—social, moral, political, and economic—on cultural backgrounds. Policies then need to be enacted and involve procedures of enforcement and accountability. As a result, formulas and methods are developed for "adopting" these policies as if singular solutions are possible.

For me, cultural diversity encompasses not only these concerns about multiculturalism, but also a range of debates and theories including identity politics, critical race theory, subaltern studies, cultural studies, First Nations studies, and cultural race politics. Yet in using the term cultural diversity to encompass the range of these debates, I am also quick to point out that there are distinct differences between these various positions. At its core, however, cultural diversity is the acknowledgment that race is assigned as a mark of difference, and one that has shifting cultural, moral, economic, and political values. More importantly, cultural diversity contends that questions of race have retained a marginalized position in various forms of institutions—educational, artistic, corporate, or otherwise. At agencies like the Canada Council for the Arts, from the very beginning policies of what became cultural diversity have been based on the understanding that visible minority artists and practices were racialized and marginalized. These policies that focus specifically on racialized communities are seen as tools that will "solve" this "problem." And today, when the term cultural diversity is used, this collusion between its plurality and its problematic reassertion of racial difference remains a legacy of the groundwork laid by the Act.

### Measures of Diversity

How then are categories of difference created? How and when is an artist identified as being a visible minority? A more complicated question involves classifying artistic practices. How is the content, intent, or implication of a work of art identified or measured as being culturally diverse? Is the work of an Asian-Canadian artist identified as being culturally diverse solely based on the ethnicity (and authenticity) of the artist, or does the work have to contain Asian-Canadian content? For me, art that merely deals with cultural diversity for its own sake tends to be either celebratory or reactionary, and retreats from judgment based on critical criteria. Cultural diversity, which as a policy tells us to "respect other voices" regardless of whether or not they are good, interesting, stimulating, or have integrity, can lead to contempt for this type of funding based on formulaic recognition.

What then is appropriate culturally diverse content? Is the work of a white European artist classified as culturally diverse if it represents

subjects from marginalized communities? And how does one measure cultural diversity? In the case of Jeff Wall's work, questions of race and culture persist. From *Mimic* (1982), *The Storyteller* (1986) and *Trân Dúc Ván* (1988) to *After "Invisible Man" by Ralph Ellison, the Prologue* (1999–2000), *Fieldwork–Excavation of the floor of a dwelling in a former Sto:lo nation village* (2003), and *Boys cutting through a hedge* (2003), Wall investigates categories and conditions of class, race, and gender, not as

Jeff Wall, *Mimic*, 1982
transparency in lightbox
Courtesy of the artist

subordinated appendages or tokens, but as complex, antagonistic, and profoundly fractured concerns. In some ways, his work reflects Vancouver, the location of their production, where race is embedded in the city's social, political, and economic life. But according to the Canada Council's statistical measurements, it is unlikely that Wall, as a white man, would "count" as contributing to issues of equity or cultural diversity; and by extension, unlikely he would have the authority or right to be representative of concerns of cultural diversity and equity. Even the institutional apparatuses supporting his work—funders, museums, collectors, writers, and curators—seem equally willing to circumvent Wall's engagement with these issues. Although asserting that his work is about race is equally prescriptive and problematic, Wall also states that, "*Mimic* was about racism in some way, about hostile gestures between races, but I'm glad the picture itself is good and it doesn't need that to be successful.

Now I try to eliminate any additional subject matter—those things are for other people, they're not my problem."[8] His remark seems ironic given that *Mimic*, and numerous other works, centre on race. It is the comment "those things are for other people, they're not my problem" that is most revealing. It polarizes the art world into producers and receptors—as if a chasm remains between an artist's intentions and the responsibilities of the institutional apparatus that assess the work. If it is "for other people," then the ways in which later works such as *Fieldwork* (2003) have been assessed suggest suppression, denial, and perhaps even a distancing from the taint of race by writers, curators, collectors, and exhibiting in-stitutions. It also reveals the limitations in the ways in which institutions measure cultural diversity, attributing it solely to the work of and by art-ists from non-white communities.

In a very different way, race is a spectre haunting the work of another Vancouver-based artist, in this case one who has often consciously and emphatically distanced himself from being identified as a visible minor-ity artist. For Stan Douglas, being Caribbean-Canadian has unwittingly implicated him in the frame of cultural diversity, conflating his racialized identity with his practice. This is not to say that his works such as *Pursuit, Fear, Catastrophe: Ruskin, BC* (1993), *Nu·tka·* (1996), and, more recently, *Inconsolable Memories* (2005) are devoid of issues of race; rather, it is that race is not foregrounded. But that Douglas is more likely to be count-ed toward a gallery's culturally diverse programming than Wall presents a question about institutions' processes of "epidermalization."[9] By man-aging the boundaries of cultural diversity through biological demarca-tions, it connects biological materiality with a racialized and politicized materiality. And if cultural diversity has a particular economic value, then funders and art institutions assign different values to artists based on biological determinants. This, at its core, is antithetical to the notion of cultural diversity, which seeks to be inclusive of *all* cultures. So the ways in which Wall's and Douglas's works are held to different standards as a result of the artists' ethnographies is largely a result of the methods used by funding agencies to quantify its successes and achievements in promoting issues of cultural diversity.

With an acute awareness of these concerns I began my curatorial practice in 2001, when I was granted a curatorial residency funded by the Canada Council for the Arts Assistance to Culturally Diverse Curators Program. My two-year residency took place at Centre A, a Vancouver public gallery with a mandate of exhibiting contemporary Asian and Asian-Canadian art. Although the gallery had been incorporated in 1999, and had only hosted a handful of exhibitions and symposia, it had already managed to become the subject of heated debate. There were a number of artists who felt that Centre A's focus would perpetuate ex-clusionary methods of dealing with cultural diversity. Concern was also raised about what Centre A meant by the word "Asian," and how the

gallery would attempt to be critical of its own institutional status. It was accused of privileging global practices over local ones and of not being sufficiently connected with the existing community of Asian-Canadian artists and writers. Although Asian-Canadian artists had been calling for inclusion in exhibitions at art institutions in Vancouver, they were uneasy about the creation of an institution dedicated to work from a particular geographical and cultural region. Critics also wondered why an auxiliary to an existing institution, such as the Vancouver Art Gallery, had not been developed.

Amidst this, Centre A Director Hank Bull and I curated a series of exhibitions that thought through these issues. *Locating Asia* was a year-long project that included work by artists Sylvia Borda, Heri Dono, Hu Jie, Evan Lee, Yoshiko Shimada, Mohamed Somani, and Ho Tam. The exhibitions, symposium, and discussions raised questions about the constructions and limitations that define a gallery dedicated to the exhibition of "Contemporary Asian Art," particularly in the socio-economic context of Vancouver. At times, I have to admit, I felt that each exhibition was a plea or proposal to bridge the divide, an argument to demonstrate that Centre A made a valid and important contribution to Vancouver's artistic landscape. After all, the criticisms launched at Centre A were frequent, pointed, and often frustrating. But if one were to take the concerns voiced against Centre A as a sign of its critical failure, then how does one explain the gallery's ability to increase its operating budget from $78,000 in 2001 to more than $250,000 by 2003? Did Centre A represent a divide between the demands of public funders and the workings of cultural diversity in the Vancouver artistic landscape?

As current Manager of Programs at Arts Now: 2010 Legacies Now Society, a not-for-profit partner organization of the Vancouver 2010 Winter Olympic and Paralympic Games, I manage funding programs that provide assistance to British Columbia arts organizations and communities to undertake capacity building initiatives. And I find myself dealing once again with these questions, and in not so different ways. At Arts Now, we attempt to ensure the equitable dispersal of grants to organizations whose mandate identifies cultural diversity as a core principle, or those who undertake initiatives that engage audiences, communities, and artists of visible minorities. We also try to ensure that our advisory panels include members with expertise and knowledge in dealing with organizations and practices of cultural diversity. A complicated aspect of this is that certain economic values must be placed on accounting for achieving this priority. But what is an acceptable measure of success? Quantifying cultural diversity requires that certain static measures must exist. And while numerous artists choose to actively identify and engage with issues of race and their own ethnographies, funders have made all types of Canadian art institutions implicit perpetrators in measuring the successes of cultural diversity. After all, cultural institutions and publications must

articulate clear, measurable, and achievable steps towards acknowledging and implementing cultural diversity as an institutional policy.

### Precedents and Acknowledging Histories

In thinking about measures and successes, the 1991 publication of *Vancouver Anthology: The Institutional Politics of Art* provides a glimpse into some of the complexities in assigning values to cultural diversity. *Vancouver Anthology* has been described as a locus of critical debates on Vancouver art in the 1980s, bringing together writers Marcia Crosby, Sara Diamond, Maria Insell, Robert Linsley, Robin Peck, Nancy Shaw, Keith Wallace, Scott Watson, Carol Williams, and William Wood. While the range and depth of its essays contributed to healthy and pluralistic local debate, it is interesting to note that the most requested, copied, and circulated piece from the book is Crosby's "Construction of the Imaginary Indian." In it, Crosby took all forms of institutions to task, pointing out that the position of the "Indian" in any institution was always posited as the "other," the frame against which definitions of insider and outsider were maintained. She argued that it enabled lines of comfort to be drawn between "dealing with the issue" and really dealing with the issue. In a sense, Crosby's position as the only Aboriginal writer in the publication implicated *Vancouver Anthology* itself in ways perhaps not considered by the editor and writers against whom her text was posited. While the book was edited by Stan Douglas, Crosby was the only writer of colour included, and save for a few mentions of issues of cultural politics, mainly in the discussions of feminist video and artist-run-culture, the issue of race was also left to Crosby. The very institutions that she critiqued were those that were being scrutinized and historicized in the other chapters. Did the idea of *authenticity* play any role in the editor's choice to defer to a writer from a marginalized community? Was navigating the fractured, complex landscape of cultural race politics left to Crosby because she was an Aboriginal woman? Perhaps this is too simplistic a reading of her context within *Vancouver Anthology*, but the fact that her essay's arguments seem antithetical to others in the book revealed, to some extent, the real conditions of critique in Vancouver. The parallel nature of the discussions in *Vancouver Anthology*—on the one hand, contemporary production; on the other, marginal practices talked about by Crosby— exposed the fissure that existed, and remains, between the ways in which art practices are discussed, exhibited, and evaluated in Vancouver. It is as though the responsibilities of dealing with cultural diversity are left to those whose embodied experiences grant them either the right, authenticity, or ownership of such issues.

But it is important to point out that this polarization is, in large part,

a product of the ways in which cultural diversity had been taken up by artists of colour in the late 1980s and early 1990s. Contemporaneous with *Vancouver Anthology*, a flurry of publications and exhibitions confronting issues of race, representation, and politics emerged. Between 1990 and 1993, *Yellow Peril: Reconsidered, Self Not Whole, To Visit the Tiger, In Visible Colours*, and *Racy Sexy* (to name a few) marked the phenomenon of large group shows staged under the rubric of deliberately racialized identities. These exhibitions and their publications were organized by and with artists of colour and, perhaps unintentionally, for culturally diverse audiences. *Yellow Peril: Reconsidered* (1990), curated by Paul Wong, included the work of twenty-five Asian-Canadian artists, and sought to "contribute in a concrete way to the ... ongoing discussion around the issue of race and representation."[10] The exhibition travelled across Canada to artist-run centres that, for the curator, manifested predominately white, middle-class sentiments. For Wong, the project provided an entry point that could involve dominant communities in the discussions. In a similar vein, *Self Not Whole* (1991), an exhibition and publication led by artist Henry Tsang, "explored ideas of heritage, tradition, and authenticity while addressing issues of displacement and racism through the work of sixteen artists and collectives."[11] Both of these projects were organized by and for artists or writers self-identified as Aboriginal or of colour, and were presented as challenges to white-dominated cultural organizations; they "work[ed] to address racism and cultural inequity in the contexts of national cultural organizations."[12] They also shared an underlying tension: their oppositional and sometimes antagonistic stance against mainstream art practices and institutions.

Perhaps the most interventionist (and antagonistic) of these projects was the creation of the Minquon Panchayat caucus in 1992 at the Association of National Non-Profit Artists Centres (ANNPAC/RACA) conference in Moncton, New Brunswick. Founded in 1976, ANNPAC was an association of approximately 100 artist-run centres across Canada. At the conference, keynote speaker Lillian Allen, a dub poet and activist, wanted to draw attention to the dismally low number of Aboriginal and people of colour at the event. She then invited them to join forces, which led to the creation of a seven-person caucus, the Minquon Panchayat. The goals of the caucus were to transform ANNPAC by encouraging significant numbers of culturally diverse artists' groups and centres to become members of the organization. The caucus was also an opportunity to network with Aboriginal and racialized artists and cultural workers already working in ANNPAC-member institutions. At ANNPAC's annual general meeting in Calgary in 1993, Minquon Panchayat challenged members to include artists of colour and First Nations artists as part of their delegations, at the same time arguing that ANNPAC members were unwilling to acknowledge their complicity in maintaining racist policies and processes. But during the meeting, irreconcilable debates erupted over Minquon Panchayat.

Since it had received modest funding from ANNPAC for its administration, the caucus was subject to the scrutiny of ANNPAC's members, and the organization's executive committee refused to consider arguments put forward about its lack of attention to issues of race. Members of the caucus saw this as telling of the dominant discourse at work across the Canadian cultural spectrum. They believed that the way that arts and cultural funding was designed and administered played a key role in perpetuating and maintaining cultural inequality. As a consequence of these confrontations, the Minquon Panchayat caucus departed from the meeting table, taking numerous centres in solidarity with them; within a year, ANNPAC collapsed as a national organization.

What these initiatives of the early 1990s shared was their desire for access—to move the work of cultural equity out of the workshop and into the forefront of an organization's priorities. And by the end of the decade, the profile of many of the artists involved in these projects had begun to grow, not only through self-generated initiatives, but through institutional recognition as well. Their work was included in exhibitions at the National Gallery of Canada, the Art Gallery of Ontario, the Vancouver Art Gallery, the Contemporary Art Gallery, the Western Front, and Artspeak, and they were also gaining international attention. Much of their work was rooted in issues of race and identity, and brought their cultural "otherness" to the fore, directly confronting the hegemonic, middle-class sensibilities that they felt had assumed control of Vancouver's artistic milieu; as a result of the efforts of these artists, issues of cultural diversity began to have a measurable effect on contemporary artistic production in Vancouver.

But these oppositional, interventionist projects shared an equally complicated function: they claimed ownership on the right and responsibility to discuss issues of race and equity. In identifying as being part of a distinct community, these artists were able to ask questions, make accusations, and expose inequities that emerged from their embodied experiences. These notions of self identification and self-representation, while enabling a sense of empowerment, also meant that in staking ownership for the parameters of debate, one of the consequences was to spare the larger artistic community from the need or desire to take up these concerns as well.

### Vancouver Institutions: Practicing Diversity

Given these histories, how then has cultural diversity been implemented by visual arts institutions in Vancouver? Beyond questions of success, what practices, exhibitions, and texts have emerged in this climate, or been apprehended by it? It is fair to say that at the least, this terrain has been as equally contested and fractured as the engagement of cultural

diversity issues by public funders. I am reminded of a particular moment in Vancouver, when two symposia, held in conjunction with exhibitions, occurred simultaneously on the weekend of June 6, 2004: the first, organized by the Vancouver Art Gallery, was entitled *Baja to Vancouver: The West Coast and Contemporary Art*; the second by Centre A, entitled *Mutations-Connections*. Both events hosted a roster of local and international artists, writers, and curators, and both sought to investigate critical issues relevant to contemporary art practices in Vancouver.

The *Baja to Vancouver* symposium accompanied an exhibition of the same name which included works by thirty-three artists from the west coast of the United States, Canada, and Baja, Mexico, that "engage with this region's social, cultural, and physical landscapes."[13] The works were intended to "reinterpret myths and re-examine clichés related to West Coast culture."[14] But the attraction to defining the "geographies" of the West Coast—physical, psychic, political, and social—while allowing for the creation of manageable curatorial premises also meant that the works included in the exhibition represented not only what the West Coast *is*, but by its absence, what it *is not*. Although the accompanying catalogue made explicit the curators' desire to avoid the classification of the works into a "brand" of west coast art, as one walked through the exhibition, the themes of Hollywood, pop music, the landscape, and recreation excluded a myriad of other identifiers of practices on the West Coast. The issue of race and identity as a category of investigation was absent in the discussions presented by both the exhibition and symposium, despite the inclusion of works by artists who navigate the complex terrain of cultural and racial identities.

Locating issues of race within larger social and political contexts was instead left to the Centre A symposium, which also accompanied an exhibition of the same name that included work by Judy Cheung, Ramona Ramlochand, and Henry Tsang. In *Mutations-Connections*, race and cultural identity were the nucleus of the discussion, raising questions of territorial representation, cultural exchanges, and institutionalization, as well as issues central to how contemporary art is presented and received in different communities around the world.

Why then did the *Baja to Vancouver* exhibition and symposium not address these issues, in light of the inclusion of artists such as Stan Douglas, Sam Durant, Kota Ezawa, Brian Jungen, Tim Lee, Ken Lum, and Yvonne Venegas, whose work raises complicated questions of race and identity? Was it possible to intersect the discussions raised by *Baja to Vancouver* with those posited by *Mutations-Connections*? And although *Baja to Vancouver* set out to "identify the cultural threads of connection that unite and distinguish the art being made along this 2,200-mile-long coastal corridor,"[15] discussions about the threads of race and culture between the works in the show were absent from the catalogue and symposium.

One might suggest that it was not the responsibility of the *Baja to Vancouver* curators to raise such questions, since this was neither their intention nor the premise of the exhibition. While it is assuredly not the *responsibility* of a curator to raise questions about cultural diversity within every context, I argue that it is his or her responsibility to do so when an exhibition seeks to construct a history or identity for a place. In stating that the exhibition was "the first in-depth museum exhibition of art from this transnational coast," the curators sought to "redefine our notions of 'regional' art centers, expanding them beyond considerations of national identity."[16] By extension of this intent, the curators are bound to the responsibility of acknowledging that race is by no means incidental to lived experiences on the West Coast. From Mexican illegal aliens and migrant California labourers to Los Angeles's Chicano culture, and from San Francisco's Chinatown to Vancouver's designation as the "Gateway to the Asia Pacific," it is undeniable that *this place* is inscribed with racial and cultural politics. My criticisms of *Baja to Vancouver* are by no means unique to this exhibition; they are symptomatic of many other exhibitions, texts, and projects in Vancouver.

One of the better-known artists included in *Baja to Vancouver* was Brian Jungen, a Vancouver-based artist whose hybrid Nike masks have garnered him international attention. But, as in *Baja to Vancouver*, discussions of Jungen's work have had a tendency to remain singular and celebratory. In a catalogue accompanying a Brian Jungen exhibition at the Vancouver Art Gallery in 2005, Jungen was described as a "multifaceted individual epitomizing a new world hybridity: he is as well-versed in Dàne-zaa family stories as he is in Western art history; as comfortable snowboarding through an old-growth forest as he is cruising through a hipster boutique; as an international artist, as adept at working in his Vancouver studio as he is at creating onsite pieces in San Francisco, Gwangju, London or Montreal."[17] Like this text, Jungen's masks have been politely acknowledged as referencing his Native ancestry. Writers have also politely refused to delve into what contradictory meanings might extend beyond those of ethnography, museology, and nostalgia.

> Brian Jungen's sculptures are among the central artistic contributions to current reformulations of ethnological and cultural evolutionary perspectives. In this respect, Jungen, who belongs to the culture of the Dàne-Zaa Indians (First Nations), does not pursue the reanimation of a marginalized (image) language and symbolism. Instead, his works show culture as a fusion of cultures, so that the belief in an authenticity and a pre-eminence in terms of both an Indian and a dominant Western tradition is called into question. In addition, his works emphasize the significance of an aesthetic language as a tool for an emancipatory cultural criticism.[18]

Fusion, authenticity, and empancipatory cultural criticism—this is language laden with the weight of dominant ideology and hegemonic positions, against which Jungen's work is often posited.

In the same Vancouver Art Gallery catalogue, the exotification implicit in this reading of Jungen's work is refreshingly refuted in a text by Cuauhtemoc Medina, who discusses the masks' location at "the crossroads of two kinds of distorted gaze, the first involving racial misconceptions about 'traditional cults,' the second dealing with the extreme pleasure of acquiring goods...."[19] Medina argues that Jungen's work "unfolds against a global context of colonial stereotyping [mobilizing] aesthetic and cultural misunderstandings to explore ways to politicize cultural stereotypes in the age of globalization."[20] This reading, while welcome, exists within the context of a solo exhibition, where the resonance of its issues extends only to Jungen's other works. What was not acceptable, it seems, was to raise the same series of questions in relation to *Baja to Vancouver*. In Vancouver, race is a relevant discussion, but only in the context of a solo, and not a group, exhibition. But would such a discussion not be as equally applicable in relation to the works included in *Baja to Vancouver*?

The absence of inquiry into race and politics in *Baja to Vancouver* was not unique to Jungen's work. Tim Lee's *The Move* is a three-monitor installation of the artist reciting a vanguard hip-hop song by the Beastie Boys. Lee uses the modalities of early video art with the lyrics from a group of three white upper-middle-class Jewish boys whose explosion onto the hip-hop scene suggested their ability to be included in what remained a predominantly black music scene. Lee's Korean-Canadianness (following his own description of his "visual Asianness") is not incidental to the layered negotiations of the work. In his own words:

> Yet no matter how the Beastie Boys have managed to make matters of their race incidental, the installation attempts to make the question of race primal. In *The Move*, a simulacrum of race is being made indistinguishable—visual Asianness conflates with white text and coded black grammar to the point where no one race becomes the dominant one. Here, the artist adopts minimalist tactics—in a reduced, deadpan and mechanical look and performance—as a process of deracination that conflates a triple stage of racial identities.[21]

Ken Lum, in a text included with Lee's submission to the 2003 *Prague Biennale*, adds to this discourse:

> Tim's work often plays off the stereotypical persona of the well-behaved, inscrutable Asian that one often encounters in the form of tourists or as visiting businessmen. The result was an odd confluence

Tim Lee, *The Move, The Beastie Boys, 1998,* 2001
video installation
4 minutes, 48 seconds
Purchased with the financial support of the Canada Council for the Arts Acquisition Assistance
Program and the Vancouver Art Gallery Acquisition Fund, VAG 2005.16.1 a-c
Photo: Trevor Mills, Vancouver Art Gallery

of a Korean Canadian man singing a Jewish and white-boy rap song
that owes much to African American roots. We know today that
there is much interchange between different ethnic and racial
communities, and new communities are often arising as a result,
but to make a work about this widely observed fact is difficult and
Tim does it very well.[22]

While the *Baja to Vancouver* catalogue points to Lee's strategy as a
"process of cultural fracturing and assimilation," it is seen as "simply add-
ing another layer to the song's already convoluted Buddhist-flavoured hu-
manist rhetoric."[23] But Lee's work could also be making a pointed critique
against the over-simplification of cultural identities that are as complex
as the geographic terrain marked by the exhibition. It might be overly
cynical on my part to think that the same disparity located in readings
and discussions of Jungen's work might also be found in Lee's and Lum's,
and that issues of race are acceptable within the singular context of his
work, but not within the larger discussions of the exhibition. Beyond re-
sponsibility, were the curators simply not interested in raising questions
that may lead to difficult answers?

The fissure between the two symposia revealed the need to encourage
spaces where audiences and organizers from both symposia could meet
and have the opportunity to listen to and engage with each other. But this
fissure, whether a result of historical fermentation, continued mistrust, or
simple misunderstanding, pointed to those in-between spaces that often
reveal the competing claims of communities, where "the exchange[s] of
values, meanings and priorities may not always be collaborative and dia-
logical, but may be profoundly antagonistic, conflictual and even incom-
mensurable."[24]

How then do artists, curators, and writers negotiate the demands placed
on institutions to provide quantifiable measures of success in dealing
with cultural diversity, and at the same time maintain programs and
practices independent of these external demands? What about artists
from visible minority communities who are aware of historical debates,
but do not feel bound to some of the positions and politics of cultural
diversity outlined in this essay?

Vancouver artist Natasha McHardy questions the politics of race and
power, but with strategies that expand on earlier frameworks of cultur-
al diversity. In her sculptural work *Picnic*, hundreds of miniature black
figurines are arranged in groups of picnicking families; youths, mothers,
toddlers, lovers, and dogs, each without a face or individuality. Although
seemingly random, the placement of the figures (configured from thir-
teen "types" reproduced from hand-crafted moulds), and the repetition of
their interactions, have been carefully considered to call attention to their

manufacture. But more than a reflection of industrialized processes, these black figures rest in stark contrast to the white walls of the gallery—an unsettling collision of black-on-white. For McHardy, this is an important consideration, in that she consciously avoids "shades of brown" which would place them too much within the frame of "multiculturalism." She sees their blackness as a way to bring to the fore notions of difference, exotification, and otherness. And while she invites the viewer to look down at the figures and imagine the multitude of stories at the picnic, she also forces the viewer to examine questions of desire. Colourful and playful, the toy-like figures allow us to fantasize and imagine with them. And, like childhood toys, they make us desire and want to own them, perhaps in the same way colonialism desired the racialized body as worker, slave, property, or sexual plaything.

McHardy's work does not adopt the common marginalized depictions that have defined cultural diversity as we know it. And while McHardy is most assuredly aware of earlier debates and projects of cultural diversity, her work is not bound by these precedents. The work does not presuppose a specific, racially defined audience; instead, it highlights questions of race and power without replicating earlier strategies of defining ownership and mounting accusations. For McHardy, it is through the formal and aesthetic arrangement that the viewer should be drawn into the work and the viewer must first and foremost see the work as beautiful. She claims that "the politics is secondary."[25] But looking at *Picnic*, I have to wonder if it is possible to separate the two. McHardy, while dealing with cultural diversity, has done so through strategies that avoid confrontation, singularity and ownership of the conditions of debate. She has emerged, along with a number of other artists in Vancouver—such as Rebecca Belmore, Evan Lee, Mohamed Somani, and Ron Terada—who are quantifiably accounted for in terms of cultural diversity, but whose practices negate simplistic readings of questions of race and identity.

More importantly, these concerns are emerging in what has historically been perceived as the hegemonic centres of art production. In 2004, the Contemporary Art Gallery (CAG) organized an exhibition by Vancouver-based artist Steven Shearer. The exhibition included hundreds of photographs, sketches, drawings, paintings, and objects collaged in an investigation of the vernacular aesthetics of the 1970s, and the mythologies of youth, celebrity, and nostalgia found in the images of 70s teen pop idols like Shaun Cassidy, boys with guitars, amateur record collections, and other "totems of youthful rebellion and identification."[26] Amidst all this, on a small sheet of paper was scribbled: "Sorry Steve, when we talk about celebrating cultural diversity we don't mean yours." Against the exhibition's emancipatory fervour of youthful revolution, the simplicity of the note stood out. What was the place of this question? At the very least, the note contained an element of truth. Yes, Steven, when we talk about cultural diversity, we do not mean white.

page from *Canadian Art*,
vol. 22, no. 3 (2005)

The note, by its presence amongst symbols of masculine white youth culture, raised questions central to issues of cultural diversity. It also pointed to the conundrum faced by the Contemporary Art Gallery in relation to the Canada Council for the Arts' new priorities. Shearer's work, although engaging with cultural diversity in new and interesting ways (and equally valid), would not be measured as contributing to the debates of cultural politics, because Shearer is not from a racialized community. This is exacerbated by the fact that the institutional apparatus his work functions within is equally disinclined to push the issue on this matter. Did the CAG present an argument that suggests that Shearer's work should be seen as one of the variety of ways in which they are engaging with cultural diversity?

With Shearer, this textual intervention was made even more complex in a 2005 Vancouver Art Gallery group exhibition entitled *Classified Materials*. Instead of the piece he showed at the Contemporary Art Gallery, Shearer's contribution to the exhibition was a page from an issue of *Canadian Art* magazine. At the top of the page was an image of Shearer's *Sorry, Steve* that was included in an advertisement for Galleria Franco Noero. Below this, announcing the upcoming Vancouver Art Gallery exhibition for Brian Jungen, was an image of *Prototype for a New Understanding #4* (1998). The irony of placing the statement against Jungen's masks was not lost on Shearer. And while his inclusion of this new version within the context of an exhibition investigating archives and collections requires an analysis beyond the scope of this essay, I feel it is important to point out, given Shearer's sentiments, that perhaps it is time for a re-evaluation of the definition and implementation of cultural diversity. Funding programs need to be able to expand their understanding of cultural diversity beyond the domain of artists of colour, accounting for practices like Shearer's and Jeff Wall's. Measuring the success of such programs should reside in how the issues of race and culture are addressed, not only in the quantifiable inclusion of artists from marginalized communities. At the same time, art institutions should be responsible for dealing with the issues of cultural diversity in engaging and explicit ways. Without forcing the inclusion of artists of colour to maintain funding levels, institutions should be encouraged to find other measures of cultural diversity. And most importantly, a pluralistic climate of debate, discussion, and practices must be fostered in which issues of cultural diversity are treated not as external or in opposition to a perceived mainstream, but as a site of contestation, an object of enquiry, or a subject of practices across communities, ideas, texts, and exhibitions.

1. Homi K. Bhabha, *The Location of Culture* (London/New York: Routledge, 1994): 2.

2. Statistics Canada, "Community Highlights for Vancouver," 2001. www12. statcan.ca (follow links).

3. In the same year, the Council adopted a series of new strategies that would encompass the breadth of its programs. These included promotion of the arts (especially to young audiences); increasing awareness of Aboriginal arts; the encouragement of artists from culturally diverse communities; international initiatives to promote Canadian arts abroad; and support for innovative programming at festivals.

4. According to the Canada Council for the Arts' website, "In 2002–03, the Council used 654 peer assessors on its peer assessment committees, and 89 (or 14 percent) were culturally diverse individuals—almost exactly the same as the culturally diverse share of the national population (13 percent). Moreover, the Council's Equity Coordinator estimates that over the past four fiscal years, between 15 percent and 18 percent of funding to individual artists has gone to culturally diverse artists" (www.canadacouncil.ca). A complete list includes Assistance to Culturally Diverse Curators for Residencies in the Visual Arts; Multidisciplinary Festival Project Grants; Artists and Community Collaboration Fund (ACCF); Grants for Media Arts Dissemination: Annual Assistance for Programming; Concert Production and Rehearsal Program for Aboriginal, Classical, Folk, Jazz and World Music; Music Festival Programming Project Grants;

The Flying Squad I: An Organizational Development Program in Dance; The Flying Squad: An Organizational Development Program in Theatre.

5. Monika Kin Gagnon, "Into the Institution," eds. Monika Kin Gagnon and Richard Fung, *13 Conversations about cultural race politics* (Montreal: Artexte Editions, 2002): 63.

6. "Multiculturalism Act of Canada" Department of Justice Canada R.S., 1985, c. 24 (4th Supp.) (1988, c. 31, assented to 21st July, 1988) //lois.justice.gc.ca/en/ c-18.7/226879.html.

7. Richard Fung, "Into the Institution": 64.

8. Melissa Denes, "Picture perfect," *Guardian Unlimited* (October 15, 2005).

9. Frantz Fanon: "If there is an inferiority complex, it is the outcome of a double process: primarily economic; subsequently, the internalization—or better, the epidermalization—of this inferiority." *Black Skin White Masks* (New York: Grove Press, 1967): 11.

10. Paul Wong, "Introduction," *Yellow Peril: Reconsidered* (Vancouver: On Edge, 1990). Shown in various locations including Gallery 44, Centre for Contemporary Photography, Oboro Gallery, and Artspeak.

11. Henry Tsang, "Racy Sexy: In Search of Cultural Space," *Parallelogramme* 20:1 (1994): 26.

12. Monika Kin Gagnon, "Building Blocks; Anti-Racism Initiatives in the Arts," *Other Conundrums: Race, Culture, and Canadian Art* (Vancouver: Arsenal Pulp Press, 2000): 51–52.

13. Exhibition Statement, *Baja to Vancouver*. The Wattis Institute. www.wattis.org/

14. Ralph Rugoff, "Baja to Vancouver: The West Coast and Contemporary Art," *Baja to Vancouver: The West Coast and Contemporary Art* (San Francisco/ Vancouver: CCA Wattis Institute for Contemporary Arts and Vancouver Art Gallery, 2003): 13.

15. Foreword, *Baja to Vancouver: The West Coast and Contemporary Art*: 6.

16. Ibid.

17. Daina Augaitis, "Prototypes for New Understandings," *Brian Jungen* (Vancouver: Vancouver Art Gallery and Douglas & MacIntyre, 2005): 5.

18. *Brian Jungen* Secession, Association of Visual Artists, Vienna Secession, September 2003.

19. Cuauhtemoc Medina, "High Curios," *Brian Jungen*: 28.

20. Ibid.: 29.

21. Tim Lee, Artist Statement, *The Move* (Vancouver: Western Front, 2001).

22. Exhibition text, Tim Lee, Prague Biennale 2003, www.praguebiennale.org.

23. Artist Description, Tim Lee, *Baja to Vancouver*: 70.

24. Homi K. Bhabha, *The Location of Culture* (London/New York: Routledge, 1994): 2.

25. Conversation with Natasha McHardy, August 10, 2006.

26. Exhibition statement, *Steven Shearer* (Vancouver: Contemporary Art Gallery,

# DO ARTISTS NEED
# ARTIST-RUN CENTRES?

Reid Shier

In Vancouver, "artist-run" doesn't necessarily mean *run* by artists. The recent hiring of professional curators Michele Faguet, Candice Hopkins, and Melanie O'Brian for the position of Director/Curator of the Or Gallery, the exhibitions program of the Western Front, and Artspeak, respectively, affirms that for three of the city's senior artist-run institutions, it isn't fundamentally necessary to the execution of their mandates that they be directed and curated by practicing artists. Vancouver's artist communities have accepted and encouraged these new curators and supported their programs. However, within the sometimes heated and fractious context of Vancouver and Canadian artist-run history, this positive and largely uncritical reception for the appointments of Faguet, Hopkins, and O'Brian is significant. There has, for example, been little debate over fundamental philosophical questions. If professional curators now run artist-run centres, can they serve the cause of "artistic self-determination?" In a climate of apparently diminishing returns for artists who involve themselves with established artist-run galleries, has the time come to ask about the mandates of these institutions? If artists stop *running* artist-run centres, will they still need them?

Vancouver's artist-run centres have cultivated a tradition of in-house curators who are responsible for directing the organizations and choosing the exhibitions. This is the current administrative structure at Artspeak, the Helen Pitt Gallery, the Or Gallery, and the Front Gallery, and a number of artists who have worked at these institutions, myself included, have gone on to curatorial careers in other, often larger, public institutions. However, as a rule, curators employed by artist-run centres aren't common in Canada, and in the majority of artist-run centres committees and boards made up of artists are the authoritative bodies in charge of hiring staff, choosing the exhibitions, and developing programming. For many centres, "artist-run" might correctly be understood as "artist-managed"; the requisite to be a practicing artist is only necessary for entry onto artist-run centres' board of directors,[1] not for staff that operate the organizations on a daily basis.

There are no strict conventions. Artspeak, for example, was started in 1986 by Cate Rimmer and visual artist Keith Higgins. At the time, Rimmer was graduating from a short-lived curatorial program[2] at the Emily Carr College of Art & Design, and she and Higgins first ran Artspeak out of a spare room at (and at the invitation of) the writer-run Kootenay School of

Writing (KSW). Rimmer is a curator, and when appraising the long history of Artspeak's achievements, there is little relevancy to how one labels her and the many writers who helped her and Higgins run the gallery. The collective of writers at KSW were as committed to Artspeak's success as any community of visual artists, and were instrumental to the gallery's development as a site for art in Vancouver. Artspeak benefited from this help when it was awarded operating funds from the Canada Council for the Arts in 1990, while KSW's Canada Council applications were consistently turned down because its practice was textual and not visual. One might parse the inflexible jurisdictional frames of Canada's cultural bureaucracy, but the critical point here is that from their inception, artist-run centres have been initiated and—at least in Vancouver—curated by loose conglomerations of individuals with varied skills who come together because of their interest in activating a space for cultural practice.

Questions about how much responsibility artists hold for institutions bearing their name have to be considered against the frequency with which non-artists have taken on roles as generators and activators of artist-run practice. Moreover, artist-run histories suggest the difficulty in generalizing how the increasing authority of a professional administrative and curatorial staff—one whose positions, conceivably, are in line with longer-term goals—might mark the emergence of a new model for artist-run centres as growing, conventional institutions. During my last year as Director/Curator of the Or Gallery, the hiring committee had long conversations about the merits of appointing an artist or a non-artist to replace me. Such conversations were necessitated by the number of applications for the job from art critics, gallerists, and art historians, both self-taught and with post-secondary degrees, all of whom were considered equally meritorious to the artists who had applied. This was, in part, evidence of the repercussive growth and newfound prestige of contemporary art curation. The increase in post-secondary curatorial programs is one aspect of the emergence of curation as a career path and formalized field of inquiry, and part of a transformative shift from a museological and historical paradigm to one that actively engages with contemporary culture. As increasing numbers of graduates emerge from curatorial, art historical, and cultural studies programs equipped to work with contemporary artistic practices, it is inevitable that artist-run centres are becoming vehicles for their ambition and achievement.

Correlatively, today's positive economic environment allows artist-run centres to operate with reasonably stable support from Canada's cultural funding agencies, led by the Canada Council for the Arts. In turn, current debates about purpose and identity within artist-run culture are muted, and a sense of institutional self-confidence has emerged that might signal how artist-run centres in Canada have (at last) survived their infancy and adolescence and reached a stage of consolidated maturity. Artist-run centres are here to stay, and questions about who is in charge—a subject

that might once have aroused protracted and heated discussion—is of diminishing concern.

Artist-run centres helmed by non-artist curators could be seen as a win-win situation. In one model of institutional growth, a developing artist-run centre with committed long-term professional staff may see necessity in graduating into a larger public gallery. In the 1990s, the Contemporary Art Gallery (CAG) in Vancouver and Plug In in Winnipeg both developed institutional identities at odds with their artist-run origins. Led by career-professionals Keith Wallace and Wayne Baerwaldt, the CAG and Plug In, respectively, changed their mandates to reflect the realities of their maturing circumstances. One direction that the recent hires at the Artspeak, Or, and the Front might offer is the possibility of a similar path. Like the CAG or the re-named Plug In (Institute of Contemporary Art), successful artist-run centres' increasing responsibilities to member communities, funders, and audiences—and their incumbent growth in size, staff, and level of public outreach—might be reflected in growing institutional ambitions.

But this course begs a number of questions, not least of which are fundamental ones about why artist-run centres exist in the first place, whom they serve, and how their mandates—if they are distinct—should continue to be maintained and realized. What place, if any, do artist-run centres inhabit within a national and international fabric of cultural practice? Is there territory that is important to claim and keep? Such questions have deep roots, and in the history of artist-run centres in Canada—since the foundation of Intermedia on the West Coast in 1968 and A Space (or as AA Bronson reminds, "a *Space*") in Toronto in 1970—have been the topics of numerous and fraught debates.[3] Without rehashing the many discussions, it is vital to synthesize a recurring argument about the efficacy and meaning of artist-run culture: that a distinction of artist-run centres—which includes organizations, magazines, affiliations, communities—is that they hold some critical purpose and, perhaps, an oppositional role in relation to a larger, more dominant ethos.

Fundamental to the founders of most artist-run centres was a wish to provide opportunities and a voice to artists. For those who started galleries, this intent was realized as the chance to exhibit work, however ephemeral or transient. It is important to distinguish two parallel goals in this organizational desire. One was to give friends and colleagues a public forum. Another was to create critical resistance to a culture in which artists and their work were improperly contextualized, ignored, or devalued. Early in the history of many artist-run centres, these two agendas were easily aligned. In the 1980s, Vancouver's Women in Focus existed as a gallery and a venue for emerging discourses opposing a larger, sexist, hegemony. It goes without saying that exhibitions were organized to further the organization's larger polemic, but it would be reductive—for the gallery and the artists—to say that this was its sole impulse.

While the intention of artist-run centres to create platforms for resistance has resulted in a fantastically diverse history of realizations (exhibitions, catalogues, talks, and seminars being just a part), it has also led to a growing mythology around the alterity of artist-run culture. Assumptions persist about the importance of the artist-run system in providing opportunities for artists to exhibit work in situations that they otherwise could not or would not. Artist-run centres can brag about their track record in this regard, significantly for showing many artists just graduating from art school, and for whom a show at an artist-run centre was and is their first experience in a professionalized milieu. In Vancouver, artists like Roy Arden, Stan Douglas, Geoffrey Farmer, Brian Jungen, and Myfanwy MacLeod had their first significant public exhibitions in artist-run centres. Yet to assert that artist-run centres hold some special place *vis-à-vis* the larger gallery system—that their mobility and spontaneity, in line with their non-profit status, allows them to take risks that larger or market-driven galleries might not afford—has to be questioned in light of the development of the contemporary art world over the past two decades. Public and private galleries have rapidly matured in their understanding, ability, and desire to profile young, experimental practices. Clearly, this has much to do with the money to be made from contemporary art. Nevertheless, interest in new practices and younger artists by commercially driven galleries and larger public institutions continues and sometimes supercedes relationships forged between artist-run centres and younger, less established artists they often claim to serve. One of Jeff Wall's first exhibitions was at Claudia Beck and Andrew Gruft's commercial NOVA gallery in Vancouver in 1978. More recently, Vancouver artist Steven Shearer had his first significant solo exhibition in 1994 at the commercial SL Simpson Gallery in Toronto—in advance of his inclusion in a group exhibition in Vancouver at the (then nominally artist-run) Contemporary Art Gallery in the same year. Lawrence Paul Yuxweluptun is vociferous on the topic of showing his work in artist-run centres during the 1980s: "I was involved in other things. I was trying to get a show in the National Gallery of Canada and get different doors to people opened.... We opened the bigger doors first.... In 1985, 1986 if you were white you could get a show. In some ways this country is still that way in the artist-run centres."[4]

Today, artist-run centres offer one of a number of possible career entry points for young artists. They are important, but the idea that they are, or ever were, *the* initial stepping stone for new artists hoping to professionalize is largely apocryphal. This being the case, the question posed in the title of this essay might well be answered in the negative. However, while artist-run centres undoubtedly help artists to build successful careers, most understand there is a much broader arc to their activity. Further, while artist-run centres can and do operate as a feeder system for more established public and private galleries and the larger visual art market, artist-run centres exist (at least ideally), for other reasons. To conceptualize

the role of artist-run centres today, one must ask how they operate within, parallel to, or outside a larger system.

Yuxweluptun's comment about an intrinsic racism within artist-run spaces points to a question that continues to haunt contemporary artist-driven culture: whether or not, and to what degree, artist-run culture is complicit in systems it once set out to critique and dismantle. Keith Wallace succinctly encapsulates this in his essay in *Vancouver Anthology: The Institutional Politics of Art*, in which he addresses a reigning paranoia in the late 1980s and early 90s around how artist-run centres might retain a relevant criticality. He states: "Resisting the bureaucracy of all institutions, including that of ANNPAC (Association of National Non-Profit Artist-Run Centres) seems to have represented not the idea, but the ideal, of alternative galleries throughout Vancouver in the 1980s. A sense of social responsibility, mixed with romantic notions of their own marginality, gave them an aura of authenticity. The ideal is rarely achievable, but maintaining an oppositional stance fuels the critical distance necessary to test the assumed social order."[5]

Wallace aptly frames a central and continuing conundrum about artist-run initiatives, especially ones that aspire to any longevity—the perception of a link between spontaneous or short-lived endeavors that maintain a critical position outside the system, and longer-term projects that become, or are from the outset, corrupted by that same system. The problem, if one can call it that, was histrionically framed in 1983 by artist Krzysztof Wodizcko in a talk presented in his then hometown of Toronto:

The Canada Council, as in Poland and in every authoritarian machine, must neurotically produce its own "coffee shops", alternative publications and spaces in order to control its own position and direction and to serve *itself* as a medium of critical discourse on its own future....

In this permanently unstable survival process the Canada Council is acting permanently against itself ... and superficially fragmenting and camouflaging its main cultural effect: a total bureaucratic pacification of the intellectual creative power of the artistic intelligentsia and artistic culture.

The only remaining difference between Toronto and Warsaw ... is that the distinction between the language and gesture of a bureaucrat and that of an artist is much less recognizable in Toronto.... Looking closer, one will be able to disclose a horrifying phenomenon: what was for Warsaw a nightmare or an immanent danger (not yet reality) receives its total three-dimensional realization in Toronto. Finally *everyone appears to be both the artist and the bureaucrat....* [but] ... the Toronto artistic intelligentsia elevates itself to a much higher level of collaboration than artists in Poland. It approaches the conscious level—the level which I shall call *cultural corruption.*[6]

What is, to my mind, striking about Wodizcko's prose is both how near and very far away his observations appear. It was written at a time when the Cold War was inflamed by Ronald Reagan's rhetoric of a pre-*Glasnost* "evil empire"; and is relevant to Vancouver, in that the date of October 1983 was when the British Columbia-wide Solidarity labour movement, organized against the restraint programs of Premier Bill Bennett, was defeated through the betrayal of IWA (International Woodworkers of America) union head Jack Munro. Munro personally negotiated an eleventh-hour back-room deal with Premier Bennett that saw his union back out of the general, province-wide strike set for the next morning, effectively knee-capping any chance at the negotiation table for other provincial unions. Delivered scant months prior, Wodizcko's lecture reminds us of the immediacy and currency in the early 1980s to discussions of bureaucratic allegiance to self-preservation rather than critical risk.

In his introduction to *Vancouver Anthology*, editor Stan Douglas situates Munro's act of duplicity at the "approximate centre" of the anthology's time-line, and points to the emergence of 1984's *Warehouse Show* and the 1987 *Artropolis* exhibition as a "parallel historical motion" within Vancouver's visual art community. The *Warehouse Show* and *Artropolis* attempted to build on the energies of the artist-initiated *October Show* of 1983, a messy, large-scale invitational featuring work by a cross-section of contemporary artists in British Columbia. The *October Show* was initiated as a grassroots riposte to the representative claims of the inaugural survey exhibition at the newly relocated Vancouver Art Gallery (VAG), *Vancouver Art and Artists 1931–1983*. Whether or not it could properly be called a *salon des refusés* (the exhibition featured some of those also included in the VAG), the *October Show* presented a clear mandate. By contrast, the first *Artropolis* exhibition was made up of work selected through submission and invitation by seven curators under a number of ambiguous themes. Its mandate—to be inclusive and representative of the art of British Columbia—was never strategically defined, and as Annette Hurtig baldly stated in her introduction to the exhibition catalogue: "Without close examination or clear prioritization of objectives, there was no consensus as to how the intent of the exhibition was to be realized."[7] Curiously, some of the show's most stinging rebukes, Hurtig's included, came in the exhibition catalogue, particularly within an excoriating essay by Scott Watson, who surmised that for the curators/jurors to "rely so heavily on a review of submissions rather than actively select work they know and value is one more symptom of our disorder."[8] Summarizing *Artropolis*, Stan Douglas asserted it became "an unofficial institution that had begun to run according to its own bureaucratic logic. It existed for its own sake, and was no longer a response to the difficult decisions under which artists generally have to produce and exhibit work."[9]

Here, the implicit peril in the long-term survival of artist-run projects is the inevitability of distortion and detour. Ideals and objectives gradually

disintegrate in the face of bureaucracies that increasingly cannibalize productive energies for the sake of institutional survival rather a defining purpose. For Wodizcko, an antidote to the certainty of capitulation was a radical ephemerality. He envisaged "...self governing artists' economic organizations and agencies, the gradual detachment of the artistic cultural community from the centralized state bureaucracy, and the organization of non-bureaucratic, small and flexible 'Intelligence'-like working institutes and other, yet to be defined, artistic, educational institutions (always ready to dissolve themselves) ... [that would] ... help to educate and recondition, to de-captivate our bureaucraticized minds; rescue and revive our stolen souls from bureaucratic protection, annexation, assimilation, and appropriation; to return to collective or individual constructive critical knowledge, independent and systematic artistic research, and a sense of social place."[10]

In the context of Wodizcko's ideas, a fascinating booklet was published in 2005 for that year's Frieze Art Fair in London in which a series of texts by a number of authors attempted to imagine futuristic scenarios for public arts funding in Europe in the year 2015. In her introduction, co-editor Maria Lind, the Director of the International Artist Studio Programme in Sweden (IASPIS), synthesizes two of these texts: "It is 2015. Art is almost completely instrumentalized—regardless of whether its financing is private or public. Art services either national or European interests, where it is especially useful in the constructing or reinforcement of specific identities. At the same time, art is a desirable commercial product. It is ideal for collecting and it contributes to regional development whilst providing society with new creative employment opportunities. Visiting art museums and centres is a popular, easily digested leisure activity. In 2015 art is also used to stave off undesirable fascistic and nationalistic tendencies in society."[11]

Contrasting this well-articulated, gloomy model, Lind encapsulates a counter-view where "future development would be towards a more critically oriented art—a cultural practice that finds its own route via the establishment of self-supporting micro-systems. This vision of art is not necessarily adapted for exhibitions and other established institutional formats, while it would remain an important component of civil society. The more engaged system would encompass more forms of collaboration than present day art appears to do." And then she concludes, "But how would it be funded?"[12]

Decades and worlds apart, how Lind and Wodizcko each imagine a critically engaged art in response to dominant social and economic systems is, on the face of it, strikingly similar. Each is also patronizing and proscriptive, calling for artists to form collaborative unions that (evidently, given their call to arms) don't exist, then or now. While both Lind and Wodizcko intelligently analyze political risks and pitfalls past and future, they downplay the ongoing activities of artists and artist-run initiatives

to negotiate methods that argue against, side-step, or productively collaborate with dominant social mechanisms.

In a relatively positivist and recuperative history of Canadian artist-run policy and practice, critic and historian Clive Robertson suggests that it is precisely the success of artist-run centre culture that has maintained an allegiance to its outsider status and in contestation to a status quo. "I presuppose..." Robertson states, "that the plane of artist projects, artists [sic]

Infest: International Artist Run Culture
discussion forum: "The Artist as Curator";
*(left to right)* Stephen Hobbs, Laiwan, Matthew Higgs
Courtesy the Pacific Association of Artist Run Centres

collective initiatives and particular artist-run culture is a practice that aims to make a difference in the world, that has, as [cultural theorist Stuart] Hall says, some points of difference or distinction which have to be staked out, which *really matter*."13 [Italics mine.] Robertson employs cultural studies methodologies as tools to understand and justify how he sees artist-run culture negotiating the delicate balance between (in his estimation) their "refusal to close the field, to police it and, at the same time, a determination to stake out some positions within it and argue for them."14

Robertson's archetype of artistic self-determination is built in relation to—and to a large degree against—ideas of "curation," particularly as he sees the practice in museums and galleries: "I think after thirty-plus years of 'artist-run culture' it is healthier to admit that artist-run centres, while now institutions in their own right, are 'simply' a way of stabilizing artists' collective initiatives. Such organizations were (and I assume are) quite happy to program rather than curate, to co-ordinate rather than to edit. Curating and editing imply other purposes, gate-keeping being one of them, that we ought to consider to be at odds with artist-run values.

'Artist-run' is neither only nor simply a personnel question. It is an ethical refusal by artists not to 'anthropologize' other artists or to use artist's productions merely as ingredients for other recipes and theses; not to exploit expressions of difference while stripping away their politics."

Robertson quotes Matthew Higgs, Director/Curator of the New York artist-run centre, White Columns, from a roundtable on the "Artist as Curator," held at Infest, Vancouver's international artist-run conference held in 2004, as an example of what he finds egregious about the type of curatorial work he sees as exploitive of artists and artistic practice. At the time, Higgs was reacting to comments by his fellow panelists, stating: "I don't sympathize with empowerment, survival, battle, frustration, and struggle. This essentially seems to be a defeatist or negative position. The idea of us being outsiders I don't agree with at all. I do not recognize that concept [in the art field]." Higgs continued by describing his practice "as looking for or thinking about what doesn't exist in the world" and as "largely selfish. I make exhibitions that I want to see.... I spend almost no time thinking about who the audience might be for the work I do." In reaction, Robertson opines that Higgs's "rhetoric of selfish concern for art or artist's intention [is] an excuse to bracket out issues of empowerment or struggle" and "very much been the standard bailiwick of male art museum curators everywhere."[15]

Within Robertson's schema, *curator* Higgs (not *artist*, his other profession) co-opts other artists' arguments and intentions in service of a unilateral and self-congratulatory thesis. Robertson then couches his criticism in a conflation of Higgs's gender with a trope of abusive male authority. It is a specious argument, and follows a long-standing and generalizing opposition to the role of curation within the discourse of artist-run centres. What Robertson fails to argue is how the act of selecting artists—for inclusion in a group exhibition or other program—might bracket out their themes or agendas. Higgs never states any lack of concern or respect for artists in his shows, only that he doesn't consider who might *view* an exhibition when formulating it. Any ethical responsibility toward artists must surely rest in the methods and means of their works' contextualization, and not in presuppositions about viewership. "Selfishness," in this context, could easily be read as part of a dialogue and engagement with artists, and in contrast to a concept of "programming" exhibitions and abnegating or abandoning responsibility to stand up for why artists have been selected and why their practice is of worth. Self-interest might be necessary, to paraphrase Robertson, to "stake out a position and argue for it."

The characterization of *choice* is critical. Robertson posits artists as intrinsically valuing one another, but argues his theory by employing semantic sophistries. "Programming" is set against "curating"; "coordinating" opposes "editing"—and each supports hostility to a hobbyhorse of curatorial "gate-keepers." In Vancouver, the hires of Faguet, Hopkins, and

O'Brian by their centres' artist communities have actively engaged these stale notions of artist-run practice, and called the bluff of years of artist-run rhetoric. What is debatable is whether these particular appointments, which could very well be a localized phenomena growing out of a history of artist/curators in the city, can be used to argue for a larger trend, or even for a different model. In fact, what remains persistently, *glacially* intransigent are the impregnable bureaucracies of artist-run centres across Canada—including those in Vancouver—within whose fortified "mandates" lie adamantine institutional protocols for programming, whether by committee or individual, artist or curator. What is significant about the employment postings in Vancouver is the (at least tacit) acknowledgment that those given the right to choose artists and engage projects also have a responsibility that necessitates refusal of other initiatives and possibilities. Any myth that an *artist's* decisions are functionally more democratic and less *curatorial* has been largely punctured by an acknowledgment that exhibitions in most of the city's public institutions are chosen in nearly identical ways.

However, it remains uncertain whether local artists, in handing over the reigns of artist-run spaces, have yielded ground in the struggle to carve out territory of productive self-determination and autonomy. In this respect, Robertson's argument can be described not only as a question of who gets shown, but in what light. The desire to take responsibility for one's own contextualization—a central tenet in the emergence of artist-run culture—might well be compromised in Vancouver in respect to three important spaces. In addition, one can question whether the history of Artspeak, the Or, and the Front mirrors the fate of the *October Show* as it mutated into *Artropolis*. This speculation hinges on whether, and to what degree, artists might have ceded authorship of their own exhibitions and projects in trade for the perceived benefits of being *selected* for shows. True or not, one must acknowledge that artists have rightly come, through three decades of experience, to understand that artist-run initiatives have never been conditional on the avoidance of curatorial powers they may have been set up to oppose. There is little functional difference, for example, in the ways programming has been determined at Artspeak or the Front Gallery since their inception and today.

How today's artists imagine the role of artist-run initiatives in facilitating their place within the constructs of the "artworld" is also an open question. Here, Matthew Higgs offers a vital opinion: "The 'art,' if it is an art, is connecting people, drawing the dots between different communities / tribes / generations / etc. It is about creating a collective sense of "ownership" and "authorship" despite my involvement. There is a huge 'space' between the galleries (market) and the institutions—which artist-led organizations / spaces / artist-led initiatives should radically address. Also, all artist-run organizations should move away from their apologetic, cap-doffing (recent) pasts and re-claim the conversation / dialog: which

Gareth Moore & Jacob Gleeson, *St. George Marsh*, June 2005–August 2006
Courtesy the artists and Catriona Jeffries Gallery, Vancouver
Photo: Gareth Moore

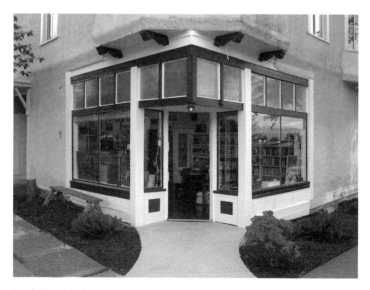

Gareth Moore & Jacob Gleeson, *St. George Marsh*, June 2005–August 2006
Courtesy the artists and Catriona Jeffries Gallery, Vancouver
Photo: Gareth Moore

is rightfully theirs. What gets me down most is young artists 'sucking up' to the mainstream art world, if they were really smart and / or talented they would create their own."[16]

   In this context—and despite the increasing value of established artist-run venues as exhibition spaces—it will be enlightening to see if artists in Canada continue to move away from the country's senior institutions as avenues for their collective and organizational energies. Other types of spaces emerge frequently. Artists Gareth Moore and Jacob Gleeson opened St. George Marsh, for example, in 2005 in an old corner store in a residential suburb of East Vancouver. Zoning regulations for the property required the two artists sell goods in order to obtain a business license, so they incorporated cans of soup, VHS tapes, library books, and other groceries into a facility that was part general store, part gallery, and part museum. The idiosyncratic structure accommodated gallery openings, music performances, games nights, and film screenings, and provided for a synthesis in which the space's peculiar exigencies became as much a part of the artist's work as it was a stage for projects.[17] Working within a modest set of circumstances and a simple idea of artistic self-determination, Moore and Gleeson's (now closed) project was a peculiar structural hybrid that offered a place of experimentation for ideas about art, display, museology, commerce, and community. Illustratively, by creating an arena for activity they also stressed the relative importance of filling established galleries with exhibitions and events, offering an important reminder that artist-run practice might find, in the act of *making* a space, one of its most evocative and fundamental forms.

1. Non-artists also fill positions on artist-run boards.

2. The diploma program in Curatorial Studies was initiated in the early 1980s by Charles H. Scott Gallery Director Ted Lindberg, and cancelled in the late 80s at the recommendation of Lindberg's successor Willard Holmes. Holmes would subsequently take the position of Director of the Vancouver Art Gallery. Another alumnus of ECIAD's short-lived diploma program is current VAG Associate Director and Chief Curator Daina Augaitis.

3. See the anthologies: *From Sea to Shining Sea, artist-initiated activity in Canada, 1939-1987*, ed. A.A. Bronson (Toronto: The Power Plant, 1987); *Whispered Art History: Twenty Years at the Western Front*, ed. Keith Wallace (Vancouver: Western Front Society and Arsenal Pulp Press, 1993); *Decalog: YYZ 1979–1989*, ed. Barbara Fischer (Toronto: YYZ Books, 1992); *Vancouver Anthology: The Institutional Politics of Art*, ed. Stan Douglas (Vancouver: Talonbooks, 1991); and in magazines such as *Artery, Fuse, Mix,* and *Parallelogramme.*

4. Yuxweluptun, quoted in: "Native Son, Lawrence Paul Yuxweluptun talks to Reid Shier on art, colonialism and the hiatus of the West," *Mix* 24 (Summer 1998): 49–55.

5. Keith Wallace, "A Particular History: Artist-run Centres in Vancouver," *Vancouver Anthology: The Institutional Politics of Art*: 37–38.

6. Krzysztof Wodizcko, "For the De-Incapacitation of the Avant-Garde," *Parallelogramme* 9:4 (April–May 1984): 23. The text is based on a lecture delivered on June 1, 1983 at the Rivoli Café in Toronto as part of the series "Talking—A Habit" co-ordinated by Christina Ritchie and produced by A Space.

7. Annette Hurtig, "Artropolis: History/Process," *Artropolis*, eds. Maja Grip and Annette Hurtig (Vancouver, 1983): 6.

8. Scott Watson, "Desiring Transparency," in *Artropolis*: 13.

9. Stan Douglas, "Introduction," *Vancouver Anthology: The Institutional Politics of Art*: 17–18.

10. Wodizcko: 25.

11. Maria Lind, "Introduction," *European Cultures Policies 2015–A Report with Scenarios on the Future of Public Funding for Contemporary Art in Europe*, eds. Maria Lind and Raymond Minichbauer (IASPIS: London, Vienna, Stockholm, 2005): 4.

12. Lind: 4.

13. Clive Robertson, "Movement + Apparatus: A cultural policy study of artist-run culture in Canada 1976–1994," Doctoral Thesis in Communication Studies, Concordia University, 2004: 57.

14. Hall, quoted by Robertson, in "Cultural Studies and its Theoretical Legacies," *Stuart Hall: Critical Dialogues in Cultural Studies*, eds. David Morley and Kuan-Hsing Chen (London: Routledge, 1992).

15. Robertson: 53.

16. Matthew Higgs in an email conversation with the author, October 2005.

17. The complete contents of the Marsh were recently sold.

# WHOSE BUSINESS IS IT? VANCOUVER'S COMMERCIAL GALLERIES AND THE PRODUCTION OF ART

Michael Turner

Catriona Jeffries Gallery advertisement
*Canadian Art*, vol. 20, no. 3 (Fall 2003): 8

...you don't need a gallery to show ideas.

—Seth Siegelaub, 2000[1]

Nobody in Vancouver buys art...they're not interested in painting.

—Andy Warhol, 1976[2]

Over the years, a literature has emerged on Vancouver artist-run formations (collectives, incorporations, centres) and their contribution to a critical art discourse in this city. Common to this writing is a discussion of the institutional landscape upon which some of these formations have developed.[3] Although public galleries and museums are an obvious and recurring foil, commercial galleries have been discussed as well (though cautiously).[4]

As far as I know, there has been no attempt to write a history of Vancouver's commercial galleries and their increasing influence on artists, art production, and audiences. Nor has an attempt been made by commercial galleries to band together and produce a critical publication, one that might allow for such a history to be traced. But rather than dwell on these absences, it might be useful to begin with a look back on the fifty-year history of commercial galleries in Vancouver, paying attention to the social, political, and economic forces that have dominated the business of art and art production.

Vancouver modernism has numerous creation myths. In the visual arts, modernism began with the paintings of Emily Carr; in architecture, with the importation of the Bauhaus and Art Deco. Poet and novelist Robert Kroetsch once wrote that Canadian literature did not have a modern period, that the literature passed from Victorian to postmodern without a peep.[5] Which isn't true, of course. For although our modern literary period was short, we did have one, and the fact that people still argue over when and where that was is encouraging—because unlike the visual arts and architecture, audiences for new writing have waned over the years, while interest in art, especially architecture, has risen. But that's another story.

With respect to commercial galleries (and modernism) in Vancouver, creation began not in the garden (of Eden), nor the beach (where Raven

freed the first Haida from a clamshell at Nai-Kun), but with an American couple, curator Alvin Balkind and architect Abraham Rogatnick, driving down Kingsway in a Volkswagen Bug. The year was 1955, and the pair, having taken seriously the words of their friend, the Vancouver architect Geoffrey Massey, came west, to start over. They are entering Vancouver for the first time.

And they are saddened by what they see. For Kingsway is not much different than it is today: a commuter route lined with auto shops, motels, cheap restaurants; a place to stop, get what you need, and leave; a working-class immigrant neighbourhood disguised as a street. Kingsway, for this couple, is a cautionary tale, what Vancouver might look like without planning. Certainly nothing like the refined, middle-class community of West Vancouver, where these two eventually landed.

Once settled, Balkind and Rogatnick are introduced to the city's modern compradors, a worldly group that includes scholars (Doris Shadbolt), painters (Jack Shadbolt), architects (Arthur Erickson), architects who paint (B.C. Binning), and painters (Gordon Smith) who live in houses designed by architects (Erickson). No doubt their earliest meetings began as debriefings, with Balkind and Rogatnick recalling their origins, the great cities of the east, before moving on to aesthetics (the shift from abstract expressionism to hard edge; the ascendancy of the International Style), pausing on occasion to express their disdain for Vancouver's Old World British "charm," and its resource-rich heterosexuality. It is a disdain shared by the compradors (and in their disdain, they are equals).

Yet as "doers," Balkind, Rogatnick, and the compradors were not about to sit back and take it; they would put their money where their mouths were. Vancouver needed to be educated, brought up to speed; they were the vanguard—and Balkind and Rogatnick, as exotics, had the Ivy League accents to sell vanguardism. It is from these early conversations that the seeds for the New Design Gallery were sown.

Opened on December 1, 1955, New Design Gallery is generally seen as Vancouver's first commercial contemporary art gallery. However, like all myths, it is not supported by the facts. In 1953, artist Ron Kelly attempted a similar venture—a gallery devoted to contemporary painting—but it closed a year later, presumably due to lack of interest.[6] Despite that—and the fact that the New Design Gallery was not opened in the city of Vancouver, but in the *nouveau riche* municipality of West Vancouver—the myth endures. Over the next few years, the gallery exhibits the work of artists Bruno and Molly Bobak, Jack Hardman, Don Jarvis, Jack Shadbolt, Gordon Smith, Charles Stegeman, and Takao Tanabe—all local painters, all working in the abstract landscape tradition. For the most part, they are successful, selling mostly (though modestly) to local collectors and collecting institutions.

But more than financially, NDG is a cultural hit, a meeting place for contemporary art and ideas. In 1958, the gallery moves to a vacant space on West Pender Street, behind the Vancouver Art Gallery, where, at the instigation of the CBC's Bill Orchard, it expands to include an "Arts Club," a place for artists and patrons to mix socially. Although the room is small, a moveable wall is added, allowing the gallery to adjust from exhibitions to cocktail parties, with little fuss. It is during this time that Balkind be-

<div style="border:1px solid">

## Contemporary B.C.

ANDRE       BINNING
B. BOBAK   M. BOBAK
JARVIS       KORNER
PLASKETT  SHADBOLT
STEGEMAN         YIP
GORDON SMITH, ETC.

## THE NEW DESIGN GALLERY

1456 Marine Drive      West Vancouver      West 3371

</div>

The New Design Gallery advertisement
*Canadian Art*, vol. 8, no. 3 (Spring 1956): IV

comes more closely associated with NDG, managing both it and the Arts Club, while Rogatnick, who had been in private practice, accepts a job at the University of British Columbia's School of Architecture in 1959. Three years later, B.C. Binning, who had, in 1954, created UBC's Department of Fine Arts, hires Balkind to run the UBC Fine Arts Gallery.

With Balkind and Rogatnick institutionalized, as it were, NDG business is left to a board. Betty Marshall is hired as Director in 1964. The following year, upon hearing that the Pender Street building is slated for demolition, she moves the gallery to 1836 Burrard Street, where it continues to exhibit painting as well as host readings and related art activities. However, not long after, Marshall takes ill, and dies in 1966. The board meets again, and it is decided that the gallery be sold, for a nominal fee,[7] to an energetic young picture framer from West Vancouver named Doug Chrismas.

If NDG succeeded in popularizing contemporary art for local audiences, Doug Chrismas made it a spectacle. Upon purchasing the NDG business in 1966, Chrismas moves both the NDG's artists and his framing shop from Denman Street to an Arthur Erickson-designed building around the corner, on Davie Street. There, under the name Douglas Gallery, he becomes known around town for his extravagant openings. Yet as much as the props, costumes, bus rides, and boat dances draw crowds, they do not overshadow the exhibits, which, like his frames, are impeccable.

Chrismas, a mere twenty-two when he purchased NDG, made it his business to cultivate the city's younger "multi-media" crowd, many of whom were involved in spectacles of their own, most notably the Trips

Festival and artist-driven spaces like Sound Gallery (a group which later formed the core of Intermedia), on Seymour Street. Through his relationships with Iain Baxter, Glenn Lewis, and Michael Morris, all of whom had international connections, Chrismas was able to meet Robert Rauschenberg, whom he would show in July of 1967. A massive accomplishment, given Chrismas's relative youth.

Baxter      Kipling
Epp         Mason
Grauer      Ngan
Ho          Stonier
Huang       Wong

*Bau-Xi Gallery*

555 Hamilton Street
Vancouver 3, B.C.
Telephone 683-3437

CARL ANDRE   ANTHONY CARO   DAN FLAVIN   SAM FRANCIS
HELEN FRANKENTHALER   MICHAEL HEIZER   JASPER JOHNS   DONALD JUDD
ELLSWORTH KELLY   ROY LICHTENSTEIN   ROBERT MANGOLD
ROBERT MOTHERWELL   BRUCE NAUMAN   KENNETH NOLAND
CLAES OLDENBURG   LARRY POONS   ROBERT RAUSCHENBERG   ROLAND REISS
JAMES ROSENQUIST   EDWARD RUSCHA   RICHARD SERRA   TONY SMITH
FRANK STELLA   JAMES TURRELL   CY TWOMBLY   ANDY WARHOL

*ACE GALLERY*   418 WEST GEORGIA ST, VANCOUVER, B.C. V6B 1Z3 CANADA

Bau-Xi Gallery advertisement
*Canadian Art*, vol. 13, no. 100 (January 1966): 8

Ace Gallery advertisement
*Vanguard*, vol. 8, no. 3 (April 1979), back cover

And the juggernaut continued. By 1970, Chrismas (who by then had changed the name from Douglas Gallery to Ace Gallery), had exhibited the work of Carl Andre, Ron Cooper, Gathie Falk, Joseph Kosuth, Sol LeWitt, David Mayrs, Al McWilliams, Bodo Pfeifer, Fred Sandback, Keith Sonnier, Frank Stella, Harold Town, and Lawrence Weiner, in addition to Baxter, Lewis, and Morris. An impressive list, helped along, of course, by the connections of local artists. Which is not to diminish the time and energy Chrismas spent installing his exhibitions; on the contrary, not only did Chrismas work hard at getting people out to his shows, he also went to great lengths making sure they understood them. (Artist Stan Douglas once remarked that it was Chrismas who taught him about minimalism.)[8]

Yet as visible as Chrismas was, as big as his shows were, little was known of him. It was the era of the Warholian personality, where it wasn't enough to have mystery; you had to have intrigue as well, for without intrigue there is no curiosity. And curiosity, in those days, was infectious, driving Vancouverites to places they had never been before. Art galleries were one such place, the stock market another.

The late 1960s saw record gains for the Vancouver Stock Exchange,[9] gains that paralleled the rising idealism of youth, many of who were critical of the mode of production that had market speculation as one of its touchstones. In some ways, Chrismas was a low-impact version of the

stock promoter—a hipper Murray Pezim, a more tasteful Peter Brown.[10] Not as genteel as Balkind and Rogatnick, the original canners of west coast modernism, but effective. For how else could one convince collectors of the importance of conceptual artists like Kosuth, Weiner, and Robert Smithson? If people were buying stock in northern BC goldmines based on little more than a well-written prospectus, why wouldn't they speculate on a text painting by Kosuth, or a snapshot by Dan Graham—or even an earth work, as architect Ian Davidson had when, at Chrismas's urging, he commissioned Robert Smithson to create the earthwork *Glass Strata with Mulch and Soil* (1970) on the grounds of his West Vancouver home?

But as the 1970s opened, Chrismas, like the Vancouver Stock Exchange, began to sputter. Although he had expanded his network to include Ace galleries in Los Angeles (1967) and Venice Beach (1974), and had connected with New York-based Leo Castelli, whose artists he began representing on the West Coast, his Vancouver career seemed to spiral downward. For every visit by a Robert Rauschenburg, an Andy Warhol, or a Frank Stella, for every sale to an Ian Davidson, a Brigitte and Henning Freybe, or a Ron Longstaffe, there was a disgruntled artist waiting to get paid (or leaving the gallery altogether, as Toni Onley and Jack Shadbolt did, for Bau-Xi). Add to that Chrismas's worsening reputation as an employer (in 1971, he opened a west coast Native restaurant, called the Muckamuck, in the gallery's basement, employing a mostly First Nations staff, whom he treated poorly), and the Chrismas name was becoming mud. The *coup de grâce* came in 1978 when, after moving Ace Gallery to West Georgia Street, Chrismas reproached his recently unionized restaurant staff by opening a cowboy-themed bar in the empty space above. "I'll deal with my natives *my* way," he told Muggs Sigurgeirson, the union representative who helped the Muckamuck workers organize.[11]

By 1980, Doug Chrismas was done with Vancouver, moving permanently to Southern California, where he continued to wheel-and-deal. However, unlike New York-based conceptual art gallerist Seth Siegelaub, whose galleries were getting successively smaller, Chrismas's were growing larger, and he was soliciting bigger and bigger pieces. All of which came to a brief standstill, in 1986, when he was charged with defrauding West Vancouver collector Frederick Stimpson of seven art works worth over $1 million US.[12] Apparently, he had intentionally sold Stimpson's Rauschenberg work, *Rodeo Palace* (1975–76), then worth $600,000 US, to three different people, in order to feed his gallery habit. (Talk about multiples.)

The end of the Chrismas era marks the end of what had been, since the New Design Gallery, a twenty-four year trajectory—eleven years as New Design (1955–1966), thirteen as Douglas/Ace (1967–1980). Obviously, much happened in that time. Although Vancouver had nowhere near the collecting base of art's Mecca, New York City (nor even Montreal and Toronto, where most of the country's corporate and individual wealth was located), there was still enough interest in art collecting for the city

to support a commercial gallery district on South Granville, anchored in part by Bau-Xi and, later, Equinox. Yet, as much as "gallery row" spoke of Vancouver's interest in acquiring art, the work, for the most part, was not that far removed from the abstract landscape painting that was going on when Balkind and Rogatnick arrived in 1955. Which is not to disparage the work, so much as to ask: Where might one find the minimal and conceptual artists Doug Chrismas was showing in the late 1960s and early 70s? What happened to what was new?

NOVA Gallery, dedicated to vintage, modern, and contemporary photography, opened in 1976. Like Balkind and Rogatnick, NOVA's proprietors Claudia Beck and Andrew Gruft came to Vancouver from elsewhere (Beck from Indiana, in 1970, to teach art history at UBC; Gruft via Brazil, in 1964, to work at an architectural firm, before joining Rogatnick at the UBC's School of Architecture in 1967). Interest in opening a gallery came later, during a 1975 visit to San Francisco, where they met Simon Lewinsky, a gallerist who dealt in photography and who encouraged the couple to take prints home, on a trial basis. According to Beck, what started as a series of Saturday afternoon salons—friends and acquaintances nibbling snacks and viewing photos laid out on tables and chairs—evolved into a gallery on 4th Avenue, just west of Arbutus Street.

But this was not a capricious venture, undertaken by naïve enthusiasts. Beck and Gruft were well connected to the local avant-garde, some of whom (like Western Front co-founders Michael Morris and Vincent Trasov) had been incorporating photography with other art forms since the 1960s. As well, they knew—just as Balkind, Rogatnick, and Chrismas had—that in order to stay in business they had to promote an understanding of the medium and its history. It was not enough to recognize the increased presence of photography in contemporary art; one had to build and educate an audience, and this they did.[13]

Photography was not new to Vancouver. Chrismas had shown photo-based works at Douglas Gallery, and Art and Emily Grice ran a small photo gallery in Gastown in the early 1970s. There was the "straight" photography of Fred Herzog, as well as the more experimental photography of artists Marian Penner Bancroft, Michael de Courcy, Christos Dikeakos, Roy Kiyooka, N.E. Thing Co., Henri Robideau, Jeff Wall, and Ian Wallace (all, with the exception of Kiyooka, went on to exhibit at NOVA). As for local art collectors, they were, in some cases, as knowledgeable about the medium as the artists. Not that there were many collectors, and even fewer were collecting photography.

An early impediment to NOVA's potential financial success was having to deal with the already established reputations of local artists, many of whom were selling directly to public institutions like the National Film Board, the National Gallery of Canada, the Vancouver Art Gallery, and the Art Bank. Sales like these were easy, and few artists were willing to hand them over to a dealer (unlike today, where most institutional sales are

brokered by dealers). Thus, if NOVA wanted to make a go of it, it was up to them to create and encourage a new group of photography collectors—a difficult thing in a city as small as Vancouver. As for sales to individuals outside the city, they were even rarer.

Undeterred, NOVA opened with a major group exhibition in the winter of 1976—featuring locals Bancroft, Jim Breukelman, de Courcy, Morris, N.E. Thing Co., and Trudy Rubenfeld, among others. Subsequent group

NOVA advertisement
*Vanguard*, vol. 9, no. 2
(March 1980): 42

and solo shows mixed local and international artists. In an effort to contextualize the then-current practices, NOVA presented shows that combined contemporary works with historical and modern prints. Significant shows included the premiere of Jeff Wall's *Destroyed Room* (1978), which was displayed in the gallery window, while behind it, facing inward, an apochryphal work featuring Wall's death-by-drowning, *à la* Bayard, entitled *Faking Death* (1977). It was shows like Wall's that contributed to the gallery's artistic and (modest) financial success.

But success was expensive. Beck was spending more and more time on the road—not at international art fairs,[14] as gallerists do now, but at galleries in New York and Europe, where work is taken on consignment and shipped home COD. There were auctions and conferences, such as the International Photographic Art Dealers. And, of course, there were the artists, one of whom, Rodney Graham, was at the centre of the gallery's biggest controversy.

There is more than one version of what happened in 1979 between NOVA and Rodney Graham. Here is a composite, a montage if you will, based on at least three different points of view: the gallery approached the artist to do a show; the artist, who had participated in a prior NOVA group show, agreed, proposing a scale model of a shack-sized camera obscura he was building on his uncle's Fraser Valley farm, as well as a photographic print taken from that shack (which the artist thought theoretically possible, based on the principles of photography). However, the work that was delivered (within forty-eight hours of the opening) was not a photo from

the Fraser Valley shack but one taken by a large-format camera—and no scale model.

The absence of the model is not explained, but the story of the photo goes like this: due to the "reciprocity failure" (whereby the longer film paper is exposed to light, the fainter the image becomes), it was impossible for the shack (i.e. pinhole camera) to capture the landscape Graham was seeking. So he asked his friend Jeff Wall if he might simulate the effect on his 8 × 10 camera, placing the camera in front of the shack and opening the aperture full tilt. Same principle, Graham argued, but the gallery said no—not the same work (or at least not the work they had agreed upon). So NOVA cancelled the show. On the night of the opening, Graham stood outside the gallery and invited patrons to the show's new time and place—Ian Wallace's studio. It was there that both the photo and the model were exhibited.

Although by no means the end of NOVA, what happened with Rodney Graham created unrest between the gallery and certain members of the artist community. It was not the same as what happened with Doug Chrismas (who, though morally suspect, always made sure his shows looked good); this time the conflict had to do with the temerity of the gallerists. They said no. To an artist. And who were they to say no? It was as if these people were curators. How dare they!

As I said, there are numerous versions of what happened at NOVA. Yet no matter who is right, most will agree that a power struggle ensued. And there were consequences: Graham, Wall, and Wallace took their business elsewhere. Adding weight to this, I believe, was a long-simmering suspicion towards commercial gallerists in general, a suspicion rooted in the Doug Chrismas era—a gallerist who not only had a reputation for not paying artists, but who capitalized on their contacts, and then stopped showing them altogether.

In the wider scheme, the province of British Columbia, which has long been polarized between free wheeling entrepreneurs and working people, was becoming increasingly divided, especially with the re-election of Bill Bennett's Social Credit government in 1979, which like Margaret Thatcher in the UK and Ronald Reagan in the US, planned to cut, and perhaps dismantle, many social programs. Although it would be simplistic to equate commercial gallerists with entrepreneurs, and artists with working people, I wonder how Wall and Wallace saw themselves, or were seen by others, in light of this divide. As artists who make objects out of opportunities, and who consign those objects to galleries, would that not also make them entrepreneurs? At the same time, because Wall was employed by Simon Fraser University and Wallace by Emily Carr College of Art & Design, as teachers, were they not wage workers as well? I bring this up not to force a distinction so much as show how the commercial gallerist and the artist are, with respect to production and consumption,

not that dissimilar. Indeed, it is the "graying" of this area between artist and commercial gallerist, and who does what to whom, that is of interest.

By the time NOVA closed in the spring of 1982, the provincial government and organized labour were heading towards a showdown, due in part to the government's plan to reduce social programs, limit public sector wage increases, and sell off Crown corporations. These cuts were being organized under the rubric of "restraint."[15] Citizens were being asked

Coburg Gallery advertisement
*Vanguard*, vol. 11, no. 9&10 (December/January 1982/1983): 43

to tighten their belts, prepare for hard times. Although Beck and Gruft had considered recapitalizing, they decided that the immediate future did not look good for art collecting.

It was during the dark days of "restraint" that the Coburg Gallery opened, in the winter of 1983, on Vancouver's Downtown Eastside. Like Balkind, Rogatnick, and Beck, Coburg Gallery's founder Bill Jeffries also came to Vancouver from the United States (in this case, via Vancouver Island). However, unlike his predecessors, he did not have the capital to seed his gallery, nor a profession to subsidize it. Nor was he well-connected to the local scene. What he did have—growing up in a family-run grocery store in New Jersey—was retail experience, as well as a two-year studio education at UBC. He, too, was interested in photo-based work.

In order to keep costs down, Jeffries would show works that were already prepped and framed. When he wasn't at the gallery, he would drive a cab, relying on the volunteer work of artists Ken Lum, Nancy Shaw, and others. Rent was cheap. The Coburg Gallery continued in this manner for over four years, showcasing some of the newer artists on the local scene—including some who had previously shown at NOVA, and others, like Louise Lawler, from abroad. Although Jeffries had better luck selling work to public institutions, the gallery required an inordinate amount of time and effort, and after five years, he was spent. In May of 1987, Jeffries closed his doors and left for Europe.

The impact of the Social Credit government—from the "restraint" period in the early 80s to the transportation-themed Expo '86 world's fair—is taken up in the book *Vancouver Anthology*, and I won't get into it here.[16] For British Columbians, Expo '86 was intended to be the catharsis after years of tough love or "restraint." For those outside the province and abroad, it was a trade show designed to lure foreign investment. The emphasis on foreign investment (at the expense of foreign review boards and the welfare state) was consistent with US and UK foreign economic policies—policies that, in effect, were geared towards a new world, where power is brokered not through politics, but by finance. Suffice it to say, at no time before or after has this city seen a provincial government "restructuring" of such proportion—an often draconian attempt to shift the economic base of the province from primary (resource) to tertiary (service, "hi-tech") industry, using a world's fair as its rationale. And there were consequences—numerous displacements, reorganizations, and, in the case of the Downtown Eastside, outright banishments. That much of Expo '86 was accomplished with federal transfer payments earmarked for health and education is equally galling. Imagine beating someone up for five years, then, at the end of it, hosing them down and throwing a party in their honour, inviting the world to see (a pattern that is feared will recur, in advance of the 2010 Vancouver-Whistler Winter Olympics). Looking back, we have come to characterize those years (roughly 1979 to 1992) as "neo-conservative," a conservatism that was paralleled in the world of contemporary art.

With respect to the western art world, the late 1970s marked the beginning of a revived interest in the buying and selling of painting: first in Europe, with the neo-expressionist canvases of Anselm Kiefer and Georg Baselitz; then, in the early 1980s, with New York painters like Julian Schnabel and David Salle. Vancouver's painting revival followed, in the mid-1980s—the Vancouver Art Gallery's exhibition *Young Romantics* (1985), which featured a mix of artists engaged in the problems of painting (Charles Rae, Philippe Raphanel, and Mina Totino) and painters celebrating the return of narrative figuration (then-recent Emily Carr College of Art & Design graduates such as Graham Gillmore, Angela Grossman, and Attila Richard Lukacs). The success of the *Young Romantics* show is remembered, in part, by the inclusion of its artists in subsequent shows at Diane Farris Gallery, whose namesake is a former folk art dealer who "succeeded" in selling the work of these artists to whoever wanted to buy it. Or, put another way, the "failure" of the Diane Farris Gallery lies not in her lack of sales, but her inability to get the work into influential international collections, thereby increasing the value of her artists. But these were the times where artists' success (indeed, their identity) was once again perceived to be based on their ability to participate in the market—however shortsighted that might be.

It was, to some extent, this revived interest in painting (and its attendant culture) that allowed Catriona Jeffries, a West Vancouverite, and Monte Clark, who was raised in Maple Ridge, to imagine galleries of their own. Yet, as we shall see, if it was painting that got them into the game, it was photo-based work that made them prominent.[17]

The story of Catriona Jeffries Gallery and Monte Clark Gallery is, necessarily, one of progressive reassessments. I say "necessarily" because for

*(left)* Diane Farris Gallery advertisement
*Vanguard*, vol. 14, no. 7 (September 1985): 8

*(right)* Catriona Jeffries Gallery advertisement
*Canadian Art*, vol. 11, no. 3 (Fall 1994): 140

a commercial gallery to remain relevant, it must always be adding new artists and positioning their work in relation to the tastes and preoccupations of the day. The same is true for older, more established artists— one has to ensure that the historical context from which they emerged is both available and has bearing on what is new. NOVA was good at this—exhibiting contemporary photography with historical prints— and Beck and Gruft's impact on Monte Clark, through their curation of the *Proposal for an Exhibition* (2002–2003)[18] show at his gallery, is a measure and, perhaps, a vindication of their curatorial prowess. With respect to Catriona Jeffries, it is the importation of work by international artists such as Carsten Holler, Frances Stark, and Chen Zhen that allows for a dialogue between local artists such as Ken Lum, Myfanwy MacLeod, and Alex Morrison.

Of course, the pairing of international and local artists was not yet part of the program when Jeffries and Clark opened their galleries (Jeffries in 1988, at Burrard and Dunsmuir Streets; Clark in 1991, at Carrall and East

Pender Streets). Both showed mostly painting. Both struggled to position themselves within a scene where better-known Vancouver artists such as Stan Douglas, Rodney Graham, Ken Lum, Jeff Wall, and Ian Wallace had representation outside the country; and where younger artists were exploring non-traditional media, such as installation, or had practices that were more interested in investigating minimal and conceptual histories than making objects representing those histories.

Monte Clark Gallery
advertisement
*Canadian Art*, vol. 21, no. 2
(Summer 2004): 1

Reassessment for Jeffries began in 1993, with her partnership with British art dealer Nigel Harrison, who had experience in the international art market—something Clark had been involved in while working in Southern California in the 1980s (though Clark, it should be noted, was working primarily in the secondary market, reselling paintings, an area which continues to account for a good part of his revenue). In June 1994, after moving from her second location (in Yaletown) to 15th Avenue and Granville Street, Jeffries re-opened with a show of photo-based works by Marian Penner Bancroft, Christos Dikeakos, and Ian Wallace. Jeffries, by then, had been taking art history classes and had developed an interest in local photoconceptual practices. As for Clark, his reassessment began in 1997, at the Contemporary Art Gallery's *bonus* show, a group exhibition curated by artist Roy Arden and featuring the photographic works of artists Damian Moppett, Howard Ursuliak, and Kelly Wood. It was there that Clark became interested in Ursuliak's photos of corner stores and used furniture shops, later taking the work to the ARCO International Art Fair in

Madrid, where it sold. Clark, by this time, had also relocated to Granville Street, seven blocks north of Jeffries' gallery.

In the years that followed, both galleries were entertaining proposals by independent curators, some of whom were also artists. Christopher Brayshaw and Ken Lum curated shows at Catriona Jeffries,[19] while Roy Arden, Claudia Beck, Andrew Gruft, and Kitty Scott did the same at Monte Clark's.[20] Jeffries, by then, had been employing artists and art history graduates to work in the gallery, as well as commissioning catalogue essays by local and international writers. Perhaps most significantly, she was presenting the work of gallery artists that linked to exhibitions by those same artists at artist-run centres, like the Or Gallery, which had emerged in 1983.[21] What was once a clear line between public and private was, like Graham's "reciprocity" landscape photo, becoming faint. But this was the trend, for the mantra running through government-funded arts organizations in the late 1980s and 90s was "public-private interface." One need only look at the blank back cover of the Vancouver Art Gallery's *Vancouver Art & Artists* publication (1983)[22] and compare it to the corporate logo tattooed inside the *6: New Vancouver Modern catalogue* (1997) from UBC's Morris and Helen Belkin Art Gallery to get a sense of the increasingly "interactive" relationship between public and private economies.[23]

Yet nowhere is the relationship between public and private more manifest than in the federal government's increasing commitment to commercial galleries as agents for the distribution of Canadian art world-wide. In the past, and continuing into the present, programs such as the Program for Export Market Development (PEMD), which is administered by the Department of Foreign Affairs and International Trade (DFAIT), provided grants to commercial galleries wishing to participate in international art fairs, where much of the work by younger Vancouver artists is sold. Another program, Audience and Market Development, made available to commercial galleries through the Canada Council for the Arts, funds visits by foreign curators. These programs have become better utilized in the last two decades, and while artists such as Stan Douglas, Rodney Graham, Ken Lum, Jeff Wall, and Ian Wallace (who had already made names for themselves outside of Vancouver) did not benefit from these programs,[24] local galleries—and their younger artists—have.

So what has happened with Vancouver's commercial galleries in the last fifty years? What do we know? The municipality of West Vancouver certainly looms large in the production of modern and contemporary art, as the site of Vancouver's first contemporary art gallery, as well as the home of Vancouver's early moderns. So, too, does the University of British Columbia, which, at various times, employed many of the city's architects (Binning, Rogatnick, Gruft), curators (Balkind, Scott Watson), and artists (Lum, Wall), all of whom have exerted influence on the local scene (sometimes as cop, other times as priest). With respect to contem-

porary commercial gallerists, despite modest (read: unsustainable) local sales, they have expanded their roles to include educator (New Design) impressario (Douglas/Ace), curator (NOVA), and institutional collaborator (Catriona Jeffries). The city, as an economic landscape, has also contributed. Once a major resource port, Vancouver now doubles as a film and television location, as well as a setting for photo-based works by Arden, Douglas, Lum, Wall, and Wallace; what was once an importer of cheap labour is now a solicitor of foreign investment; the graveyard of the Vancouver Stock Exchange, a theme park called Real Estate Speculation. And now, with the ghost of Expo '86 still haunting the Downtown Eastside, the municipal, provincial, and federal governments are in the midst of employing the latest agent of rationalization, the 2010 Winter Olympics.

One topic that hasn't been discussed is the role of the collector in commissioning works and what they (the wealthiest of them being developers and real estate agents) derive from it. At a recent (commercial) gallery opening, I overheard one such collector yawn: "I think we own this room." It was a depressing moment. Not because this person laid claim to the work that surrounded us, but because he failed to acknowledge that the artist, together with the gallerist, had worked so hard to make it happen.

1. Seth Siegelaub, interview with Patricia Norvell, in *Recording Conceptual Art*, eds. Alexander Alberro and Patricia Norvell (Berkeley/Los Angeles/London: University of California Press, 2001): 38.

2. Andy Warhol, *The Andy Warhol Diaries*, ed. Pat Hackett (New York: Warner Books, 1989): 1.

3. Books include: *Vancouver Anthology: The Institutional Politics of Art*, ed. Stan Douglas (Vancouver: Talonbooks, 1991); *Whispered Art History: Twenty Years at the Western Front*, ed. Keith Wallace (Vancouver: Arsenal Pulp Press, 1993); *Vancouver: Representing the Postmodern City*, ed. Paul Delany (Vancouver: Arsenal Pulp Press, 1994); *Making Video "In": The Contested Ground of Alternative Video on the West Coast*, ed. Jennifer Abbott (Vancouver: Video In, 1996); *Writing Class: The Kootenay School of Writing Anthology*, eds. Andrew Klobucar and Michael Barnholden (Vancouver: New Star Books, 1999). Catalogues include: *Vancouver: Art and Artists 1931–1983* (Vancouver: Vancouver Art Gallery, 1983); *Intertidal: Vancouver Art & Artists* (Vancouver/Antwerp: Morris and Helen Belkin Art Gallery/MUHKA, 2005). Magazines include: *Vanguard* (1979–1989), *Boo* (1994–1997), *Last Call* (2001–2002), *fillip* (2005–).

4. Keith Wallace, "A Particular History: Artist-run Centres in Vancouver," *Vancouver Anthology: The Institutional Politics of Art*: 42.

5. Jeff Derksen, "Sites Taken as Signs," *Vancouver: Representing the Postmodern City*: 146.

6. Personal communication with Scott Watson.

7. Personal communication with Abraham Rogatnick.

8. Personal communication with Stan Douglas.

9. David Cruise & Alison Griffiths, *Fleecing the Lamb: The Inside Story of the Vancouver Stock Exchange* (Vancouver: Douglas & McIntyre, 1987): 107.

10. Both Pezim and Brown were stock promoters who went on to head the Vancouver Stock Exchange.

11. Quoted in Douglas Coupland, "Ace In The Hole," *Vancouver Magazine* (June 1987): 45.

12. "Art dealer charged," *The Province* (February 9, 1986): 7.

13. Personal communication with Claudia Beck.

14. Although Madrid's ARCO celebrated its 25th anniversary in 2006, the impact of art fairs as primary sites for the buying and selling of artwork is a relatively recent one, taking off as it did in the late 1990s, rising steadily since. A list of the world's most prominent fairs includes Art Basel (held in Miami's South Beach in 2006), New York's Armory Show, Artforum Berlin, and Frieze Art Fair (London).

15. For a detailed analysis of Social Credit policy and its consequences, see *The New Reality: The Politics of Restraint in British Columbia*, eds. Warren Magnusson, et al (Vancouver: New Star Books, 1984).

16. *Vancouver Anthology: The Institutional Politics of Art*.

17. I am focusing on Catriona Jeffries Gallery and Monte Clark Gallery (and not other contemporary art galleries, such as the State Gallery and Tracey Lawrence Gallery), because only Jeffries and Clark, to my mind, have established distinct gallery programs (the former focusing on what she calls "post-conceptual practices"; the latter, the history of photography). Indeed, implicit within the notion of establishment is the passage of time, something both the Jeffries and Clark galleries have had lots of.

18. Artists in this show were Roy Arden, Eugene Atget, Karin Bubaš, Lynne Cohen, Joe Deal, William Eggleston, Peter Henry Emerson, Walker Evans, Chris Gergley, Evan Lee, Helen Levitt, Scott McFarland, Stephen Shore, Howard Ursuliak, Stephen Waddell, and Gary Winogrand.

19. At Catriona Jeffries Gallery, Christopher Brayshaw curated the *Configuration* show, 1997; Ken Lum curated *Chen Zhen*, 1998; *Artists Curating Artists: Myfanwy MacLeod Curates Kyla Mallet* and *Damian Moppett Curates Allison Hrabluik and Zin Taylor* (both 2004).

20. Roy Arden curated *After Photography*, 1999; Kitty Scott curated *Universal Pictures II*, 1999; Beck and Gruft curated *A Proposal for an Exhibition*, 2002–2003.

21. For SWARM 2 (2001), an evening of fall openings organized by local artist-run centres, MacLeod exhibited a series of drawings at Catriona Jeffries Gallery (*Miss Moonshine*) that linked thematically to an installation at Or Gallery (*The Tiny Kingdom*, curated by Reid Shier). Significantly, the SWARM poster included the show at Catriona Jeffries Gallery.

22. The example of the monochrome/blank page on the back cover of the Vancouver Art Gallery's *Vancouver Art & Artists* catalogue has always intrigued me. I would like to believe that its "blankness" was an homage to the derive-scapes of Ian Wallace, though it appears more likely the result of a corporate sponsor pulling out at the last minute.

23. Recently, over drinks, former Artspeak Director/Curator Lorna Brown spoke to a group of us about the variegation of "public" and "private" funding, asking us to consider places where public and private met. Which we did, beginning with the art student, who pays tuition (some

of it supplemented by government loans) to attend a publicly-funded institution; how that artist/student might one day exhibit at a publicly-subsidized artist-run centre, receiving an artist fee to help make the work; how, if that work attracts attention, the artist might be picked up by a commercial gallerist who applies for and receives public monies to allow for foreign curatorial visits with that artist, as well as supplement the exportation of that artist's work to art fairs; how, if the work sells, the artist receives somewhere between 50 and 60 percent of the sale (less expenses), with some of those sales coming from public institutions (some of whom, in a recent trend, seek out private individuals to pay for the work they are acquiring). Then-Western Front Gallery Director/ Curator Jonathan Middleton pointed out that local dealers have been increasingly successful at receiving grants from the Canada Council for the Arts, support that often goes unadvertised and therefore does not enter into public awareness. The Canada Council website offers funding statistics that reveal that Catriona Jeffries Gallery received more funds from the Council in the 2004–05 fiscal year than over 34 percent of Canadian artist-run centres in the same year.

24. After leaving NOVA, Wall, Wallace, and Graham exhibited work with Toronto-based gallerists, such as David Bellman and Ydessa Hendeles, eventually leaving them for American and European representation. Of the three, only Wallace continues to work with a Canadian gallerist (Jeffries). I should also mention that the above artists, along with Roy Arden and Stan Douglas, have, at various times, received funding through the Department of External Affairs, now the Department of Foreign Affairs and International Trade.

### Appendix: Vancouver Commercial Gallery Chronology

1955 **New Design Gallery** opened in West Vancouver. It was founded by Alvin Balkind, who acted as Director until 1962, and Abraham Rogatnick. The gallery was the first in the region to show Michael Morris, Toni Onley, and Jack Shadbolt.

1956 **New Design Gallery** began advertising in *Canadian Art* magazine. At that time, the artists represented by the gallery included Peter Aspell, Bruno Bobak, Molly Bobak, B.C. Binning, Don Jarvis, John Koerner, Joe Plaskett, Jack Shadbolt, and Gordon Smith.

Alan Jarvis, Director of the National Gallery of Canada, visited **New Design Gallery** and declared Vancouver a thriving art scene.

1958 **New Design Gallery** moved from West Vancouver to Pender Street in downtown Vancouver. The gallery was part of the new Arts Club and the space was divided by a movable wall.

1960s The 1960s marked the wider emergence of commercial galleries in Vancouver. Many presented important contemporary art from the United States and beyond, providing a broader context for the production of Vancouver-based artists. At this time there was a growing interest among Vancouver collectors in the work of Carl Andre, Robert Rauschenberg, Robert Smithson, and Andy Warhol, as well as Canadian artists Roy Kiyooka, Michael Morris, and Jack Shadbolt.

1962 Alvin Balkind left the **New Design Gallery** to direct the University of British Columbia Fine Arts Gallery. **New Design Gallery** was then run by a Board of Directors and Betty Marshall was hired as the gallery director.

1965 **Bau-Xi Gallery** was opened by Paul Wong (Huang) at 555 Hamilton Street (which was later the site of the Contemporary Art Gallery and is currently the site of the Belkin Satellite).

In its early years, **Bau-Xi Gallery** represented Maxwell Bates, Toni Onley, Jack Shadbolt, and Gordon Smith, among others.

1966 **New Design Gallery** closed and was sold to Douglas Chrismas. In Rogatnick's words, "Chrismas absorbed the New Design Gallery and turned it into Ace Gallery."

**Ace Gallery** (originally called Douglas Gallery) was opened by Douglas Chrismas. Chrismas brought the work of Carl Andre, Dan Flavin, Bruce Nauman, Edward Ruscha, Robert Smithson, Frank Stella, and Andy Warhol to Vancouver.

1969  *Focus 69*, a group show at **Bau-Xi Gallery**, included Jeff Wall.

1972  **Equinox Gallery** was opened by Elizabeth Nichol. In its early years Equinox showed Richard Hamilton, David Hockney, E.J. Hughes, Jasper Johns, Roy Lichtenstein, and George Segal, among others.

At the time of publication, the Equinox Gallery represents twenty-two artists including Gathie Falk, Liz Magor, Al McWilliams, Philippe Raphanel, Jack Shadbolt, Gordon Smith, Takao Tanabe, Renée Van Halm, Neil Wedman, and Etienne Zack. The gallery also has works available by Donald Baechler, Louise Bourgeois, Vija Celmins, David Hockney, and Roy Lichtenstein, among others.

1974  **Atelier Gallery** opened. The business began as a framing shop that showed European prints including work by Barbara Hepworth and Henry Moore. Ilana Aloni, who began working at the gallery in 1976, sold the business to current director John Ramsay in 2006. In the 1980s, the gallery began showing Canadian artists and has published catalogues for Enn Erisalu, Paul de Guzman, and Robert Young.

**Equinox Gallery** moved to the third-floor penthouse of 1525 West 8th Avenue.

1975  **Marion Scott Gallery** opened. The gallery's focus was, and continues to be, Inuit art and work from Northern Canada.

**Bau-Xi Gallery** moved to 1876 West 1st Avenue.

1976  **NOVA** was opened by Claudia Beck and Andrew Gruft. It was the first gallery in Vancouver to specialize in photographic work. Artists shown include Sorel Cohen, James Collins, Michael Morris, Jeff Wall, and Ian Wallace, among others.

**Bau-Xi** Gallery opened a second location in Toronto.

1978  **Heffel Gallery** opened, founded by Kenneth Heffel. It was a secondary market gallery focusing largely on historic Canadian

painting. Heffel, currently a nation-wide auction house and multi-venue business, has gallery locations in Vancouver, Toronto, Ottawa, and Montreal.

Jeff Wall's *The Destroyed Room* and *Faking Death* were exhibited at **NOVA**.

Ian Wallace exhibited at **NOVA**.

1979  **Buschlen Mowatt Gallery** opened.

**Inuit Gallery of Vancouver** opened.

1980  Andy Sylvester became director of **Equinox Gallery**. Rudi Fuchs, artistic director of Documenta 7, visited Vancouver and **Equinox Gallery**.

**Ace Gallery** closed. Douglas Chrismas left Vancouver.

1982  **NOVA** closed.

1983  **Coburg Gallery**, another gallery focused on photography, opened. Run by Bill Jeffries, the first exhibition featured the work of Henri Robideau.

1984  **Diane Farris Gallery** opened. During the first year, Diane Farris worked with Toronto gallerist Olga Korper to send work to Documenta, including Vicky Marshall and Philippe Raphanel.

In the 1980s, **Diane Farris Gallery** represented many young painters featured in the Vancouver Art Gallery's *Young Romantics* exhibition (1985), including Angela Grossman and Attila Richard Lukacs. During this time, the gallery brought speakers from outside of Vancouver to speak about the work or to discuss collecting.

1985  **Equinox Gallery** published *Gathie Falk: Chairs*.

1986  Vikky Alexander and Ian Wallace exhibited at the **Coburg Gallery.**

1987  **Coburg Gallery** closed.

**Equinox Gallery** moved to its current location, 2331 Granville Street.

1988  **Catriona Jeffries Fine Art** opened in a third-floor office space on Burrard Street.

At the time of publication, Catriona Jeffries Gallery
represents Christos Dikeakos, Geoffrey Farmer, Arni Runar
Haraldsson, Brian Jungen, Roy Kiyooka, Germaine Koh,
Myfanwy MacLeod, Damian Moppett, Alex Morrison, Isabelle
Pauwels, Jerry Pethick, Judy Radul, Kevin Schmidt, Ron
Terada, Ian Wallace, Kelly Wood, and Jin-me Yoon.

1989    *Robert Davidson: An Exhibition of Northwest Coast Native Art*
        at the **Inuit Gallery.**

1991    **Catriona Jeffries Fine Art** changed its name to **Catriona
        Jeffries Gallery** and moved to Yaletown.

        **Monte Clark Gallery** opened. The gallery opened a second
        location in Toronto in 2001. At the time of publication,
        Monte Clark Gallery represents Roy Arden, Karin Bubaš,
        Douglas Coupland, Chris Gergley, Graham Gillmore, Evan Lee,
        Mark Lewis, Scott McFarland, Derek Root, Allan Switzer,
        Howard Ursuliak, and Stephen Waddell, among others.

        **Art Beatus** was founded by Dr. Annie Wong. The Nelson
        Street gallery opened in 1996, and Art Beatus also has two
        Hong Kong locations.

1993    *DRAWING: by Artists, Sculptors and Architects* at **Atelier
        Gallery** included drawing by Jeff Wall.

1994    **Catriona Jeffries Gallery** moved to 3149 Granville and Nigel
        Harrison joined the administration as a Director.

        Christos Dikeakos and Ken Lum had solo exhibitions at
        **Catriona Jeffries Gallery.**

1995    **Spirit Wrestler Gallery** opened, featuring Northwest Coast
        and Inuit works.

        Ian Wallace and Marian Penner Bancroft had solo exhibitions
        at **Catriona Jeffries Gallery.**

1996    **Third Avenue Gallery** opened.

1997    Christopher Brayshaw curated *Configuration: New Art from
        Vancouver* at **Catriona Jeffries Gallery.**

        **Catriona Jeffries Gallery** began publishing texts to
        accompany exhibitions. Writers included Lindsay Brown,

Clint Burnham, Jesse Caryl, Jeff Derksen, Kyla Mallett, Pamela Meredith, Melanie O'Brian, and Michael Turner, among others.

*Jean-Michel Basquiat* exhibited at **Art Beatus**.

1998    **Whitman Lawrence Gallery** opened and operated until 2000.

**Buschlen Mowatt Galleries** began the Vancouver International Sculpture Project which became the Open Spaces Sculpture Biennale in 2004.

Thomas Ruff exhibition at **Atelier Gallery**.

**Catriona Jeffries Gallery** began to work with the N.E. Thing Co. archive.

*CHINA 4696/1988* exhibited at **Art Beatus** including work by Gu Wenda, Liu Wei, Luo Brothers, Yang Jie Chang, and Yue Min Jun in collaboration with Lehmann Maupin Gallery, New York.

**Art Beatus** participated in *Jiangnan*, a city-wide exhibition of contemporary and modern Chinese works at thirteen locations in Vancouver, including artist-run centres and public galleries.

1999    Roy Arden curated *After Photography* and Kitty Scott curated *Universal Pictures II* at **Monte Clark Gallery**. Both group exhibitions were accompanied by a publication.

**Equinox Gallery** exhibited *Sleeping Rough* by Liz Magor.

*Futura Bold—Fifteen Years Later*, included Graham Gillmore, Angela Grossman, Attila Richard Lukacs at **Diane Farris Gallery**.

*Playing with Matches*, an exhibition of work by Beck and Al Hansen, was held at **Art Beatus**.

2000    *Royal Art Lodge* exhibition at **Atelier Gallery**.

**Tracey Lawrence Gallery** opened. At the time of publication, the gallery represents artists Robert Arndt, David Carter, Tim Lee, Euan Macdonald, Kelly Mark, Jason McLean, Shannon Oksanen, Jeremy Shaw, Kathy Slade, Althea Thauberger, Brandon Thiessen, Mina Totino, and Janet Werner among others.

**Jennifer Kostiuk Gallery** opened.

*Talk the Talk* at **Atelier Gallery** included local and international artists such as Steven Shearer and Louise Bourgeois.

**Catriona Jeffries Gallery** attended its first Armory Show in New York.

**State Gallery** opened by Susan Almrud. Artists included Vikky Alexander, Kim Kennedy Austin, Jim Breukelman, Miguel Da Conceicao, Eric Glavin, Angela Leach, Natasha McHardy, Sandeep Mukherjee, Isabelle Pauwels, Lucy Pullen, and Danny Singer among others.

*Catriona Jeffries Catriona* by Geoffrey Farmer at **Catriona Jeffries Gallery**.

2001   **Monte Clark Gallery** exhibited Steven Shearer's *Pussyfootin'*.

2002   *Entering City of Vancouver* by Ron Terada exhibited at **Catriona Jeffries Gallery**.

Brian Jungen exhibited at **Catriona Jeffries Gallery** for the first time.

*A Proposal for an Exhibition*, curated by Claudia Beck and Andrew Gruft, at **Monte Clark Gallery**.

**Catriona Jeffries Gallery** attended Artforum in Berlin.

**Bau-Xi Gallery** bought Foster White Gallery in Seattle, retaining the name.

*China Diary*, Gu Xiong at **Diane Farris Gallery**.

2003   Drawing on Architecture at **Atelier Gallery**, guest curated by Patrik Andersson.

*Halleluja Garden*, guest curated by Mark Soo, at **State Gallery**.

**Equinox Gallery** published *Gordon Smith* with text by Douglas Coupland.

**Catriona Jeffries Gallery** organized *Seethe* which included work by international artists Carsten Holler, Raymond Pettibon, Lawrence Weiner, and Erin Wurm, among others.

2004   The *Artists curating Artist* series ran at **Catriona Jeffries Gallery** and included Myfanwy MacLeod curating Kyla Mallet; Damian Moppett curating Allison Hrablick and Zin Taylor.

*Fugitive (Unbidden)* by Jin-me Yoon exhibited at **Catriona Jeffries**.

Tim Lee and Jason McLean had solo exhibitions at **Tracey Lawrence Gallery**.

*Sweet and Sour* exhibition at **Tracey Lawrence Gallery** included Cathy Daley, Shannon Oksanen, Kathy Slade, Althea Thauberger, and Janet Werner.

Vikky Alexander had a solo exhibition at **State Gallery**.

**Tracey Lawrence Gallery** made its first trip to Liste (Basel) taking work by Robert Arndt, Tim Lee, Jason McLean, and Althea Thauberger.

**Bjornson Kajiwara Gallery** opened, taking over **Third Avenue Gallery**.

2005    Shannon Oksanen had a solo exhibition at **Tracey Lawrence Gallery**.

**Tracey Lawrence Gallery** again went to Liste (Basel), taking work by David Carter, Shannon Oksanen, Jeremy Shaw, Kathy Slade, and Brandon Thiessen.

**Catriona Jeffries Gallery** showed international artists Sam Durant, Frances Stark, and Johannes Wohnseifer, as well as Vancouver artist Neil Campbell.

**CSA Space** opened, founded, and directed by Christopher Brayshaw, Adam Harrison, and Steven Tong.

Isabelle Pauwels and Sara Mameni at **State Gallery**, guest curated by Patrik Anderssen.

2006    **State Gallery** closed.

**Catriona Jeffries Gallery** moved to new location at 274 East 1st Avenue.

Compiled by Melanie O'Brian with research assistance from Colleen Brown and Martin Thacker.

CLINT BURNHAM is a Vancouver writer and teacher. Burnham is the author of numerous books, including *Airborne Photo* (1999), and *The Jamesonian Unconscious* (1995). His latest book, *Smoke Show*, a novel, was published by Arsenal Pulp Press in 2005. Burnham has written on such artists as Ian Wallace, Tim Lee, and Theodore Wan, and he is a freelance art critic for the *Vancouver Sun*.

RANDY LEE CUTLER is an educator, writer, and performer. She is an Associate Professor at Emily Carr Institute in Vancouver, where she teaches cultural studies, art history, and media theory. Additionally, as Associate Dean of Curriculum, she fosters links between material practices as well as generates new degrees in art, media, and design. Her research investigates the expanded relationships between mediation, gender politics, cultural theory, and embodied knowledge.

TIM LEE is a Vancouver-based artist. Since receiving his MFA from the University of British Columbia in 2002, his work has been shown in numerous exhibitions in Vancouver as well as internationally, including at the Vancouver Art Gallery; Tracey Lawrence Gallery, Vancouver; Art Gallery of Ontario, Toronto; Cohan & Leslie, New York; Lisson Gallery, London; Mori Art Museum, Tokyo; and Museum of Modern Art, New York.

MELANIE O'BRIAN is Director/Curator of Artspeak. She has organized exhibitions locally and internationally and has written for numerous catalogues, magazines, and journals.

SADIRA RODRIGUES is an independent curator and arts administrator in Vancouver. She has curated a number of exhibitions by local, national, and international artists. She was the Assistant Curator of the 2004 Shanghai Biennale, and also curated *At Play* at the Liu Haisu Museum. She has been a sessional Instructor at Emily Carr Institute since 2001 and has a Masters in Art History from the University of British Columbia. Her writing has appeared in journals and catalogues including *Thirdspace* and *Yishu—Journal of Contemporary Chinese Art*. She has also co-organized symposiums such as Locating Asia and InFest: International Artist Run Culture. Formerly the Manager of Arts Programs for 2010 Legacies Now, she is currently involved in a range of projects including public programming at the Vancouver Art Gallery, and as diversity facilitator with the Equity Office at the Canada Council for the Arts.

MARINA ROY is an artist, writer, and assistant professor in the Department of Art History, Visual Art and Theory at the University of British Columbia. As a practicing artist, Roy is interested in the intersection between language and the visual arts. Her work has been exhibited nationally and internationally, and she has also written articles and essays for a number of local and national art magazines, catalogues, and journals. In 2001, her book *Sign After the X* ____ was published by Arsenal Pulp Press and Artspeak.

SHARLA SAVA is a writer and university educator based in Vancouver. In 2006, she completed a doctorate in the School of Communication at Simon Fraser University. She has lectured, curated exhibitions, and published a variety of articles about art after modernism, discussing the works of Robert Filliou, Antonia Hirsch, Ray Johnson, N.E. Thing Co., and Jeff Wall, among others.

REID SHIER is Director of Presentation House Gallery in North Vancouver. He has curated numerous exhibitions locally, nationally, and internationally. An artist and critical writer, he was also one of the founding editors of *Boo* magazine, which he co-edited from 1994 to 1998.

SHEPHERD STEINER is currently teaching in the Art History Department at Emory University. He is the editor of *Cork Caucus: on art, possibility and democracy* (Frankfurt: Revolver, 2006). Contributions to recent publications include "Loose Ends: Untitled, Unstretched, Rolled Round" in *Morris Louis, Now* (Atlanta: High Museum of Art, 2006); "In Other Hands: Jeff Wall's Beispiel" (*Oxford Art Journal*, vol. 32, no. 2); "of painting and its abuses" in *Jörg Immendorff* (Los Angeles: Patrick Painter, 2006); and "v.s. a beginning of sorts" (*Intertidal*, Antwerp: MUKHA, 2006).

MICHAEL TURNER's fiction has been widely translated and adapted to radio, stage, and feature film. His criticism has appeared in journals such as *ArtText, Art On Paper*, and *Art Papers*. He has collaborated on scripts with Stan Douglas (*Journey Into Fear, Suspiria*) and Bruce LaBruce (*Von Gloeden*), as well as a series of sound compositions with Andrea Young. A libretto for Wilhelm Busch's *Max & Moritz: A Juvenile History In Seven Tricks* was commissioned by the Modern Baroque Opera Company and set to music by Jeff Corness. It premiered at the 2002 Vancouver International Children's Festival, and was later published (with drawings by Geoffrey Farmer) in *Public*.

VANCOUVER ART & ECONOMIES

Copyright ©2007 by the contributors

ARSENAL PULP PRESS

341 Water Street, Suite 200

Vancouver, BC

Canada V6B 1B8

*arsenalpulp.com*

ARTSPEAK

233 Carrall Street

Vancouver, BC

Canada V6B 2J2

*artspeak.ca*

Arsenal Pulp Press gratefully acknowledges the support of the Canada Council for the Arts and the British Columbia Arts Council for its publishing program, the Government of Canada through the Book Publishing Industry Development Program, and the Government of British Columbia through the Book Publishing Tax Credit Program for its publishing activities.

Artspeak gratefully acknowledges the ongoing support of the Canada Council for the Arts, the BC Arts Council, and the City of Vancouver, as well as project support from Arts Now: Legacies Now 2010, the Spirit of BC Arts Fund, and the Hamber Foundation.

Text and cover design by Robin Mitchell for hundreds & thousands

Editing by Deanna Ferguson

Cover by Geoffrey Farmer with photography by Scott Massey

Printed and bound in Canada

Library and Archives Canada Cataloguing in Publication:

Vancouver art & economies / edited by Melanie O'Brian.

Co-published by: Artspeak.

Includes bibliographical references and essays.

ISBN 1-55152-214-4

1. Art, Canadian--British Columbia—Vancouver.
2. Artists—British Columbia—Vancouver. I. O'Brian, Melanie, 1973-
II. Artspeak Gallery

N6547.V3V36 2006          709.711'33          C2006-903960-7

ISBN 13 978-1-55152-214-2